Cole, Aaron James.
Aaron James Cole's get
lost!, the cool guide to
2009.
33305221157989
la 07/13/10

A the cool guide to A msterdam

British Library in Publication Data. A catalogue record for this book is available from the British Library.

Get Lost Publishing, March 2009

All rights reserved. No part of this publication may be reproduced, stored in a retrieval system, or transmitted in any form, or by any means, electronic, mechanical, photocopying, recording, or otherwise, without the written permission of the publisher.

The author and publisher accept no responsibility for any injury, loss, or inconvenience sustained by any traveller as a result of the advice or information in *Get Lost!*

ISBN 978-90-76499-07-9

For all their help, advice, information and support, many thanks to... Adam, American Book Center, Anthony and Nina, Arnie & Tia, Betts family four, Bulum family three, Close Act, Dan, Derma Donna, DNA, Doug, Eefje, E-fans, Ellen, Franck, Gen, The Headshop, Hempworks, Jelleke, Jon, Joseph, Julian, Kim, Kokopelli, Kristin, Larry, Lies, Lin, Mark, Mike's Bikes, Misty & Fams, Mom and Pop Cole, Mama and Papa van Drimmelen, Paige & Mike, Patrick, Pink Point, Pollinator, Red, Richard, Roland & Tinne, Rosana, Sensi Seed Bank, Shayana Shop, Steve, Texas Mike, Tijmes & Zeraya, Tumbleweed Cartel, Vanessa, Village Grind in Wrightwood CA, Wavy Davy ...Extra special thanks and love to my darlings Saskia and Jadie Moon: and Joe and Lisa who made this book possible

Edited by	John Sinclair
Cover design and layout	Ellen Pauker
Photos	Patrick Weichselbaumer
	Aaron James Cole
	Joe Pauker
	Saskia van Drimmelen
(Thanks to Zeraja	Terluin for the bathtub tower photos)

Printed with vegetable-based inks on post consumer recycled paper.

NO MORE BLOOD FOR OIL

Introduction

C

ongratulations! You have wisely decided to visit the world's coolest city

Despite a wild reputation, Amsterdam is a relaxed place, a little big city vibrant with culture, a welcome oasis of sanity in our increasingly mad world. And, yes, it can be as wild as you desire – or as chilled out and sedate.

When I first came here, I was amazed at how happening Amsterdam was. There were non-commercial, underground music and art scenes happening in squatted 18h century buildings, warehouses and abandoned grain silos. Everything was accessible to everyone. I met people from all over the world and realized this could be my adopted home.

I now have the privilege of continuing *Get Lost!* – started by my good friends Joe and Lisa to share information about Amsterdam's coolest places with friends and fellow travellers.

So welcome to the little city where everything's possible.

This new 11th edition has been completely revised and updated with lots of new hot spots and the latest Amsterdam happenings. It continues to be an independent DIY project. We've sold some ads to help pay for the printing and the paper but nobody pays to be included in *Get Lost!* The book is printed on post-consumer recycled paper using vegetable-based ink.

Amsterdam changes all the time. I've tried to correctly report prices, opening times, phone numbers and websites, but I'm just a spacer, so send us a mail if you have any updates. We also accept suggestions, criticisms and donations. There will be regular updates on places and Cool Guide info, with links to various shopson our website: (www.getlostguide.com).

GET LOST! Box 18521, 1001 WB Amsterdam, The Netherlands www.getlostguide.com

Contents

Hostels	
HOSTEIS	8
Hotels & Guest Houses	10
Camping	
Getting Around	15
Bicycles	15
Inline Skates	
Public Transport	
Cars	
Boats	
Ferries	
Map of Amsterdam	
Getting Out of Amsterdam	26
Train	26
Bus	
Hitching	
Air Travel.	
Train to the Airport	
Taxi to the Airport	20
Maps & Travel Books	20
Practical Shit	29
Tourist Info	29
Money	29
Phone	30
Post.	30
Left Luggage	31
Voltage	
Weather	31
Tipping	31
Toilets	
Free English News	32
Recycling	
Laundry	
Identification Laws	
Pickpockets	
Drug Testing	
Smoking Ban	
Gay & Lesbian Info	
Food	
Supermarkets	
Health Food Stores	
Street Foods	
Night Shops	40
Late-Night Eating	41
Bread	
Free Samples	
Breakfast	43
Restaurants	45
Cofés	56

Cannabis	
Coffeeshops	
Seeds & Grow Shops	
Hemp Stores	
Cannabis Competitions	
Shopping	72
Markets	
Books & Magazines	
Records & CDs	
Used Clothing Stores	
Tattoos and piercing	
Haircuts	
Chocolate	
Smart Shops & 'Shroom Vendors	
Miscellaneous	
Hanging Out	88
Parks	
Public Squares	89
Libraries	
Internet Cafes	
Free Concerts	91
Snowboarding & Skateboarding	92
Kite Flying & Juggling	93
Tower Climbing & View Gazing	
Saunas & Massage Therapy	
Swimming Pools	
Beaches	
Street Festivals	
Kids	
Museums & Galleries	101
The Unusual Ones	101
The Big Ones	105
Out of Town	107
Music	
How To Find Out Who's Playing	
Live Music & Party Venues	
Dance Clubs	
Music Festivals	
Musicians	
Street Performance	
Underground Radio	119
Bars	121
Dais	121
Film	127
Cinemas	
Miscellaneous Film Stuf	
Wildowia i i i i i i i i i i i i i i i i i i	100
Sex	134
Sex Shops	134
Peep & Live Sex Shows, Miscellaneous Sex Stuff	136
Dictionary	139
Phone Numbers	142
Emergency & Health	
General Info Lines, Embassies & Consulates	142
Index	146

About the Author

aron James Cole was born in the year of the rat. In a strange twist of fate, he found a rat's head in a can of a popular American soft drink. The resulting lawsuit made him a small fortune, most of which he spent hiring Mötley Crüe to play his 12th birthday party. He took the rest and headed to China. One day, while smoking green tea, he met the ghost of Bruce Lee, who urged him to wander the great wall. Years later, with a beard to his knees, he was still trekking the wall. Mistaken for a member of ZZ Top he was shot by a UFO cult who collected famous beards for aliens from Uranus. Bloodied but unbowed, he stumbled to the forest where a shaolin herbalist found him and nursed him back to health.

Aaron now spends his time roaming the world's woodlands, eating berries and roots, and attempting conversation with various rodents.

ccommodation is one of the most expensive parts of a trip to Amsterdam. Rooms have always been relatively expensive and rate increases are frequent. There's an abundance of expensive and luxury hotel rooms, but budget-minded travellers don't have as many options. It can really suck trying to find a room, particularly in the busy summer months, or for short visits. Here are some tips:

During the summer, a bed in a hostel runs anywhere from about €18 to €35, and a clean double room for less than €90 is a good deal. In the winter (except around holidays) prices can drop considerably, especially on weekdays.

Bed & Breakfasts are springing up around town, some with just a couple of rooms. Due to Amsterdam's accommodation shortage the city is offering incentives to people starting B & Bs, which are usually much more affordable than hotels. Sleep At Amy's, located in an 18th-century house on the Haarlemmerdijk, is a friendly placed run by an American couple. Rooms go for around €35 per person per night. You can find them and other B & Bs at www.absoluteamsterdam.com.

The Amsterdam Tourist Office (a.k.a. the VVV), across the square in front of Centraal Station and to your left, or in the station on Platform 2 has a room-finding service. They can book you a dorm bed or a hotel room, but the cheap ones go fast, of course. You pay the full amount at the tourist office plus a €3.50 per person service charge. The people who work at the Tourist Office are very nice and sometimes you can get a good deal, but in high season the line-ups are painfully long and slow. Open: Mon-Sat 8-20: Sun 9-17.

The Amsterdam Hotel Service (Damrak 7, 520-7000; www.amsterdamhotelservice.com), just across the street from Centraal Station, offers last-minute specials on all categories of hotels. They charge a €3 per person booking fee. You prepay 10% of the room cost there, and the other 90% at the hotel. Open: Daily 9-21.

The GWK bank (627-2731) in Centraal Station also offers a room-finding service. There you pay a whopping €9.75 per room fee and the full amount of the hotel in advance. The fact that you can't see the place first is a drawback, but their "same-day" sell-off rates (on all grades of hotels) are sometimes a real bargain, especially off-season. Open: Daily 8-22.

There are dozens of online hotel booking agents, but lately a few friends of mine have been scoring some great deals via www.bookings.nl – even on five-star hotels! I've also had good experiences with CityMundo (www.citymundo.nl). They book apartments and houseboats all over the city. The rates (from about €110 a night) are comparable to those of a quality hotel, but then you've got your own place with all the comforts of home.

Finally, wherever you stay, and no matter how safe the place seems, never leave your valuables lying around. Keep your important stuff with you or, even better; leave it in a safety-deposit box if your hotel has one.

hostels

Schiphol Airport

You know, I've slept in a lot of airports around the world, and Schiphol is definitely the best. If you have an early flight, crashing here is a good way to save the cost of a night's lodging. They have comfortable couches in the departure lounges where you can actually lie down and sleep (that's in the boarding area, not in the rest of the airport). This area is accessible to passengers only until midnight, though: if you don't get there before, it's plastic chairs or on the floor. Before you check in, hit the Food Village supermarket (open daily 6-24) on the arrivals level. It's the cheapest place in the airport for food. And if you need to bathe, there are free showers next to the British Airways lounge (like the good couches, they're in the boarding area). Or for €12.50 you can have a more luxurious being experience in a private cabin with soap, towel, and a

www.schiphol.nl

Christian Youth Hostels (The Shelter City, The Shelter Jordan)

www.shelter.nl

Only €16 to €19 for a dorm bed and breakfast makes these two hostels a great deal. But separate rooms for men and women, curfews, sing-alongs in the lounge, and a clean-cut staff looking for converts should persuade you to spend a little more elsewhere. As for these, you'll have to find the addresses yourself.

The Flying Pig - Nieuwendijk 100, 🏗 420-6822; Vossiusstraat 46, 🛣 400-4187

www.flyingpig.nl

The guys who run these places are travellers themselves, which explains such things as the use of kitchens, late-night bars, free internet access (wireless too, if you've got a laptop), and the absence of curfews. For hanging out, both locations have lounges, and Nieuwendijk has DJs. All rooms have toilets and showers, and prices include a free basic breakfast. The hostel on Nieuwendijk (Flying Pig Downtown) is very close to Centraal Station. The rates per person for shared rooms with 4 to 22 beds range from €21 to €31.50. Couples can save money and have fun by booking an extra wide bunk bed which, depending on the size of the room, runs from €31 to €47 per bed. They also have a girls-only dorm. The other hostel (Flying Pig Uptown) is by Vondelpark. They have shared rooms with 4 to 10 beds for €20 to €29.50 per person, and double bunks from €29.50 to €45 per bed. A €10 cash deposit for sheets and keys is returned when you leave. Both sites are central, but the neighborhood around Vondelpark is nicer and, of course, next to the park. To reach the Uptown from Centraal Station take tram 1, 2, or 5 to Leidseplein. Walk across the bridge to the Marriott Hotel and turn left. The hostel is on the street that runs along the left side of the park. (Map areas D4, B8)

Tourist Inn - Spuistraat 52, 2 421-5841

www.tourist-inn.nl

There's nothing fancy about this hostel, but it's a bit more spacious and clean than some of the others in the neighborhood around Centraal Station. Dorm beds cost from €20 in low season (that's okay) to €35 per person in high season (that's not). They have an elevator for those with screwed-up knees, and there's a TV and phone in every room. Breakfast is included. Doubles and triples are also available, but the price is too high for what they're offering. You can take trams 1, 2, 5, 13 or 17 and get off at the first stop. Or just walk from Centraal Station. (Map area D4)

Bob's Youth Palace - Nieuwezijds Voorburgwal 92, 2 623-0063

www.bobsyouthhostel.nl

You can usually find this hostel by looking for a bunch of backpackers sitting on the front steps, smoking joints and hanging out. This is a pretty cool place where a lot of travellers stay, but it's cheap, simple lodging don't expect more than the basics. It's right in the center of the city and €19 gets you a dorm bed and breakfast. They also rent apartments complete with kitchens for €70 for two people. Bob's also has a women's dorm. Trams 1, 2, 5, 13 or 17 will take you there, or you can walk from Centraal Station: it's not far. (Map area D4)

International Youth Hostels - Zandpad 5 (Vondelpark), 🏗 589-8996

Kloveniersburgwal 97, 7 624-6832

www.stayokay.com

These are "official" youth hostels. The one in Vondelpark (a great location) has been completely renovated and all their rooms are equipped with toilet and shower. They offer dorm beds in larger rooms, depending on the season, from €20 to €27, and quad rooms from €25 to €30 per person. Double rooms cost €65 to €74 per room. Friday and Saturday nights there's a €2 per person surcharge (€1 at the other location). Members receive a €2.50 discount. Sheets are included in the price, as is an all-you-caneat breakfast. There are also restaurants, a bicycle rental service, internet facilities, and a tourist info center. And I've been assured that, most of the time, groups of kids on field trips will be booked into a different building from the one housing independent travellers. From Centraal Station take tram 1, 2, or 5 to Leidseplein. Walk to the Marriott Hotel and turn left. The hostel sign is just a block ahead of you. The other location is also nice: on a wide canal right in the center of the city, but there are only dorm rooms. Beds cost €20 to €24. (Map areas E6. B7)

Stay Okay - Timorplein 21, 🏗 551-3190

www.stayok.com

This brand spanking new Hostelling International hostel is located in the up-and-coming *Indische buurt* in East Amsterdam, a bit far out of the center. The prices work on a sliding scale, depending on how full the place is. A bed in a spacious six-person room will run you between €20 and €22. If you want a two-person room it can be €28 to €46 per person, with breakfast included in the price. The rooms are clean and have a toilet and shower, a modern key-card system and 24-hour access. This place is massive (460 beds) but still books out in high season. A bar with half-price happy hour from 21:30-22:30 and Sunday night free big-screen Wii tournaments are a bonus, but expensive internet services, including paying for WiFi, are not. The place is completely wheelchair-accessible and has rooms designed for the disabled. Take tram 7 or 10, direction Javaplein. Right around the corner from Studio K (see Film). (Map area J7)

Hans Brinker Hotel - Kerkstraat 136-138, 🏗 622-0687

www.hans-brinker.com

The motto here: It Can't Get Any Worse. A reception desk carved with dozens of initials and a graffitied elevator that looks like a punk bar toilet add to the trashy appeal. You can book a bed during high season in a six-person room for €25, including a locker. The rooms are clean but not fancy. There's a restaurant with veggie lasagna for €6.50 and fish and chips for €6, which is cheap. €3 pints are available at the bar and there's an mp3 jukebox. The super-friendly staff is a big plus. Located near Leidsestraat. (Map area C6,7)

The Winston - Warmoesstraat 129, 2 623-1380

www.winston.nl

This funky hotel (see below) also has dorm beds for around €25-30. A continental breakfast is included. (Map area D4)

hotels and guest houses

Here are a few places with clean, reasonably-priced rooms. In the summer you should really try to arrange your accommodations in advance, or at least before leaving Centraal Station (see intro to this chapter for details). Expect prices to jump during holiday periods.

Hotel Rookies - Korte Leidsedwarsstraat 147, 2 428-3125

www.rookies.nl

All the rooms in this popular, centrally located hotel have private facilities, cable TV, a telephone, a safe, and reading lights. The building is 200 years old, but the interior is modern and clean. Prices per room are €85 for singles, €117 for doubles and €127 for a twin room with a bathtub – all include a full breakfast with scrambled eggs, cheeses, cold cuts, and fresh OJ. There's also a stylish townhouse available, complete with kitchen and small patio, that sleeps 6 and goes for about €40 per person. This hotel is run by the same people as The Rookies Coffeeshop (see Cannabis chapter), so it's smoker-friendly, too. Take tram 1, 2, or 5 to Leidseplein and then it's just a short walk. (Map area C7)

Hemp Hotel Amsterdam - Frederiksplein 15, 🏗 625-4425

www.hemphotel.com

This little pension in the center of Amsterdam is totally unique. Each of the five small rooms all decked out in hemp has its own theme. Try sleeping on a hemp mattress for a few nights in the Afghani room. Or, if you've always fancied a visit to the Himalayas, book the Indian room. Rates are €55 for a single, €70 for a double, €75 for a twin with private shower, and all include a vegetarian breakfast. An extra mattress in the room costs an additional €10. Look for a drop of about 10% off season. Downstairs, the Hemple Temple bar has turned into a popular late-night hangout. You can party there until 3 on weeknights and 4 on Friday and Saturday. They serve hemp snacks, hemp beer, but alas, no more hemp vodka right out of the freezer. Take tram 4 from Centraal Station to Frederiksplein. (Map area E8)

Hotel Abba - Overtoom 122, 2 618-3058

www.abbabudgethotel.com

The staff at this hotel is friendly and helpful. Depending on the season, singles cost from €25 to €55. Doubles (some with a shower and toilet) range from €45 to €80. They also have rooms for 4 and 5 people that run from €25 to €35 per person. All rooms have TVs, and an all-you-can-eat breakfast in a sunny room is included in the price. The free safety deposit boxes in the reception area are a very nice feature: use them! There's a nice view from the front (especially from the upper floors), but it can be a bit noisy because of the street traffic. Close to Leidseplein and Vondelpark. Take tram 1 from Centraal Station to Constantijn Huygensstraat. (Map area A7)

Hotel Princess - Overtoom 80, 612-2947

This hotel is located at the corner of a busy intersection about a five-minute walk from the Leidseplein and just up the way from the Abba (see above). It's a bit run-down but maintains some nice touches like

reading lights by the bed. Depending on the season, single rooms cost $\[\in \]$ 38 to $\[\in \]$ 43; twins and doubles are $\[\in \]$ 60 to $\[\in \]$ 65; triples are $\[\in \]$ 75 to $\[\in \]$ 95; quads are $\[\in \]$ 80 to $\[\in \]$ 10. Toilets and showers are all shared, but there are TVs in the rooms. Breakfast is included: bread, cheese, ham, cereal, boiled eggs, juice and coffee. The rest of the day, drinks and snacks are available at the reception. Take tram 1 from Centraal Station to Constantijn Huygensstraat. (Map area B7)

Hotel Crystal - 2e Helmersstraat 6, 2 618-0521

www.hotelcrystal.nl

Brought to you by the same owners as the Princess, Hotel Crystal is also close to the Leidseplein but on a quieter street. They have singles for around €60, and doubles without facilities for €80. Doubles with a shower and toilet start at €95. Triples with facilities are €130, and quads with facilities cost €165. All rooms have TVs, and the house provides an all-you-can-eat broakfast as well. From Centraal Station take tram 1 to Overtoom and then walk two blocks along Nassaukade. (Map area B6)

The Greenhouse Effect - Warmoesstraat 55, 🏗 624-4974

www.thegreenhouseeffect.com

The 17 rooms of this smoker-friendly hotel each have a different theme (outer space, tropical dream, Turkish delight, etc), making it the perfect place for the stoner traveller with a bit more money to spend on accommodation. Prices start at €70 for a single, €110 for a twin, €140 for triples and €180 for quads. Every room has a color TV and a safe, and most have a private shower and toilet. The price includes a breakfast buffet until noon, and guests are entitled to special happy hour prices all day on weed and booze at the hotel's coffeeshop and bar downstairs. If you're travelling with a group, look into one of the three apartments they rent. The Greenhouse Effect is located in the Red Light District, which is walking distance from Centraal Station. (Map area D4)

St. Christopher's at The Winston

Warmoesstraat 129, 623-1380

www.winston.nl

Over half the rooms at the Winston were designed by artists. Some are really fantastic, but others are superugly or sponsored by crappy corporations. Fortunately you can see pics of the rooms on-line before you make a booking. Depending on the season, prices range from €50 to €80 for singles, €65 to €100 for twins, €90 to €123 for triples, and €105 to €156 for quads. They also have dorm beds for €20 to €30. A continental breakfast is included, and there's a great club on the premises (see Music chapter) where hotel guests get half-off on admission. It's situated in the Red Light District just a couple of minutes from Dam Square. (Map area D4)

The Flying Pig - Nieuwendijk 100, 🏗 420-6822, Vossiusstraat 46, 🏗 400 4187

www.flvingpig.nl

Buth these hostels have private rooms, too. Singles start at €60, and twins at €73.60. See the Hostels section (above) for more details.

Groenendael - Nieuwendijk 15, 🏗 624-4822

www.hotelgroenendael.com

If you prefer to stay close to the center of town, then this hotel is a good deal. Singles go for €35, doubles for €60, and triples for €90 (cheaper off season). Showers and toilets are in the hall. The rooms are tiny and pretty basic, but you're paying for the location. Breakfast is included, and there's a lounge where you can hang out and meet people. The shopping street where Groenendael's located on is a trifle sleazy, but it's not at all dangerous. From Centraal Station, walk or run. (Map area D3)

Hotel Aspen - Raadhuisstraat 31, 2 626-6714

www.hotelaspen.nl

There are a bunch of hotels here in the beautiful *art nouveau* Utrecht Building. The hotel Aspen is a small, family-run place that feels more like a guest house than a hotel. Singles here start at €35. Doubles with a sink in the room start at €50. A triple with shower and toilet goes for €85 to €95. And a quad with shower and toilet is €100. No breakfast, but a great location close to Dam Square and the Anne Frank House. From Centraal Station take tram 13 or 17 to Westermarkt and walk back half a block. If you don't have much luggage, it's about a 15-minute walk. (Map area C4)

Bed & Coffee - Rustenburgerstraat 427, To 065-519-4911

www.bedcoffee.nl

Because this tiny guesthouse is a bit out of the center and only has three rooms, you can stay here for the same price you'd pay for a dorm bed at a hostel. But hostels don't feature "light art" in every room. Here you can choose from four special lighting options: black light, colored spots, psychedelic, or space. Obviously it's a smoker-friendly place. Prices vary from €40 - €100 per room. The shower and toilet are shared. It's very clean, and there's a cozy lounge with a TV, 24-hour internet access, and free coffee, tea, soup, and hot chocolate. Book very early. Bed and Coffee is located in the *Pijp* (Pipe) area. From Centraal Station take tram 24 or 25 to Ceintuurbaan, walk two blocks further along Ferdinand Bolstraat and turn right.

Van Ostade Bicycle Hotel - Van Ostadestraat 123,

679-3452

www.bicyclehotel.com

If you're travelling by bicycle take note. This is one of the only hotels in Amsterdam with free indoor bike parking. They also rent bikes to guests and provide info on bicycle tours in and around Amsterdam. And they have recycling bins for glass and paper. That's cool. The rooms? €40 to €70 for a single. €50 to €120 for doubles. €80 to €150 for triples. €120 to €170 for a quad. Breakfast is included. The rooms aren't exciting, but they're clean and all have TVs. There's a library/lounge downstairs with free internet access. It's located in *De Pijp* – a fun, lively neighborhood crammed with bars, shops and restaurants. From Centraal Station take (or cycle behind) tram 24 or 25 and stop at Ceintuurbaan. Cross the street and go one block further.

Hotel Rembrandt - Plantage Middenlaan 17, 627-2714

www.hotelrembrandt.nl

This is a sweet little hotel in a beautiful, wealthy area of town. All the rooms have private facilities, a TV and a coffee/tea maker, but if you've got the dough, splurge on the more expensive doubles (€115 per room). Each of those rooms is uniquely decorated, has a modern bathroom, and is way nicer than what you normally get for that price in Amsterdam. Other doubles cost €95 per night. Sometimes they can squeeze in an extra person for €22. Quad rooms cost €165. A free breakfast is served in an incredible antique-filled room. On weekends there's a minimum three-night stay. Book early! The Botanical Gardens (see Museums chapter) is two minutes away, and just beyond that is the Waterlooplein market. From Centraal Station take tram 9 to Plantage Kerklaan and then walk back half a block. (Map area F6)

Lloyd Hotel - Oostelijke Handelskade 34, 2 561-3636

www.lloydhotel.com

The Lloyd is a unique hotel in a beautifully renovated monumental building located in a newly developed area east of Centraal Station known as the Eastern Docklands. It's billed as a "cultural embassy"

and the rooms as well as the atmosphere are artistic. The rooms range from one to five star quality, but each is unique. Prices range from €70 to a whopping €295. Some of the views are amazing. There's a café, bar, restaurant, library, ticket outlet, and a parking lot on the premises. It's close to the Bimhuis jazz center (see Music chapter) and the Cantine (see Bars). From Centraal Station take Tram 26 to Rietlandpark. (Map area I4)

Amstel Botel - Oosterdokskade 2 4, 🏗 626-4247

www.amstelbotel.com

This four-storey hotel-on-a-boat used to be in front of Centraal Station (CS) but has moved to Amsterdam North, near the NDSM terrain (see Music). It now takes a 10-minute ferry ride from behind CS to get to the Botel. It may seem a bit far, but this part of the North on the IJ waterway has a definite urban waterfront charm and a unique view of Amsterdam. The rooms here are small but very clean and modern. Each has a tiny shower and toilet, a phone, and a TV with free in-house videos (including a porn channel). The reception is open 24 hours and they don't charge commission to change your money. Single and double rooms cost €89 per room (€94 for a water view); triple rooms cost €119 (€124 for a water view). Breakfast is not included. Prices drop about €10 in the winter. A ferry goes to NDSM two times per hour (until midnight on weekdays and 1:00 on weekends), departing from directly behind CS. After that time, a free shuttle will bring you from the all-night ferry, which also departs behind CS, direction Buiksloterweg.

House-Boat Hotel

www.houseboathotel.nl

If you like the idea of sleeping on a canal, another possibility is to rent a houseboat. This website offers several boats for daily or weekly rental. If you're travelling with a small group, this sometimes works out to be comparable to the price of a hotel but is usually much more luxurious. These boats are very popular so make sure you book well in advance. There's a €20 booking fee. Note also that smoking is only allowed outside – on the balconies or in the gardens.

Hotel Arena - 's Gravesandestraat 51, 🏗 694-7444

www.hotelarena.nl

Years ago, this huge old mansion was converted into a low-budget hostel because the City wanted hippies to stop sleeping in Vondelpark. It turned into one of the coolest hostels in town, in spite of being located a bit outside of the center. Now the dorms are gone and they only rent rooms. Depending on whether or not you want their expensive breakfast, doubles and twins go for €80 to €175. Triples go for €135 to €202. All rooms have shower and toilet, TV, telephone, and the very important reading lights by the bed. If you need a video game fix, you can rent a Playstation (€10 for 24 hours) and there's WiFi access in some parts of the building. Breakfast is included, but not a 5% tax. As always, it's a good idea to make a reservation. It's close to the Tropenmuseum and Oosterpark. From Centraal Station take tram 9 to Mauritskade. Night bus 356. (Map area G8)

Xaviera Happy House - Stadionweg 17, 🏗 673-3934

www.xavierahollander.com/sleeper

The Happy Hooker has a guest house: that had to be in *The Cool Guide*. I know that €120 a night isn't exactly cheap, but this is the home of a real celebrity. Xaviera Hollander's house is in the wealthy area of Amsterdam south. She rents two rooms to visitors. Both have TVs and king size beds, and breakfast is included. Prices sometimes drop in the off season or for long stays. Go to the website to see pictures of the rooms and to read about all the creative projects Xaviera's got going.

Black Tulip Hotel - Gelderskade 16, 🏗 427-0933

www.blacktulip.nl

I should start by saying that this hotel, situated in a 16th-century canal house near Centraal Station, caters exclusively to leather men – that is, gay men who are seriously into S/M, B&D and leather fetish. Each of the nine luxurious rooms is decorated differently, but all feature kinky sex equipment: metal cages, stocks, fist-fuck chairs, etc. In addition to slings and bondage hooks, all rooms have TVs with VCRg, minibars, telephones, and private bathrooms (some with whirlpool). Prices range from €125 to €195 and include a buffet breakfast in their comfortable lounge. And, as a service to guests who prefer to travel light, they rent body bags, straight jackets, heavy leather boots and other paraphernalia. (Map area E4)

Prins Hendrik Hotel - Prins Hendrikkade 53. 623-7969

www.hotelprinshendrik.nl

I've never been inside, but this is the hotel Chet Baker was staying in when he fell (or took a dive, or was pushed) out of his window to his death, back in 1988. If you're a big fan you might want to stay here too, or – if you find that a tad morbid – check out the plaque in front commemorating one of jazz's late greats. (Map area E4)

camping

Camping Zeeburg - Zuider IJdijk 20, 2 694 4430

www.campingzeeburg.nl

They have all kinds of facilities here, including a funky bar that throws regular parties in the summer. Camping costs €11 per person during high season and €7 during low season. Camping site rates drop in price the more people you have in your group. There are also "camping huts" with beds at around €20 per person. Open all year. From Dam Square take Bus 22 (direction *Indische Buurt*) to the Kramatweg, or Tram 14 to the end of the line. From there you can follow the signs that lead you over the big bridge and to the campgrounds on the right. Night bus 359 (then a 20 minute walk).

Gaasper Camping - Loosdrechtdreef 7, 696 7326

www.gaaspercamping-amsterdam.nl

€5 per adult, €2.50 per kid, €2.50 per dog (plus €6 for a 2 person tent, €7 for a 3 or more person tent, and €4.50 per car). Open March 15th to November 1st. Take metro 53 from Centraal Station to Gaasperplas. From there it's a five-minute walk. Night bus 357.

Amsterdamse Bos - Kleine Noorddijk 1, 2 641 6868

www.campingamsterdamsebos.nl

There's a campsite here in the beautiful woods just south of the city center. €5 per person, €6 to €7 per tent, €4.50 per car. They also have basic, little cabins for about €10 per person, and more comfortable cottages that sleep five for about €25 per person. Open year round. Bus 172 from Centraal Station takes you to Amstelveen station where you transfer to bus 171 which takes you to the campground.

Vliegenbos - Meeuwenlaan 138, 🏗 636 8855

www.vliegenbos.com

This site is located in a wooded area of Amsterdam North. It costs €8 per person, and an extra €8 if you have a vehicle. There are also 30 cabins (four beds each) that rent for €70 a night. They accept written reservations for the cabins from March. They're open from April 1st to September 30th. From Centraal station take buses 32 or 36. Night bus 361.

Getting around

msterdam's old city center, with its countless canals and cobblestone streets, is a perfect place to wander and get lost. Getting found is easy – everyone speaks English. The names of the streets, which often change every few blocks, can be daunting to pronounce. Usually, if you point to a map a local can explain how to get where you're going. A good city map costs about €2 and is a worthy purchase. The street names are all listed on the back, making it quick and easy to find the addresses in this book.

If you don't want to pay for a map, there are a variety of free maps available around town. These maps are often limited to the old Centrum but can be handy to find coffeeshops (Cannabis Retailers' Association and High View both make maps), tourist locations, and Gay tourist spots. The Visitor Guide has a pretty good map. Gay tourist maps are free at Pink Point (see Practical Shit). There's also a map in the front of the phone book, complete with a street index.

The basic layout of the city, with a series of horseshoe-shaped canals surrounding the oldest part, makes it fairly easy to find your way on foot. This is certainly the best way to see Amsterdam and fully appreciate its incredible beauty.

Online, go to www.atlas.amsterdam.nl. Type in the street name and number of your hotel or any other place in Amsterdam you're looking for and it loads a printable map of the street, neighborhood, or entire city with your destination clearly marked. So, now you know your way around town: go get lost!

bicycles

Don't be scared to rent a bike and go for an authentic Amsterdam experience. Unlike most North American and many European cities, bikes are respected in Amsterdam. There are still too many dirty, ugly, polluting cars in the city center, but there are also thousands of beautiful, clean, fast, efficient bicycles. There are bike lanes all over town and it's a fun, relatively safe way to explore. Listed below are several places to rent bikes. If you're here for a while you may want to consider buying a used bike and selling it to someone when you leave. Make sure you lock your bike everywhere, even if you're only leaving it for an instant (see note on bike theft). One of the cheapest places to buy a lock is the Waterlooplein flea market (see Markets, Shopping chapter).

Over the past couple of years, in an effort to "clean up the city" (whatever that means) there have been several crackdowns on illegal bike parking (I'm not joking). So if you see a sign that says "geen fietsen plaatsen" or "fietsen worden verwijderd," or notice that an area is conspicuously free of any other parked bikes, you're probably better off locking up somewhere else. Parking is particularly difficult and enforcement is especially ruthless around Centraal Station. Make sure you use the free multi-level bike parking lot at the west side of the station, or if you don't mind paying €1.10 for the service, park at one of the two guarded indoor lots at either end of the station.

fietsen worden verwijderd 禁停單車

Œ

getting around

A fun day ride a bike is the annual Autovrije Zondag (Autofree Sunday; www.autovrijezondag.nl). It takes place in mid- to late September, and even though the cab drivers are still allowed to drive like idiots through the city, a good portion of the Centrum is closed to motorized traffic.

Mike's Bike Tours - Kerkstraat 134, 2 622-7970

www.mikesbiketoursamsterdam.com

If you enjoy the comfort and sociability of riding with a group, or you're a bit nervous about biking here for the first time, or you'd like to learn a bit more about Holland, consider a guided bicycle tour with this reputable company. Mike's Bike's popular four-hour tour winds through the city and out into the countryside, including numerous stops and photo-ops along the way like a windmill, a cheese

farm, and other points of interest. The guides are knowledgeable about history and architecture, but also about nightlife, urban lore, and where to party. The cost is €22 (€19 for students, €15 for kids). They also offer a "bike and boat" tour at €29 (€25 for students, €20 for kids) that includes a bike tour and a one-hour boat trip. It's a good deal. Reservations aren't necessary - just show up at Mike's Bike shop on Kerkstraat just off Leidsestraat. Departure times for the standard tour are daily as follows: March 1 to May 15, 11;00; May 16 to August 31, 11 and 16:00; September 1 to November 30, 11:00. And now there's also a winter tour that departs Fridays, Saturdays and Sundays at noon. The "bike and boat" tours leave June through August, Tuesday to Sunday at noon. Finally, if you want to head off on your own, Mike's has the coolest-looking rental bikes in town. They cost €7 for a day rental and €10 for 24 hours (extra days €5 each; optional insurance €3 per day; photo ID, a credit card, or €200 cash deposit required). Open: Daily (Mar-Nov) 9-18; (Dec-Feb) 10-18. (Map area C7)

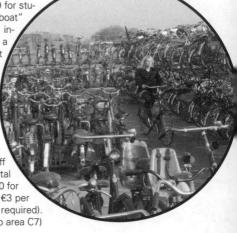

Bike City - Bloemgracht 70, 🏗 626-3721

www.bikecity.nl

This is a genuinely friendly shop located on a beautiful canal near the Anne Frank House. Standard bikes cost €8.50 per business day, €10 for 24 hours, €30 for 5 days, and €5.50 for each additional day. They also rent three-speed bikes with hand brakes (€14.50 for 24 hours). If you request it, you'll be provided with a puncture repair kit – a bonus if you're heading for the countryside. You'll be asked for a passport and a cash deposit of €25 (or a credit card slip). Open: Daily 9-18. Closed in January. (Map area B4)

Macbike - Centraal Station, ☎ 625-3845; Mr. Visserplein 2, ☎ 620-0985; Marnixstraat 220, ☎ 626-6964; Weteringschans 2 (by Leidseplein), ☎ 528-7688

www.macbike.nl

Macbike has quality bikes and a good reputation, but sometimes there are long lines to pick up and return rentals. And the bikes have big, annoying signs on the front that scream "tourist." Standard bikes cost €8.50 per day (24 hours). Bikes with handbrakes and gears cost €12.75 per business day. The more days you rent, the cheaper it gets. A €50 deposit or a credit card slip, plus a passport, is required. Theft insurance (optional) costs an extra 50%. But they sell maps and information on cycling routes in and outside the city for €1. Open: Daily 9-17:45. (Map areas B5, E6, C7, B7)

Rent A Bike Damstraat - Damstraat 20, 2 625-5029

www.bikes.nl

You'll find Rent A Bike in an alley off Damstraat just east of Dam Square. They're also very friendly. The only drawback to renting here is that their bikes also have big ads attached to their front carriers. You

can rent by the hour (€3.50 for the first hour, then cheaper for each additional hour), or by the day (€7 from 9 to 18:00 or €9.50 for 24 hours). Their special weekly rate is €31. They require a €25 deposit (cash or credit card) and a passport. Seats and helmets for kids are also available. Keep your eyes peeled for their small coupons that are worth a 10% discount. Open: Daily 9-18. (Map area D5)

Frederic Rent a Bike - Brouwersgracht 78, 2 624-5509

www.frederic.nl

It's just a 10-minute walk from Centraal Station to this small shop. They charge €10 a day (24 hours) and the price includes insurance and a child-seat, if you need it. They don't ask for a deposit, just a credit card or passport. And there's no advertising on their bikes, which is a nice touch. They also organize room rentals in several houses and boats in the neighborhood and the prices are pretty good. Open: Daily 9-18. (Map area D3)

Recycled Bicycles - Spuistraat 84A T 06-5468-1429

www.recycledbicycles.org

This hole-in-the wall bike shop is one of the smallest, coolest and definitely the cheapest in Amsterdam. The owner of this little company used to build hikes from spare parts that were donated or garbage-picked, but the Dutch cops eventually stopped his business by claiming everything found in the garbage – including junked bicycles – is property of the Queen! What a bunch of shit! Luckily, he still sells used and rebuilt bikes at fantastic prices and none of them are stolen. You can usually peddle away for between €40 and €65 (and that includes a one-month guarantee). This is an inexpensive alternative if you plan to stay in Amsterdam for an extended period, plus they let you sell your bike back to the shop when you leave. Rentals are €5 a day with a €50 cash deposit, and that's extremely cheap. Mon-Fri 9-18 (siesta from 12-1); Sat 14-18. (Map area D4)

Amsterdam Weekly

Check the classified section at the back of this weekly English paper (see Practical Shit). It appears every Wednesday and there are often used bikes for sale.

Via Via - 🏗 626-6166

www.viavia.nl

Via Via is a classified ads paper that's published every Tuesday and Thursday. There are always lots of cheap bikes listed, though you'll have to find a Dutch speaker to help you read the ads. Look under *fietsen* or *tweewielers*. The paper features thousands of items for sale and is available all over town. The paper costs €2.40, but you can peruse it at the library for free (see Hanging Out chapter).

Soul Cycle - Nieuwe Herengracht 33, 771-5484

www.soulcycle.nl

Though there's sometimes rivalry with the skateboarders, most of the spots mentioned for skateboarding in the Hanging Out chapter get used by BMX bikers too. Check out this shop to get the most upto-date info on what's really happening on the scene – they're

in the middle of it all. (Map area E6)

Tall Bikes

www.tallbike.net

Original tall bike constructor and guru, the legendary squat inventor Moonflyer, has sadly passed on, but his legacy remains. These custom-made super-tall bikes are designed and created for a variety of purposes, including jousting tournaments. That's right, jousting! They're quite an impressive spectacle. The website has pics and info about other

getting around

events, too, including the Bike Wars demolition derby where, with some heavy tunes playing in the background, participants ride around and smash the crap out of each other's bikes until only one is still rideable. Cool.

Critical Ass - Mid-June

www.worldnakedbikeride.org

Why would a horde of cyclists meet annually to ride naked through the streets of Amsterdam? According to the organizers of the World Naked Bike Ride, it's to "protest against indecent exposure to automobile emissions and to celebrate the power and individuality of our bodies." In the past, the meeting point has been at Centraal Station.

inline skates

Rodolfo's - Sarphatistraat 59, 2 622-5488

www.rodolfos.nl

Inline skates for rent! Skating's not too bad on the bike lanes, and the people who work here at Europe's oldest skateshop know all the hot spots around town. The rental is from 12 noon until 11:00 the next day, and the price is €7.50. A €100 deposit and ID, or a credit card, is required. They also sell snowboards, skateboards, and skate fashions. Open: Mon 13-18; Tues-Fri 10-18 (Thurs till 21); Sat 10-17. (Map area E8)

Rent A Skate - Vondelpark, 2 664-5091

www.vondeltuin.nl

Vondelpark (see Hanging Out chapter) is the best place to skate, especially if you're inexperienced and want to avoid traffic. Skates are rented by the café at the Amstelveenseweg end of Vondelpark. You'll need €5 per hour plus a passport and a €20 deposit. They're open daily (when the streets are dry) from March to October, 11 to sunset; and on weekends from mid-March to May.

Friday Night Skate - Vondelpark

www.fridaynightskate.nl

As long as the roads are dry, skaters meet every Friday evening at 20:00 just to the right of the Film Museum in Vondelpark and head out for a 15-kilometer tour through the city. Everyone is welcome, but you should be an experienced skater. (Map area B8)

public transport

Most people visiting Amsterdam stay mainly in the center and don't have to rely too much on public transit. But if you need it, you'll find there's a good network of trams, buses and Metro (subway) lines.

Amsterdam is divided into zones, and the more zones you travel in, the more expensive your ticket will be. If you'll be using public transit for more than one round-trip your best bet is to buy a *strip-penkaart*. Buy these at Centraal Station or at post offices, tobacco shops and supermarkets all over town. Single tickets can be purchased on trams and buses, but at €1.60 they're much more expensive. You can also purchase day-tickets that are good on all buses, trams, and the Metro from 1-3 days (1 day: €6.30; 2 days: €10; 3 days: €13). After midnight, night buses take over, but only on some routes, and the prices go up.

Most of central Amsterdam is one zone. There are 15 strips on your card, and for each ride in the Centrum you must stamp two strips on your card. On trams there's only one entrance, there you'll find a conductor who will stamp your *strippenkaart* for the amount of zones you plan on travelling. Your ticket is then valid for an hour within that zone – the last in the series of numbers stamped on your ticket is the time you embarked – and you can take as many rides as you wish within that 60-minute period. You have to stamp an extra strip for each additional zone you want to travel in or through. One zone costs two strips, two zones cost three strips, etc.

To request a stop, push a red button on one of the poles. To disembark your train, tram or bus, push the button by the door.

Public transit here operates largely on the honor system, so you can try to ride for free if you want. But if you get caught by the transit squad in the red jackets there's a hefty fine plus the fare and the "I'm a tourist; I didn't understand" routine usually won't work. By law you have to show them some ID (see Practical Shit chapter).

In addition to the regular buses and trams, Amsterdam also has a wonderful mini-bus service called the *Opstapper* that leaves Centraal Station every 10 minutes, runs along the Brouwersgracht, Prinsengracht, Amstel, and ends at the Stopera (see Free Concerts, Hanging Out chapter) where the Waterlooplein flea market is. There are no stops: you can flag it down and get on or off anywhere along the route. It's a one-zone fare and you can use your *strippenkaart*. (Hours of service: Mon-Sat 7:30-18:30.)

For more information about public transit (or help finding your way somewhere), visit the GVB ticket office and pick up a free route map. Walk across the little square in front of Centraal Station and you'll see it on your left, in the same building as the Tourist Office. (Open: Mon-Fri 7-21; Sat-Sun 8-21.) You can also call 0900-9292 for directions, but it costs 70 cents per minute and I've found that they often give bad advice. Perhaps it's a feeble attempt to get the public to support the privatization of public transit.

Since I'm complaining, I'll tell you another thing that's fucked in Amsterdam; the big construction messes that you'll encounter all over the city for the next half decade or so are the result of work on a "North/South" subway line. It's one of those extremely unpopular, ill-conceived mega-projects that

getting around

steadily leeches millions from education and other social services. You know, the kind of project that stays alive in spite of safety concerns, serious doubts about its necessity, and ongoing allegations of massive fraud. See, there are some similarities between Amsterdam and the city you come from.

cars

Parking

There are already too many fucking cars in Amsterdam, but if you have to bring one into the city the best thing to do is put it in a garage and leave it there. It's expensive but nowhere near as much as if you get caught parking illegally. The Arena/Transferium (tel: 400-1721) is a huge garage under the Arena stadium south of the city center (from the A10 take exit A9/A2 and turn off at Ouderkerk aan de Amstel). It's one of several Park-and-Ride lots located around the outskirts of the city. Their normal price is €19 a day, but they have a special deal: 24 hour parking and 2 free public transport tickets for only €5.50. Take your parking ticket to the P+R kiosk and they'll give you the free tickets and explain how the discount works. Innercity parking is much more expensive. At the Heinekenplein lot (entrance off Eerste van der Helststraat, 470-0888), the price is €2.50 an hour (€25 a day). They're open Mon-Sat from 7:30 to 2:00 (Map area D8). ANVB Parking (Prins Hendrikkade 20a, 638-5330) costs even more - €3.40/hour: €42.50/day - but it's open 24 hours (Map area D3). For a list of all the parking garages in Amsterdam, along with maps and prices, check online at: www.naaramsterdam.nl

From 9 until midnight (noon to midnight on Sundays), parking on the street in the center costs about €4 an hour and the prices are constantly rising. Amsterdam Centrum is now one of the most expensive places for parking in the world – four times as much as Paris! You pay at little blue boxes that are on every block, and the instructions are in English. The further out you go, the cheaper the price. A day ticket (from 9 to 19:00) in Osdorp and the western part of Bos en Lommer costs €6.60. Don't fuck around to save a couple of euros – the parking police work on quotas and they can spot an out-of-town plate or a rental car from a kilometer away. If you get ticketed, towed or the dreaded wheel clamp you'll be out serious money.

Car Rental

If you want to rent a car, look in the Yellow Pages under Autoverhuur. Kuperus has small cars starting at €25 per day in the east end (Van der Madeweg 1, 668 3311), but the guys who work there are exceedingly unpleasant: it might be worth it to pay a bit more somewhere else. I once got a good deal from Sixt (Amsteldijk 52; 470 8883). Avoid Adams Rent a Car Service. Note that if you can provide an Amsterdam address for the rental agreement, you might get a better deal from the major rental companies as some have special rates for residents.

24-Hour Gas Stations

There are gas stations open 24 hours at Sarphatistraat 225 and Marnixstraat 250. Please remember when you're buying gas that Shell Oil helped prop up the apartheid regime in South Africa. They also supported the corrupt military dictatorship in Nigeria that murdered Ken Saro-Wiwa and so many other Ogoni people. And now they're making record profits off the war in Iraq. Shell isn't the only sleazy oil company around, but they are the target of a world-wide boycott. Hit the greedy bastards where it hurts them the most: in their pockets.

www.taxi.amsterdam.nl

They're expensive, and they treat cyclists like shit, but if you really need one call 777-7777 and enjoy the service: these taxis are very comfortable. You can sometimes flag one down on the street, but usually you have to go to a taxi stand. You'll find them at Centraal Station, Dam Square, Leidseplein, Rembrandtplein, Nieuwmarkt, Haarlemmerpoort, the Tropenmuseum.... Note: if you're treated badly by a driver, or think that you might have been overcharged, be sure to get a receipt, jot down the license plate number, the exact time of the journey, and then call this Complaint Line: 0900-202-1881 (13 cents a minute)

www.wielertaxi.nl

Bicycle Taxis

You'll find bike taxis all over the center and at their home base. Dam square. They're a bit expensive, but can be a nice way to kick back and tour old Amsterdam. You can also reserve

door to door rides on their website.

Tuk Tuk Company

www.tuktukcompany.nl

Two people can ride in a Thai-style Tuk Tuk taxi, a threewheeled scooter with back seats, anywhere within Amsterdam's center ring for €5. If you're alone the fare is €3.50. A fee of €3 is added for extra zones, meaning trips out of the center. This is a great deal, much cheaper than standard taxis. Their stations are at Leidseplein, Albert Cuyp Markt and Amstel Station.

hoats

Tours

Boat tours leave from several docks in front of Centraal Station and along the Damrak and Rokin. It's very touristy, but it's fun to see the city from the canal perspective, and some of the taped info is interesting. The tours usually give you a quick look at the harbor and then cruise along the canals while a recording describes the sights in four languages. The one-hour routes vary slightly, depart every 20 minutes or so, and cost about €10. The canals are particularly beautiful at night. The last tours depart at 22:00 and are often sold out in advance during high season.

St. Nicolaas Boat Club

www.boatclub.nl

While the tours above are okay, these trips are way more fun. The '30s-era flat-bottomed boats used by this non-profit club are perfect for touring the canals, especially since they can go where the big tour

getting around

boats can't. They seat about 10 people, and you can bring your own food and drinks aboard. Smoking weed isn't a problem either. The captains are friendly and knowledgeable: They're happy to answer your questions and they know all kinds of cool info about places along the routes. There are several tours a day (and sometimes at night), and you can get more info and sign up for one at The Boom Bar (Leidseplein 12). There's a suggested donation of €10. (Map area B7)

ferries

Behind Centraal Station you'll find free ferries that make the brief journey to North Amsterdam every few minutes. You can take your bike on with you and it's a good starting point if you want to ride out into the countryside. Most of the bike-rental places will give you free info about scenic routes. There's also a ferry to the NDSM terrain that takes about 10 minutes (see Music, Hanging Out).

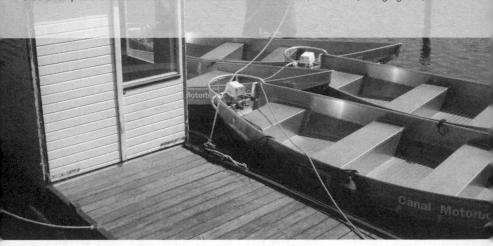

Canal Motorboats - Zandhoek 10A, 2 422-7007

www.canalmotorboats.com

Electric-powered boats for up to 6 passengers are available at this place, the only small-boat rental in town. After a short introductory lesson, you're free to putt around the city's famous canals. The rentals cost €50 for the first hour, €40 for the second and €30 for the third. Additional hours cost €20 each. An ID and €150 or a credit card is needed for a deposit. It's a bit expensive, but it's not too bad if you're with a group, and you'll have a unique experience being your own skipper. Bring a picnic and munch away as you cruise Amsterdam's historic canals. Located just north of Haarlemmerdijk/Prinsengracht corner, on the Westerdok. (Map area C1)

Canal Bikes - 2 626-5574

www.canal.nl

Two-to-four-person pedal boats called Canal Bikes are all over the old city canals in summer and are a lot of fun. They can be rented at several locations, including in front of the Rijksmuseum, near Leidseplein, and Anne Frank House. One or two people pay €8 per hour each; €3 or more people pay €7 per hour each. Deposit: €50. Open: in summer 10-18 ('til 22 if the weather is really nice) and in winter, only at the dock opposite the Rijksmuseum, 10-18.

a note on bike thief motherfuckers

Last year in Amsterdam over 100,000 bikes were stolen. Sorry-looking dope fiends who cruise around mumbling "fiets te koop" sell hot bikes, but more are actually stolen by organised gangs. Junkies sell the bikes very cheap, but if you're tempted to buy one while you're here, think again. When you buy a stolen bike you're hurting the person who owned it, as well as keeping the asshole who nicked it in business. You can also get busted: The cops are cracking down on bike theft by arresting people when they buy a stolen bicycle. Supporting shops like Recycled Bicycles, where 2nd-handers are sold cheap but legal and in perfect working order, flies the finger to all the pathetic fuckers hocking stolen bikes for profit or to pay for their habits.

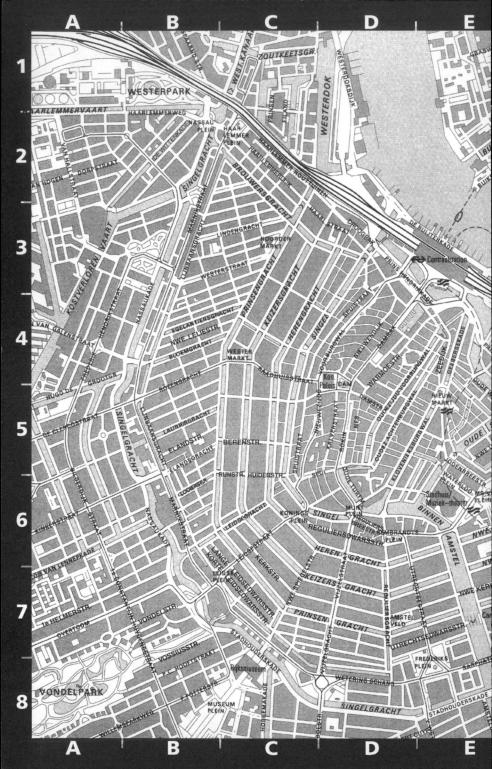

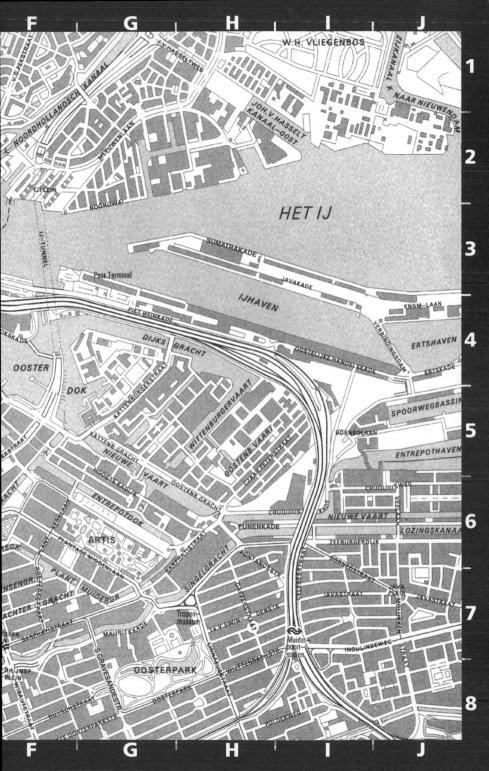

train

Travelling by train is certainly the most pleasant and comfortable way to get around Europe, but it can also be very expensive. The Dutch system in particular has seen massive price hikes in recent years, while at the same time major cuts in service. On some routes you have to reserve a seat (and pay a reservation fee) even if the train isn't full, which seems kind of ludicrous; but in the summertime it's a good idea to book a seat even if it isn't mandatory. The booking office for international train journeys is at the front of the station, left of the main entrance. Grab a number and be prepared to wait. Tickets for destinations within Holland can also be purchased here or from the big yellow machines (which have instructions in English). If you buy your tickets from a person, there's an additional 50-cents-per-ticket service charge, and – note well – neither the ticket office nor the machines take credit cards. For international train info and reservations by phone, call 0900-9296 (35 cents/min plus €3.50 per ticket service charge); for trains within the Netherlands, dial 0900-9292 (70 cents/min). Online, go to: www.ns.nl. The website also provides information about special deals on rail travel in Holland.

Thalvs - 2 0900-9296 (35 cents/min)

www.thalys.com

Here's a tip: If you're planning to go from Amsterdam to Paris, you can ride this high-speed train from Centraal Station to Gare du Nord for around €80 round-trip. It's a little more expensive than the bus but takes about half the time (4 hours) and it's much more comfortable. There are only a few seats offered at this price on each train, so book early.

bus

Eurolines - Rokin 10; Amstel Station, 🏗 560-8788

www.eurolines.nl

Eurolines has service to almost 500 destinations. I've had both good and bad experiences with this-company, from making new friends toting a bottle of booze, to being forcibly locked out of the bus for a long hour in front of the freezing and sleazy Hamburg bus station, but they are much cheaper than the train, especially off-season. Check it out early because not all routes are served daily and they often sell out in advance. You need to provide your passport number to buy a ticket. Keep in mind that border checks, especially going into France, tend to be a lot more severe on buses than on other modes of transport. Rokin office open: Mon-Fri 9:30-17:30; Sat 11-16. Amstel Station office open: Daily 7-22:30. (Map area D5)

hitching

There is a lot of competition hitchhiking out of Amsterdam in the summer, but people do give lifts. Hitching isn't allowed on the national highways: stay on the on-ramps or in gas stations. It's easier for drivers or truckers to pick you up and you'll avoid hassles from the cops. I once caught a ride at a gas station all the way to Munich with an herb-loving German trucker. If you're heading to Utrecht, take tram 25 to the end of the line and join the crowd on the Utrechtseweg. How about southern or central

Germany? Hop the metro to Amstel station and try your luck on the Gooiseweg. For Rotterdam and The Hague go by tram 4 to the RAI convention centre and walk down Europaboulevard until you see the entrance to the A2 highway. But before you hit the road, check www.hitchhikers.org and see if you can arrange a ride without breathing exhaust. Good luck.

air travel

Budget Travel Agencies

There are a couple of budget travel agencies south of Dam Square (going away from Centraal Station). Budget Air is at Rokin 34 (627-1251). For last-minute specials (mostly to southern Europe and North Africa) check the L'tur site (320-5783; www.ltur ams.com), or visit their counter at Schiphol Airport. Martinair also has a counter at Schiphol Airport (601-1767; www.martinair.com) where tickets for last-minute flights can be purchased. I had a good experience once at D reizen (Ferdinand Bolstraat 58; 200-1672), which is part of a big chain. They've got last-minute deals on various airlines for two people travelling together. World Ticket Center (Nieuwezijds Voorburgwal 159, 626-1011) sometimes has special offers and the consultants there are very nice. Note that all travel agencies in Amsterdam tack on an exorbitant "service charge" of about €15 per person! For a complete listing of travel agencies, look in the phone book (the white pages) under Reisbureau. Shop around.

easyJet

www.easyjet.com

Like all airlines, they suck. But at least easyJet isn't so expensive. Book online with a credit card and you can get some dirt-cheap fares. You can fly one-way from Amsterdam, including all taxes, to London for €42, Geneva for €50, and Belfast for €40! They fly to several other destinations as well. There's no paper ticket: just print your confirmation and bring it to the airport.

Transavia

www.transavia.com

Transavia is a Dutch airline offering cheap flights from Amsterdam to dozens of European destinations as well as Egypt, Turkey and Morocco.

Jet2

www.jet2.com

This little airline has one-way no-frills flights from Amsterdam to Manchester for only €14, but tax is another €28. Thomson (www.thomsonfly.com) also has cheap flights to England, and I once flew from London to Amsterdam on BMI (www.flybmi.com) for €10 plus tax. In fact, BMI is about as good as it gets in this category.

Snowflake

www.flysnowflake.com

SAS operates this budget airline. They fly one way to Copenhagen for €78 including all taxes.

KLM

www.klm.com

The official Dutch airline sometimes offers pretty good fares, both one-way and return. They hit you up for an extra €10 for online bookings, but that's better than the €25 to €35 they charge you to do it by phone!

train to the airport

Easy as pie! Hop on the train at Centraal Station (€3.40) and you're at Schiphol Airport (www.schiphol. n/l) in about 20 minutes. Trains depart regularly starting at about 4:40 in the morning until just after midnight. After that, there's just one train per hour. Keep a close eye on your luggage. (Did you know that Schiphol Airport is five meters below sea level?)

taxi to the airport

Taxi to Trust (489-6200) charges €30 to and from the city center. You can call them when you land at Schiphol, for instance, and they'll pick you up in 10 minutes. The TCA taxi company (677-7777) offers a set price (vaste tarief) from the center of Amsterdam to the airport. Currently the rate is €38. Make sure that you specify that you want that vaste tarief (pronounced "fast-ah teh-reef") when you book the cab on the phone, and again with the driver before he departs. Not all taxis will honor this rate from Schiphol into town. If the first cabbie in line refuses, continue until you find one who says yes – and you will. For more taxi info see the Getting Around chapter.

maps and travel books

à la Carte - Utrechtsestraat 110 112, T 625-0679

Open: Mon 13-18; Tues-Fri 10-18 (in summer, Thurs 'til 21); Sat 10-17. (Map area E7)

Pied à Terre - Overtoom 135-137, 2 627-4455

www.piedaterre.nl

Open: Mon 13-18; Tues-Fri 11-18 (Thurs 'til 21; Sat 10-17.) (Map area C5)

Boekhandel Jacob van Wijngaarden - Overtoom 97, 🏗 612-1901

www.jvw.nl

Open: Mon 13-18; Tues-Fri 10-18 (Thurs 'til 21); Sat 10-17. (Map area A7)

Evenaar - Singel 348, 2 624-6289

http://travel.to/evenaar

(See Books & Magazines, Shopping chapter) Open: Mon-Fri 12-18; Sat 11-17. (Map area C5)

tourist info

The Amsterdam Tourist Office (a.k.a. the VVV) is the city's official tourist agency. However, it's also a privately-run business, so even though the people working here are almost always patient and friendly and can be very helpful, you can see that their motivation is "sell, sell." There's a branch inside Centraal Station, upstairs on platform 2b that's open Mon-Sat 8-20; Sun 9-17, and another just to the left as you cross the square in front of the station that's open daily from 9-17. There's also a branch at Leidseplein (open: Sun-Thurs 9:15-17; Fri-Sat 9:15-19). If you're here during high season, be prepared for a long wait. They have an info number (0900-400-4040; Mon-Fri 9-17), but at 40 cents per minute – including all the time you spend on hold – it's very expensive. (Map area E3)

money

While there may be valid arguments for a single European currency, the old white guys in suits that concocted this deal didn't do it for the benefit of you and me. The euro (€) is the official currency in the Netherlands. You don't have to change money now when you travel between most EU member countries, but you pay higher prices for everything.

As for banks, I hate them! They're all thieves and scum. However, changing money at bank alternatives in the tourist areas (like Leidseplein) is mostly a big rip-off, too: high commission charges and low rates. Beware of places that advertise "no commission" in big letters followed by fine print that says "if you're purchasing" (this means if you're giving them euros to buy US \$, for example). It's a scam, and once they have your money inside their bulletproof glass booth you won't get it back. It's hard to recommend a place because they're changing all the time, but here are a few stable money changers.

Lorentz Change - Damrak 31, 🏗 422-6002

www.lorentzchange.com

These guys offer the best rates on cash and no commission on non-euro currencies. Open: Daily, 24 hours. (Map area D4)

Pott Change - Damrak 95, 🏗 626-3658; Rembrandtplein 10, 🕿 626-8768

If you're changing non-euro currencies there's no commission charged here either, and Pott's fee for cashing non-euro travellers checks is relatively low. Open: Mon-Sat 8:15-20; Sun 9:15-20. (Map area D4)

American Express - Damrak 66, \$\overline{\Omega}\) 504-8777 1NTL +31 20 504-85 04

Amex doesn't charge a fee to process their own travellers' checks if you want them cashed out in euros. Open: Mon-Fri 9-17; Sat 9-12. (Map area D4)

GWK Bank - Centraal Station, & 627-2731

This member of the bank mafia charges 1.5% commission on the total cash amount changed, plus an extra €2.25. And the fee for changing travellers' checks is even more. It's a rip-off but they're open late if you are stuck. Open: Mon-Sat 8-22; Sun 9-22. (Map area E3)

phone

Pay phones that take coins are almost extinct, with train stations being just about their only remaining habitat. To use a phone booth you'll need a phone card. They can be purchased in denominations of €5 and €10 at the Tourist Office, post offices, tobacco shops and supermarkets. Phone booths have instructions in English.

For long distance calls dial 00, then your country code and the number. Holland's country code is 31. Amsterdam's city code is 20 from abroad and 020 if you're dialing from elsewhere in The Netherlands. Long-distance phone cards are available in most of the "call centers" on tourist strips like the Damrak, and at tobacco shops. They come in different denominations and they can be a very good deal. A card called EuroCity is a great buy. Easy-to-use instructions, in English, are printed on the back of the cards.

post

The Dutch postal service has been privatized, which has led to higher prices and the closure of hundreds of offices all over Holland. There are now only a few outlets left in Amsterdam's city center and they're always crowded. The main post office is located at Singel 250 (556-3311), at the corner of Raadhuisstraat, just west of Dam Square. If you're just buying some stamps or something else quick, you can line up at the express counter – number 1. Otherwise, take a number and be prepared to wait a while. Letters and postcards up to 20 grams cost 72 cents for Europe and 89 cents overseas. There's also a stationary store here, and a bank that changes money (though they're very slow and charge commission). The main post office is open: Mon-Fri 9-18; Sat 10-13:30. (Map area C4)

The entrance to the Poste Restante is down some stairs to the left of the entrance to the main post office. If you're having mail sent to you the address is: Poste Restante, HoofdpostkantoorTNT, Singel 250, 1012 SJ, Amsterdam, The Netherlands. Don't forget to bring your passport when you go to pick up your letters. Open: Mon-Fri 9-18:30; Sat 9-12.

There are also post offices at Waterlooplein 2 (inside the City Hall) and Haarlemmerdijk 97, but note that their opening hours are often shorter than those of the main office listed above. Some supermarkets also sell stamps from vending machines near their entrances. For more postal info, call the free customer service line: 058-233-3333 (choose "9" twice to speak to a human).

If you're posting letters from a mailbox, the right-hand slot is for Amsterdam, and the left side is for the rest of the world.

If you want to send or receive e-mail, stop by one of the internet cafés or the main library. (see Hanging Out chapter). Got a lap top? There are many cafes, coffeeshops and bars with WiFi and they usually have stickers advertising this fact on the window.

left luggage

The lockers at Centraal Station cost about €4-5 for 24 hours. Bags are x-rayed before you can enter, and the area is closed at night from 1 to 7:00. **Warning:** Like all big train stations the world over, Centraal Station has its share of bag-snatchers hanging about. Never take your eyes off your luggage – not even for a second.

voltage

The electric current in Holland operates on 220 volts. If you're from Canada or the U.S. and you want to plug in anything that you've brought with you, you'll have to get a converter and/or a transformer. It's probably cheaper to buy them in North America than in Holland.

weather

Expect lousy weather. Then if it's warm and dry you'll feel really lucky (which you will be). Bring layers of clothing and something waterproof. Umbrellas don't always do the trick, as this is a very windy country, especially in the fall. The North Sea wind also means that the weather can change very quickly and several times a day. Winters are cold, but it rarely goes much below freezing. July and August are your best bet for nice weather (of course). Having said all that, Amsterdam is a fun city to visit any time of year.

tipping

Tipping isn't really part of Dutch culture, and service is supposed to be included in the price at restaurants and cafes. But if you have a nice waiter you can round up the bill: 5% is sufficient; 10% is generous. At bars you can round up a bit, but it's not necessary. A little tip, however, can go a long way – guaranteeing prompt service for your next round. And if you don't have much dough it's perfectly acceptable not to tip at all.

toilets

You often have to pay to use public toilets in Europe. There's usually an attendant on duty who collects the 25 or 50 cents required and who's supposed to be keeping things clean. It's not a lot of

money, but it sure does piss me off (excuse the pun). Expensive hotels are good places to find free, clean toilets. Just walk in looking confident and head straight in past the reception desk. There's always a washroom nearby. (I like The Grand at Oudezijds Voorburgwal 197). Also, if you can handle it, you can take a whiz for free in any police station. And guys should think twice before peeing in the canals or alleys: Not only are you acting like a pig, but you're risking around a €90 fine if a cop spots and accosts you.

free english news

Amsterdam Weekly

www.amsterdamweekly.nl

This English language newspaper appears every Wednesday and includes articles about local news and culture; regular columns and reviews; music, film, and art listings; and free classifieds. It's easy to find at cafes, bars and bookstores all over town.

The Amsterdam Times

www.theamsterdamtimes.nl

Amsterdam's other free paper definitely isn't as hip as the Weekly when it comes to culture and entertainment, but it's worth picking up for its coverage of Dutch news and politics. It's published every Friday and can be found at Waterstones and the American Book Center in the Spui (see Shopping chapter).

Expatica

www.expatica.com

Though it's often geared towards the interests of corporate expats, this is a very useful site for anyone who's interested in issues that concern foreigners living in Holland. Along with features and listings, there are daily English summaries of current Dutch news items.

recycling

Bring your old batteries to any supermarket. Toss them into the box with a picture of a battery on it that you'll see near the entrance. It only takes a second. Glass and paper recycling bins (marked *glasbak* and *papierbak*) are found on street corners every few blocks or so.

laundry

The Wash Company - Haarlemmerdijk 132, 2 625-3672

Wash €5; dry (only in combo with wash) 20 cents per 6 minutes. Wash/dry/fold service takes 4 hours and costs €7 for 6kg. Open: Mon-Sat 8:45-19; Sun 10-19. (Map area C2)

Wash & Mail - Amstel 30

Wash €5 including soap; drying costs about €1.50. Internet access is €3 an hour. Wash and dry service is €8.50 and includes 15 minutes online or free coffee. Open: Daily 9:30-20. (Map area D6)

Wash-o-matic - Pieter Langendijk 12

Out near Vondelpark you can do a load of up to 8kg for €5. Dryers cost 20 cents for 6 minutes. Open: Daily 8-20 (last wash in at 19:00).

identification laws

I never thought I'd see the day when I'd have to write about pass laws in The Netherlands as a current issue rather than a hideous historical anomaly, but here it is... Everyone is now required by law to carry state-sanctioned identification with them at all times, and ordinary people on the street are routinely being checked and punished for non-compliance. This is just one of the many regressive social changes introduced by the extreme right-wing government of Jan Peter Balkenende (who will hopefully be a footnote in history by the time you read this). Though outrage to this draconian law has been surprisingly muted, in typical Dutch fashion what resistance there has been is creative and inspiring. For instance, one activist group (www.geen-id.nl) has formed to encourage people not to carry ID and has created an insurance fund to cover fines and bail. While it's unlikely that you'll be stopped, you should be aware of this offensive law. Personally, as an experienced traveller, I believe that the safest place for your passport is in a hotel safe.

pickpockets

Amsterdam is a very safe city and the only crime you're likely to witness or experience is pick-pocketing. It's not a violent crime, but what a drag when it happens! Watch out for these assholes: they're very good at what they do. Keep your valuables safely stashed and watch your bags at all times. The worst areas are around Centraal Station, Dam Square, Leidseplein, and the Red Light District – in other words, tourist areas where you'll probably end up at least a couple of times during your stay. They also work on public transit and the trains (especially to and from Schiphol airport). Try not to act like a total space cadet (in spite of how you might feel) and you probably won't have any problems. If you do, see the Phone Numbers chapter for the services you'll need.

drug testing

Hard drugs are illegal in Holland. Buying them from strangers can be dangerous. And anything you buy on the street is almost guaranteed to be crap. But if you've scored some ecstasy or coke

practical shit

elsewhere and want to be sure that it's okay, drop in at the Stichting Adviesburo Drugs (Entrepotdok 32a, 623-7943; www.adviesburodrugs.nl). They do not sell drugs. It's a non-profit foundation that, among other things, will test your ecstasy to see what it really is. A test costs only a few euros. They take a tiny sample and usually within a couple of minutes they can tell you what you've bought. This is a fantastic service (anonymous too, by the way). By testing these drugs they know what's on the market, and if something bad is going around they can help track it down and get it out of circulation. Open: Tues-Fri 14-17 (Thurs 'til 19:30). (Map Area G6)

smoking ban

The Netherlands, one of the last bastions of cigarette smoking in Europe, has finally decreed that tobacco be banned completely from public places. This means you can enjoy a meal in a tiny café without the blue haze that used to be so common. Bars and clubs are trying to keep their patrons happy while having to send them outside, sometimes in the cold and rain, to puff smokes. Some bars have ignored the ban, especially late at night, or have big customer contribution jars to pay off the fines. A handful of bars and coffeeshops have separate smoking rooms, but most people are taking their cigarettes and joints outside. Here's the coolest and craziest part: Pure weed can still be smoked in coffeeshops. The Dutch health minister claims that cannabis, unlike tobacco, hasn't proved to be harmful to your health. That's some seriously progressive thinking!

Most coffeeshops have banned mixed spliffs (rolled with tobacco, European-style) and insist that their patrons smoke pure joints, while some don't seem to mind. Several shops have a herbal tobacco substitute which looks like tea, you can also brew it, and apparently smells like a burning Christmas tree. I don't know anybody who uses it, but it's available. You can also smoke joints in certain bars, like Batavia, Barney's Uptown and Kashmir Lounge (see Bars chapter.)

In clubs like the Paradiso small smoking rooms are provided, but the effect is a bit claustrophobic, like in a smoky airport box. Concerts, especially in small, crowded halls, now tend to smell like sweat and beer instead of cigarettes. I personally think clubs need to hire aroma jockeys (like Amsterdam's own Odo 7) to mix smells with music – our noses will appreciate it!

gay and lesbian info

The Cool Guide has never included a lesbian and gay chapter. Instead, in each section of the book I've highlighted a couple of spots that cater mainly to a gay crowd (and any place that isn't gay-friendly won't be listed). However, to find out more about gay happenings around town, your first stop should be the fabulous Pink Point kiosk at Westermarkt (just in front of the Homomonument). They provide all sorts of free info including the *Gay News* and the *Lesbian Listings*. Pink Point also sells guidebooks (check out Darren Reynoldson's *The Bent Guide*) and all sorts of unique queer souvenirs. Open: daily 10-18 in summer; Fri-Mon 10-17 in winter. (Map area C4)

a note about squatting in Amsterdam

A building in Amsterdam can be squatted if it remains empty more than a year without the owner putting it to some use. This legal custom is meant to protect the city from speculators who sit on their property while prices rise due to the severe housing shortage. That doesn't mean that squatters have an easy time taking over a building. The legal definition of occupancy is a slippery one, and it's difficult to have a building defined as vacant. In addition, a great deal of work is usually needed to make a squat habitable and legal battles often result.

I have a lot of respect for those who choose to squat as an expression of their political beliefs. They are simultaneously working to preserve and create housing in this overcrowded city. Several of these organised squats have generated in-house restaurants and clubs that are among Amsterdam's best. Many squatters live under imminent threat of being forced out by banks and developers. Going to these squats is a way of showing your support for a creative, cooperative way of living as well as your opposition to conservative pigs who care more about money than people.

For more information about squatting, look online at http://squat.net. And for up-to-date info about events in squats, check out the excellent and user-friendly database at http://radar.squat.net

ating out in Amsterdam can be expensive, particularly since the introduction of the euro several years ago. But if you pay attention to this chapter I promise you a full belly at the best price. Don't be surprised if the service in some restaurants is not particularly friendly, and don't take it personally: Rude isn't just a popular Dutch name.

If you're on a super-tight budget, head to the markets for the cheapest fruit, veggies and cheese. I've listed several in the Shopping chapter. For dry foods, go to the large supermarkets and remember to bring your own bags, because they'll charge you for the ones you get from them.

If you've got access to a kitchen you can visit a *tropische winkel* for inspiration. They're found throughout the city, especially near the markets, and they specialize in foods from tropical countries: everything from mangoes to hot sauce to cassava chips.

supermarkets

Supermarkets in Amsterdam are now open much longer than they used to be – in general it's Mon-Sat 8-20; Thurs 'til 21). At some you can even shop until 22:00, and more and more stores are staying open on Sundays too. At some stores you have to weigh your produce yourself. Push the button marked "bon" and a sticker with the price pops out of the scale. If there's no "bon" button on the scale, it means that they'll price your veggies at the check-out. At Albert Heijn supermarkets you'll have to pick up a free plastic "bonus card" if you want to buy anything that's on sale: without it you'll be charged the full price. Just ask for one at the front counter (where they sell the film) and hand it to the cashier when you check out. **Note:** Remember to check the ingredients – gemodificeerd means genetically modified.

Aldi - Nieuwe Weteringstraat 26; Admiraal de Ruijterweg 56C (West End)

This is one of the cheapest, but their selection is not as good as the bigger chains and they don't carry any organic products. (Map areas C8, 5A)

Dirk van den Broek - Marie Heinekenplein; Bilderdijkstraat 26

The best of the cheapies, and they stock some organic products. The big American-style store is behind the Heineken Brewery and the Bilderdijkstraat market is in the West End. (Map areas D8, 5A)

Albert Heijn

Nieuwezijds Voorburgwal behind Dam Square; Van Baerlestraat 33; Haarlemmerdijk 1; Jodenbreestraat 20; Koningsplein; Centraal Station

Every time I blink there's a new one. My friend calls them Adolf Heijn, because of the way they've conquered Holland and now occupy every neighborhood. However, they carry lots of organic products (look for labels marked *bio*), and all the branches listed above stay open until 22:00 ('til 19 on sun), except the Haarlemmerdijk store closes at 21. The stores can be poorly stocked and also relatively expensive, but location and convenience are definitely their strong points. The Albert off of Dam Square and the Jodenbreestraat installation are both well stocked with a good selection, which is not so good at the Koningsplein store. The big Albert on Van Baerlestraat is at the far end of the Museumplein, while the Haarlemmerdijk store is only a 10-minute walk from Centraal Station, where there's also an Albert Heijn located in the west tunnel by Shakies that's smaller and more expensive than the bigger stores but very handy if you're catching a train—and it's open daily 'til 22:00. Remember to pick up a *bonus card* before you shop at any of these stores. (Map areas D5, B8, C3, E5, C6)

health food stores

De Natuurwinkel - Elandsgracht 118, ተ 412-4696; Haarlemmerdijk 162; Weteringschans 133; 1e Constantijn Huygensstraat 49; 1e van Swindenstraat 30

www.denatuurwinkel.nl

Health food, supermarket style. They stock a huge selection including organic produce, cheese and baked goods. If you buy fruit or vegetables here, look for the number next to each item, then punch in the number when you weigh it. Next push the button marked bon and a sticker will come out with the price. It's less complicated than it sounds and you won't be embarrassed at the check-out when they send you back to do it. There's a big, busy bulletin board by the front door at the Elandsgracht store and it's open Mon-Sat 8-19; Sun 10-18. (Map area B5)

Delicious Food - Westerstraat 24, ☎ 320-3070

www.deliciousfood.nl

If the smell of fresh-roasted coffee beans doesn't draw you into this inviting shop, then maybe one of the other 250 organic products on offer will. They have freshly baked breads and cakes, lots of bulk products (a relatively new thing here in the Netherlands), fresh produce and a good selection of wines. There's a small deli in the back for take-out. It's right by the Noordermarkt (see Markets, Shopping chapter). Open: Mon, Wed-Sat 10-19; Sun 11-15. (Map area C3)

De Belly - Nieuwe Leliestraat 174, 2 330-9483

This sweet, well-laid-out shop has been in business for over 30 years, and they guarantee that all their organic products are GM free. It's just a few doors down from the veggie restaurant Vliegende Schotel (see Restaurants, below). Open: Mon-Fri 8:30-18:30; Sat 8:30-17:30. (Map area B4)

Weegschaal - Jodenbreestraat 20, 2 624-1765

You'll find all kinds of healthy foods in this small neighborhood store: macrobiotic products, organic fruit and veggies, taco chips, and snacks. It's just around the corner from the Waterlooplein market (see Shopping chapter). Open: Mon-Fri 9-18; Sat 9-17. (Map area E6)

Organic - Cornelis Schuytstraat 26, 2 379-5195

www.organicfoodforyou.nl

It's not really worth a special trip, but if you find yourself in this well-to-do neighborhood between Vondelpark and the Museumplein, then definitely drop into this beautiful upmarket organic food store. They stock a wide range of fresh foods from meat and dairy products to bread, fruit, vegetables and more. It's all tastefully displayed along with information about the products' origins and use. Take-away soups and sandwiches are also available—handy if you're on your way to the park. Open: Mon-Fri 9-19; Sat 9-18. (Map area A8)

De Aanzet - Frans Halsstraat 27, 2 673-3415

This pretty, cooperatively run store is not far from the Albert Cuyp market (see Markets, Shopping chapter). They stock bulk products, organic fruits and veggies, and yummy baked goods. Open: Mon-Fri 9-18; Sat 9-17. (Map area C8)

Oase Natuurvoeding - Jan Pieter Heijestraat 105, 🏗 618-2887

If you're in Vondelpark and need some picnic fixin's, stop by this neighborhood health-food store. Everything here is GM free. And bring an empty bottle because they also have organic wine on tap! Open: Mon-Fri 8-18; Sat 8-17.

street foods

Falafel stands are scattered all about the city. Maoz Falafel (see Restaurants, below) are delicious and one of the best deals in town: You can stuff yourself for only €4. Burp!

The quality and origin of the meat is a little dubious, but for **shoarma** take-away try the Damstraat (just east of Dam Square), where there's a whole row of places to cop. Ben Cohen has high-quality Israeli-style shoarma at Rozengracht 239 (Map area B5) and is rated one of Amsterdam's best.

For **french fries** (chips to you Brits) try any place that advertises *vlaamse frites* (Flemish fries). These are the best. There's a large choice of toppings, but get mayonnaise for the Dutch experience. The best place, as evidenced by the long line-ups, is Vleminckx at Voetboogstraat 33, which runs parallel to the big walking street, the Kalverstraat. They're open daily until 18:00 (Thurs 'til 19). There's also one at Damrak 42, just up from Centraal Station. And there's a pretty good one called De Belg at Reguliersbreestraat 49, near the Rembrandtplein. And, finally, if you don't mind spending a bit more, you can get fries made from organic potatoes at Morning Star (see Restaurants, below). Delicious.

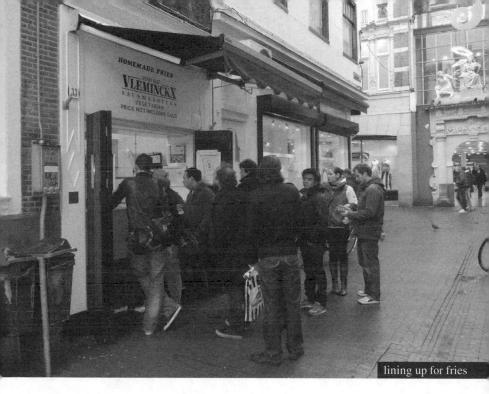

Healthy fast food is almost unheard of in Amsterdam, so Shakies (Centraal Station west tunnel, 423-4377; and in Amstel Station, too) is a real find. They make great juices and shakes—all the fruit is freshly squeezed and the milk and yoghurt are organic. If you're vegan or lactose-intolerant, they even have soya milk. Prices start at €2.95 and for an extra 70 cents they'll throw in a shot of vitamin B, ginseng or guarana. Also on the menu are organic veggie samosas and seitan rolls, bagels with cream cheese and herbal teas, as well as options for vegans. Not bad for a train station food outlet. Open: Mon-Fri 7-21; Sat 8-20:30; Sun 9-20:30.

Het Kaasboertje (2e Tuindwarsstraat 3; 624-8802) is a small shop in the Jordaan neighborhood that sells big, filling **sandwiches** at great prices (several are less than €2). The owner is super-friendly and he'll build whatever you want from their huge selection of cheeses, pates, fish, and meat. Drinks are cheap, too. They only do take-out, but there's a small bench out front.

Fish lovers should definitely try snacking at one of the herring stalls that are all over the city, easily recognizable by their fish flags. There's one close to Centraal Station on the bridge where the Haarlemmerstraat crosses the Singel canal and another next to the Westerkerk. All kinds of fish and seafood sandwiches are available. Or for authentically greasy, British-style fish and chips, try Al's Place at Nieuwendijk 10.

Another good bet for cheap food is **Indonesian** or **Surinamese** take-away. A big roti meal will cost you about €6, as will a large plate of fried rice (*nasi*) or noodles (*bami*) with vegetables. The portions are often enough for two people. Add a couple of euros if you want it with chicken or pork. See Restaurants, below, for some suggestions.

For relatively cheap **Chinese** take-away look around the Zeedijk (above the Nieuwmarkt) where there's a small Chinatown. And at the outdoor markets don't forget to try the cheap and addictive **Vietnamese Loempias** (spring rolls): veggie or chicken, €1.

If classy **picnic fixings** are what you're looking for, stop by Raïnaraï (Prinsengracht 252; 624-9791; *www.rainarai.nl*), a Mediterranean catering and take-away shop specializing in "nomadic food." They use high-quality, mainly organic ingredients, so it's tasty but not super-cheap. Veggie couscous is €8; sandwiches are €5.50 and up; containers of hummus, mushroom pate or mackerel mousse are €2 to €3.50; and the giant stuffed mushrooms go for €2.

The bakers at Mediterranee (Haarlemmerdijk 182) make delicious pastries and sweet-dough pizzas. But what they're really famous for is their **vegan croissants**, which are also available in whole wheat. Buy four and get the fifth one free.

I'm not crazy about the other baked goods on offer at De Bakkerswinkel (Warmoesstraat 69), but the **scones** rock! Get there early, they don't last long. (It's also a pleasant and popular place for soup and a sandwich.)

Melly's Cookie Bar (Nieuwezijds Voorburgwal 137) is a sweet little take-out **cookie cafe** just a stone's throw from Dam Square. Stop by when you've got a hankering for some home-style baking. They serve excellent espresso here, too.

Lovers of **Italian ice cream** should head straight for Gelateria Peppino (Eerste Sweelinckstraat 16) near the Albert Cuyp market. They've been making it fresh daily, on the premises, for decades. It's the real thing.

Febo is the name of a chain of automats that you'll see all over the city. Here you can get **greasy** deep-fried snacks out of a wall for about one euro. If you have to do it, your best bet is probably the kaas (cheese) soufflé. Here are a few locations: Damrak 6 (just down from Centraal Station); Kalverstraat 142; Nieuwendijk 220. They're open every night 'til 3:00.

Pizza slices in Amsterdam are everywhere, but most of them are pretty terrible. When they're fresh, New York Pizza (Leidsestraat 23; Spui 2; Damstraat 24) has the best American-style slices in town. Da Portare Via (Leliegracht 34) sells only whole pizzas, but they are beautifully prepared using the freshest ingredients and then cooked the Italian way in a wood-burning oven. They're available in the evening from 17-22:00 and a small cheese is perfect for one person. Treat yourself to a glass of wine or an authentic espresso while you wait and watch the fire work it's magic.

night shops

Night Shops (avondwinkels) are the only places to buy groceries after the supermarkets close and they're accordingly expensive. Fruit and veggies at these shops are exorbitantly priced, but all the usual junk foods are available. Most night shops are open every day from 16 to 1:00. After that, you're fucked. Here are a few in the Centrum:

Pinguin Nightshop - Berenstraat 5, between the Prinsengracht and the Keizersgracht. (Map area C5)

Big Bananas - Leidsestraat 73

This night shop is usually very busy because of its central location. (Map area C6)

Avondmarkt - de Wittenkade 94

This one is the biggest and most fully stocked in town with the best selection and prices, but it's in the West End. They have a full take-out counter with lasagna, pasta dishes and Indonesian food plus bonuses like organic bread and a good import beer selection. (Map area B2)

Sterk - Waterlooplein 241

They sell beer, wine, champagne, cigarcttos and deli items here: cold cuts, salads and cheeses too. (Map area E6)

Baltus T - Vijzelstraat 127. (Map area D7)

Dolf - Willemsstraat 79 - In the Jordaan. (Map area C2)

Texaco - Sarphatistraat 225; Marnixstraat 250

Open 24 hours. Eat here and get gas. (Map areas H6, B5)

late night eating

De Prins - Weteringschans 1

Right across the street from the Paradiso (see Music chapter) for your after-concert french-fry craving. Open: Sun-Thurs 'til 3; Fri-Sat 'til 4. (Map area C7)

Ben Cohen - Rozengracht 239

Eating snack-bar shoarma can be a mystery-meat experience, and it's probably best to avoid the majority of them. This late-night shoarma joint, however, is one of the best in Amsterdam and a well-known local after-hours stop. For €6 you get a pita stuffed fat. Vegetarians can go for the *pita kaas*, a gooey grilled-cheese sandwich in pita bread with lettuce and cucumber. Open: Weekdays 'til 3, Weekends 'til 4

Bojo - Lange Leidsedwarsstraat 51

This Indonesian restaurant near the Leidseplein is a good place for a late-night pig-out (see Restaurants, below). Open: Sun-Thurs 'til 2; Fri-Sat 'til 4. (Map area C7)

Midnight Sandwich Shop - Reguliersdwarsstraat 51

You can visit this little snack bar in the wee hours for sandwiches, falafels and french fries. It's right in the heart of the gay ghetto and gets pretty busy, especially when the clubs are closing. Open: Sun-Thurs 'til 3; Fri-Sat 'til 6. (Map area C6)

Snackbar de Dijk - Haarlemmerdijk 145

Here's another snack shop where you can satisfy your late-night munchies. They've got french fries (€1.25), sandwiches (from €1.50), kebabs (€3.75), and lots of junk food. Open: Sun-Thurs 'til 2; Fri-Sat 'til 3. (Map area C2)

Febo Snackbars - Oudezijds Voorburgwal 33

I can't really recommend this shit, but this branch in the Red Light District is open late and they're cheap (see Street Food, above). Do what you gotta do. Open: Sun-Thurs 'til 3; Fri-Sat 'til 4.

New York Pizza - Leidsestraat 23, Damstraat 24

Pizza slices until late (see Street Food, above). Open: Sun-Thurs 'til 3; Fri-Sat 'til 4. (Map area C6, D5)

Bakkerij de Rond - Overtoom 496

This bakery has been (illegally) selling their products before opening hours for over 30 years! The city council is debating whether to force them to stop, so if you're out in the West on a Saturday morning anytime after 4:30, stick it to the man by buying some bread. It's not too far from OT301 (see Music chapter).

bread

Le Marche - Kalverstraat 201; Rokin 160

Despite the crowds, which can be daunting, I frequently stop in here to pick up one of their delicious fresh breads: multi-grain, multi-seed, or garlic/thyme, to name but a few. They also bake panini, focaccia and rolls and sell ready-made sandwiches and fresh juices. Open: Mon-Sat 10-19 (Thurs 'til 21); Sun 12-18. (Map area D6)

Bakery Paul Annee - Runstraat 25, 🏗 623-5322; Bellamystraat 2, 🛣 618-3113

www.paulannee.nl

Exclusively hearty, healthy, organic items are sold at this famous bakery. Their dark chocolate muffins are seriously addictive. They also sell sandwiches and delicious curry seitan rolls. Open: Mon-Fri 8-18; Sat 8:30-17. (Map area C5)

Gebr. Niemeijer - Nieuwendijk 35, 🏗 707-6752

www.gebroedersniemeijer.nl

This new French-style bakery has authentic croissants and incredible bread (the fig walnut is fantastic). They also have scrumptious pastries, sandwiches and coffees. Prices here seem a bit steep, but the fresh, mostly organic ingredients and artisan baking will make you moan with pleasure after each bite. Open: Tues-Fri 8-18:30, Sat. 8:30-5 (Map area: D3)

free samples

I don't know how desperate you are but...

Stalls at the Organic Farmers' Markets (see Shopping chapter) are a great source of free samples. Natuurwinkel supermarkets have free coffee and espresso. The bigger Albert Heijn branches offer cheese samples. Bertolli Toscaanse Lunchroom (Leidsestraat 54) has baskets of bread and a variety of olive oils to sample. And finally, it's not food but the Body Shop (Kalverstraat 157) displays tester bottles of all their lotions, creams and perfumes. Just because you're travelling doesn't mean you should let yourself go.

breakfast

I love breakfast. Sometimes I can eat it three meals a day. Most hotels offer some kind of breakfast, usually bread and spread. If yours doesn't, or you find it not up to scratch, check out one of these places. An *uitsmijter* (pronounced "outsmyter") – literally, a bouncer – is a typical Dutch dish which is served to late-night guests just before you bounce them from your flat. It usually comprises three fried eggs with cheese, ham or roast beef served on white toast–not something special, but filling and usually pretty cheap.

Cafe Vennington - Prinsenstraat 2, 🏗 625-9398

Nestled in a *Jordaan* side street, Vennington is a breakfast and lunch joint with a large menu and reasonable prices. The sandwiches range in price from €2.50 for a simple Dutch cheese on a hard roll to €7.50 for a double BLT club.) Their mango ice-cream shake is a sweet treat for €3.50. They have a small terrace out front and if you're lucky, you can grab a table in the sun...while there's sun, of course. Never a guarantee in Amsterdam! Open: Daily 8-17

Cafc Latei - Zeedijk 143, 🏗 625-7485

Latei, one of my favorite cafes (see Cafes chapter), has a breakfast special for €7 that includes coffee or tea, orange juice, a croissant and a cheese sandwich. They also make *uitsmijters* and omelettes starting at €4, which means you can have one with a coffee and get out for about €6. It's right by the Nieuwmarkt. Open: Mon-Wed 8-18; Tues-Fri 8-22; Sat 9-22; Sun 11-18. (Map area E4)

Letting - Prinsenstraat 3, 🏗 627-9393

www.letting.nl

Letting is located on a very pretty street between two canals. It's a comfortable place to drink a pot of tea (€2.80) and read the paper while you wait for your breakfast. Egg dishes include a mushroom omelette with a salad and toast, or an *uitsmijter* made with 3 eggs – both €6. Yoghurt with muesli and fruit, juice, and coffee or tea is €8.50. They also serve a variety of grilled *tosties* on Turkish bread for €4. B-fast is served all day, and if the weather is good they have tables out front. If it's too crowded, try Vennington (Prinsenstraat 2; 625-9398), the little yellow place across the street. Kitchen open: Daily from 8-17. (Map area C3)

43

Drie Graefjes - Eggertstraat 1, 2 626-6787

Mind-blowing carrot cake complete with real cream-cheese icing (€3.50) is my personal pick here, but this beautiful little café nestled in a small, historic alley off Dam Square has much more. Besides amazing homemade desserts, muffins and cookies, Drie Graefjes offers a complete breakfast and lunch menu. Scrambled eggs with onion, tomatoes and fresh bread costs €5.50 (add €1.50 for smoked salmon). A fresh bowl of soup is €4.75 and the sandwiches, from simple Dutch cheese to a stacked club, run from €4-€7.50. Sit on the terrace if there's room and the weather cooperates. Open: Daily 9-18

Lef - Wijde Heisteeg 1, 2 620-5768

Lef means courage in Dutch. I don't know why you'd need it here though, because this little cafe is about as non-threatening as they come: it's cute and colorful, has a cozy upstairs and what they advertise as the smallest terrace in Amsterdam—a fold-down bench out front with a couple of pillows on it. They have egg breakfasts for around €7, fresh juices, smoothies and sandwiches on all sorts of bread. Don't miss their fresh-baked brownies. Open: Mon-Fri 9:30-16; Sat-Sun 11-17. (Map area C6)

Barney's Uptown - Haarlemmerstraat 105, 🏗 427-9469

www.barneys.biz

Feel like a joint and a stack of pancakes? Barney's Uptown is the premier spot for waking and baking. You can get breakfast all day here and they also have a full lunch menu. At night it's a cool bar where DJs regularly spin (see Bars). Located just across the street from Barney's Coffeeshop. Open: MonThurs 8-1; Fri-Sat 7:30-3, Sun 7:30-1

Bazar - Albert Cuypstraat 182, To 675-0544

Check out this huge Turkish breakfast: pita and simit breads, marinated feta cheese, cream cheese with herbs, apricot jam, honey, a Turkish pancake, yoghurt with fresh fruit, a boiled egg, sausage, juice, and coffee or tea—all that for €7.90, or €15.25 for two. You can also have a lighter meal of mild yoghurt, fruit salad, and fresh OJ for €5.25, or an omelette with pita and salad for €4.90. By the time you're finished, the market outside will be in full swing. Check the restaurant section below for a full description of this funky place. Open from 8 Mon-Fri; and 9 Sat-Sun.

Lunchcafe Nielsen - Berenstraat 19, 330-6006

They serve a full breakfast here (see Restaurants, below) for €9, or if you want à la carte, they've got yoghurt, fruit salads, croissants, and organic bacon. Open: Tues-Fri 8-16; Sat 8-18; Sun 9-17. (Map Area C5)

Winkel Lunchcafe - Noordermarkt 43, 7 623 -0223

If you're visiting one of the markets by the Noorderkerk on Saturday or Monday morning (see Markets, Shopping chapter), make a stop at this very popular cafe on the corner of the square. They serve the best apple pie in Amsterdam. Everyone gets a piece (€2.70, or 50 cents more with whipped cream) and sits outside drinking cappuccino or fresh orange juice at shared tables along the crowded Westerstraat. The slices are big and you'll feel stuffed. They've recently extended their hours to stay open late as well as early. Open: Mon 7-1; Tues-Thurs 8-1; Fri 8-2; Sat 7-2; Sun 10-24. (Map area C3)

Rembrandt's Birthday Breakfast - Rijksmuseum

To celebrate Rembrandt's birthday on July 15 the Rijksmuseum (see Museum chapter) serves a free breakfast in its garden every year. It's not a big spread, just coffee and some bread and herring, but the price is right! Last year the museum was free on that day, too. Be there by 7:30 if you want to get some chow. (Map area C8)

Wintergarden (Hotel Krasnapolsky) - Dam 9, 2554-9111

For a splurge, treat yourself to Hotel Krasnapolsky's breakfast buffet at their 19th-century Wintergarden, where you can eat your fill for €27.50. From the tiled floor to the abundant plants and grand murals

to the wrought-iron balustrade and the glass roof almost 14 meters above you, it's spectacular. Open: Daily 6:30-10:30. (Map area D4)

restaurants

Most of the time you're not going to get gourmet food on a tight budget, but there are some restaurants here that serve flavorful, nourishing food at affordable prices. Avoid the dozens of tourist-strip restaurants with guys standing out front trying to con you in – they usually suck! Most of the places I recommend are friendly to tourists (as they should be), but remember that Holland is not always known for its hospitable service. Here, as in most European cities, you need to signal the server if you want something. Also, make sure you've got enough cash on you because many of the following places don't take credit cards. Okay, now go eat.

Mok Sam - Albert Cuyp 65, 🏗 679-6776

Surinamese/Chinese. This plain little restaurant is next door to another restaurant with basically the same menu; this just happened to be the one that I tried first, so I usually end up here. They have cheap noodle dishes, rotis and a large selection of soups and sandwiches, most for under €3. For dessert try bakabana – deep fried banana strips in batter with or without spicy/sweet peanut sauce for €1. Now that's what I'm talkin' about! Located near the Albert Cuyp market (see Markets, Shopping chapter). Open: Daily 11-22.

Balraj - Haarlemerdijk, 🏗 625-1428

Indian. This restaurant has been serving authentic Indian edibles to Amsterdammers for more than 30 years. The curries are sublime; I especially recommend the *Shahi Korma*. Chai lovers will enjoy the house recipe. If you split a main course and add a side dish like *Saag* (mildly-spiced spinach) plus drinks, two people can have a full belly for €10 apiece – an excellent price for such quality Indian food. Open daily: 16:30-10:30. 9 (Map area: C2)

Burgermeester - Albert Cuypstraat 48, 🏗 670-9339

www.burgermeester.eu

Burgers. This gourmet burger joint has a unique claim – the only Amsterdam restaurant selling "real" burgers – quality beef, veggie or lamb. Their honest food policy means that all the ingredients are either organic or locally raised, a responsible practice more restaurants should follow. They have eight different burgers ranging from €6 to €8 (or mini versions for half price) and a burger-of-the-month from

recipes submitted by patrons. A portion of the proceeds from burger-of-the-month sales goes to a charity of the winner's choice. Divine desserts, like lemon cheesecake with raspberry sauce (€3), are made fresh daily, and they have a luscious juice bar. Everything here – from juice combinations to which ingredients you want on your burger – can be custom-ordered. WiFi connected. Open: Daily 12-23.

Burrito - De Clergstraat 14, 2 618-9807

Mexican. Fans of good Mexican food, a rarity in Europe, will like Burrito, a little family-run restaurant with delicious stewed meat tacos, big combination plates (taco/enchilada €13.50), quesadillas and, of course, fat burritos. If you order spicy, they stuff pickled jalapeños in their food, which I personally don't dig − try their homemade hot sauce instead. They have margaritas and Mexican beer to cool the fire. Open: Tues-Sun 4-10:30 (Map area A5)

The Taco Shop - Tolstraat 200, Ta 470-3657

Mexican. The Taco Shop, from its Miami-green paint job to the Memphis blues on the stereo, is a little piece of the U.S. along Amsterdam's Amstel river offering American-style Mexican fast food. A huge bean tostada (€5.50) topped with lettuce, cheese, tomatoes and sour cream is a meal in itself. They also have hard-shell tacos, burritos, chimichangas and quesadillas, and they will gladly customize orders to your dietary desires. All the orders include tortilla chips on the side. Expats are known to frequent this shop, as well as famous Yankee musicians whose autographs adorn the walls – from Lou Reed to System of a Down. It's a bit far out of the center, but if you're jonesing for a giant burrito it's well worth the trek. Open: Daily 12-22.

Vliegende Schotel (Flying Saucer) - Nieuwe Leliestraat 162, 2 625-2841

www.vliegendeschotel.com

Vegetarian. This restaurant is situated in the beautiful *Jordaan* (pronounced "Yordahn") neighborhood, so make sure to take a walk before or after your meal. They have a big menu, mostly organic, that includes some vegan dishes. Meals start at €7.80 for their daily special and run up to about €11. Half-servings are also available. Soup of the day is €3. Order at the back and leave your name. They'll run a tab for you and you pay when you leave. It's comfy and friendly inside – the only problem is that the service is slow and they often run out of food. If you're in a hurry or are very hungry, make sure you show up early. Open: Daily 16-23:30 (but the last call for dinner orders is at 22:45). (Map area B4)

Pondok Indah - Prinsengracht 42, 🏗 422-0029

Indonesian. An Indonesian couple runs this little hole-in-the-wall. The food is already prepared and laid out in a glass case and there's a lot to choose from for both vegetarians and meat eaters. The best deal is the "Box2Go," a small box with either noodles or fried rice and your choice of any two dishes for only \in 4.95. If you're really hungry or are sharing, you can get a bigger box for \in 6.95. There are all kinds of other Indonesian specialties too, and they speak English, so you won't have any problem finding out what's what. There are a couple of stools inside, but this is really a take-out place. Grab your food and walk north (toward Centraal Station) for a few minutes and, just past the Noorderkerk, you'll find a couple of benches across the bridge. You couldn't ask for a nicer place to sit and enjoy your meal. Open: Mon-Sat 12-21. (Map area C3)

Sushi - Taksteeg 3, 🏗 422-8978

Japanese. This is a clean, calm, family-run restaurant boasting friendly service and tasty, inexpensive food. The set menus start at €8 for a large vegetarian sushi plate and run to €14 for marinated eel. An 18-piece super maki roll assortment goes for just €11.50 – not bad for Japanese eats. An extra €2 will get you a green-tea ice cream for dessert. You'll find Sushi on a small, surprisingly peaceful alley that runs between Rokin and the Kalverstraat. In the summer there are a few tables outside. Cash only. Open: Daily 12-22. (Map area D5)

Kagetsu - Van Woustraat 29, Hartenstraat 17; 🏗 662-7340

Japanese. You'll find this unassuming yet stylish Japanese joint in *De Pijp* near the Albert Cuyp Market. The décor is simple and the comic-style hand-drawn menus add a humorous touch. The sushi rocks and the young chef adds his own flare to the rolls: the spicy tuna is divine. A salmon-and-avocado hand roll costs €4.50; nigiri sushi runs from € 3.50-€4.50 per two pieces. Warm dishes run from €7.50 (vegetables and fried Soba noodles) to €15 (steak with sweet soy sauce). There's a traditional Japanese-style room in the back where larger groups can eat. Kagetsu is unique for its decent prices and high-quality authentic eats, as evidenced by a steady Japanese clientele. Feel like seriously splurging? Try the Master's Choice, where the chef makes a combination meal customized to your culinary desires. There's another teeny tiny Kagetsu at Hartenstraat 17 in Amsterdam's charming *Negen Straatjes* (Nine Streets) area. Open: Tues-Sun 17-23.

SushiMe - Oude Leliestraat 7, 627-7926; Delivery: 🅿 627-7043

www.sushime.nl

Japanese. This stark sushi outlet just off the Herengracht sits right across the street from Foodism (see Restaurants chapter) and the Grey Area (see Coffeeshops). The décor is stern but I found the sushi to be just about the best in town, with combi menus starting at €6.90 and the Big Maki Menus from €13.50. They offer soups, salads, sashimi, delicious handrolls, a veggie menu, and there's fresh ginger for your sushi. "Some Rules to Remember" from some other time and place are stenciled on the wall but they're probably best ignored. Credit cards, however, are welcomed. Open: Daily 14-22. (Map area: C4)

Chao Phraya - Nieuwmarkt 8-10, 🏗 427-6334

Thai. On a sunny day Chao Phraya is a great place to get your *phad thai* and clock the interesting human activity in the Nieuwmarkt from your sidewalk table outside the restaurant. It's nice inside too, and the staff is exceptionally warm and friendly. It's not cheap, but the rice or noodle dishes with beef, chicken or shrimp from €13-€15.00 are well prepared and deliver everything you could ask for in a Thai meal. Credit cards cheerfully accepted. Open: Daily 12-22. (Map area: E5)

O'cha - Binnenbantammerstraat 1, 🅿 625-9958

Thai. If you like curries that hurt so good, you'll appreciate this homey restaurant run by two Thai sisters. A huge bowl of green curry costs €9 (tofu) to €13 (prawn) and can easily be shared. Last time I ate here, I was sweating like I had just run a marathon but still sporting a scarlet-faced smile. One of the sisters kept handing me napkins to wipe the perspiration from my brow. Less masochistic curry fans can ask for mild. Open: Daily 15-23. (Map area E4)

New King - Zeedijk 115-117, 🏗 625-2810

Chinese. New King, one of Amsterdam's most popular Chinese restaurants, is an authentic, affordable dining experience. Just thinking about their crispy fried noodles with minced shrimp (€9) makes me salivate. They have a massive menu, prompt service and – as a real bonus – free jasmine tea with your meal. Located in the heart of Chinatown. (Map area: E4)

Thais Snackbar Bird - Zeedijk 77, 2 420-6289

www.thai bird.nl

Thai. If you've ever been to Thailand you'll like this place. It's got the atmosphere down pat, with Thai pop songs, pictures of the king, and orchids on the tables. I've seen Thai people eating

here, which is a sign of authentic cooking. The meals aren't super cheap but the food is always prepared fresh and it's delicious – well worth the walk through this sleazy Amsterdam version of Chinatown. Open: Daily 15-22. (Map area E4)

Cook Kai - 2e Rozendwarstraat 3, 2 528-7887

www.cookkai.nl

7FFDIIK

Thai. It seems like the best Thai restaurants in Amsterdam are all tiny. This one is really cute. It's on a little side street in the *Jordaan* and it has room for only three small tables next to the open kitchen. Fortunately, the three women cooking here are not only friendly but fast, too, so there's usually not a terribly long wait for a table. I'm crazy about Cook Kai's #84 – tofu with mixed veggies and Thai basil in a red coconut-curry sauce. Oh yeah! Prices start at €8.30 for a filling main dish, so you can get a meal and a drink for about €10. Figure in a few more euros if you want meat or fish. Open: Daily 16-22. (Map area B5)

Kam Yin - Warmoesstraat 6, 2 625-3115

Surinamese/Chinese. The best food of this type at the right price in the center of Amsterdam. They have a big take-away menu of rice and noodle items, and the servings are huge. Dishes start as low as €4.50 and one main dish along with a side order is probably enough for two people. You can also eat in for just a little bit more. Two minutes from Centraal Station. Open: Daily 12-24. (Map area E4)

Planet Rose - Nicolaas Beetsstraat 47, 612-9838

Jamaican. Luscious fresh dishes prepared with love make this little out-of-the-way restaurant a must for Jamaican/Caribbean food lovers and anyone who appreciates home-style cooking. Rose, the owner and chef, is a gracious host and her meals – from a scrumptious vegetarian curry to Jerk chicken or salmon – are a good deal. A small plate runs from €6 to €8.50 and a large plate from €12 to €14.50. A piece of freshly-made cake, like the delicious coconut cake with custard I devoured, is only €3. The menu changes daily and all the meals include salad, rice and peas plus fried plantains. You need a bit of patience – the food is all freshly made – but your belly will be rewarded. Located out of the center in the West near the Ten Kate Markt (see Shopping/Markets). Take tram 17 (direction Osdorp) and get off at Ten Kate Markt, walk down the market street, take the first left , walk a small block and it's on the corner. It's a bit of a mission to get here but you won't regret it. Open: Tues-Sat 14-22; Sun 17-22

Lunchcafé Nielsen - Berenstraat 19, 7 330-6006

Western healthy. Before or after you finish exploring the little streets in this charming neighborhood, stop by this lively, family-run cafe for a freshly-prepared breakfast or lunch. But don't be in a rush: The tasty food draws in a lot of people, and it's always busy. The menu is in English and has plenty of vegetarian choices, a few vegan options, and only free-range meat. A full breakfast costs €8.95, or you can go à la carte if you just want a fruit salad or an omelette. They also have sandwiches from €4.75 to

€9.50, giant salads from €9.25, and homemade soups from €5. *Eet smakelijk*. Open: Tues-Fri 8-16; Sat 8-18; Sun 9-17. (Map Area C5)

Maoz Vegetarian - Oudebrugsteeg 30, 🏗 625-0717

Falafel. Over the last 10 years this falafel take-away has grown in reputation and store numbers. The newest branch, across from the 420 Café (see Coffeeshops) in a small alley just off the Damrak, is a small, clean veggie joint. A whole-wheat pita stuffed with 5 falafel balls, fried eggplant and limitless salad bar is only €4.30 for a small and €5 for a large. This particular Maoz includes cauliflower pakorma (yum!) in the salad offerings. For veggie fast food this is the place. Note: the green sauce is smoking hot; usually they warn you, but not always. Other outlets include: Muntplein1, Leidsestraat 85 and the original Maoz at Reguliersbreestraat 45, near Rembrandtplein. Open: Daily 11-1. (Map area D4)

Foodism - Oude Leliestraat 8, 2 427-5103

Everything. This funky little restaurant is on the same pretty street as Grey Area (see Coffeeshops, Cannabis chapter) and has a sign on the door that says "Sorry, We're Open." They make wonderful soups (€4.50), salads, filling sandwiches (€5), and a delicious vegetarian pasta (€10). It's a place you can walk into wrecked after an all-night bender and feel comfortable listening to some chilled tunes while enjoying a big plate of scrambled eggs, salmon and a bagel. Open Mon-Sat "around 10:30 til 22," Sun 12-18. (Map area C4)

Morning Star - Nieuwezijds Voorburwal (opposite 289), 🅿 620-3302

Everything. This place used to be called Dolores and was known for organic burgers, good coffee and super-friendly service. Luckily, the new owners adhere to the same standards: fresh food, lots of healthy options and a pleasant terrace. One recent trend around town has seen the addition of organic and healthy items to food menus; Morning Star sticks to this recipe and offers an organic beef burger with fries for €8.50. You can get the veggie equivalent for €6.00. Or why not go exotic – an organic chicken

focaccia sandwich with spicy sweet peanut sauce (€5.50). There are also soups, salads and scrumptious desserts. The kitchen is in a beautiful little historic cottage. There are only a couple of stools along the bar inside, but the picnic-table terrace is roomy. Grab a fruit shake (€3.50) or a soy latte and enjoy a bit of modern Amsterdam café life. Located near Dam Square. Open: Mon-Fri 6-16. (Map area C5)

De Peper - Overtoom 301, 2 412-2954

http://squat.net/overtoom301

Organic Vegan. This former film school was squatted after sitting empty for some time and now houses several studios and workshops, a movie theatre (see Film chapter), living spaces, and a great restaurant called De Peper. It's very popular, so make sure you call at 16:00 to reserve a meal. Let them know when you arrive, and then kick back with a beer or juice. Everything on offer is organic – even the cognac. The bar opens at 18:00 and the food is served at about 19:00. The meal consists of soup and a carefully prepared main course. The €6 price is cheap for healthy, vegan food. Dessert costs an extra €1.20. At the moment they're cooking full meals on Tuesday, Friday and Sunday nights. There are often DJs and performances after dinner and the bar stays open until 1:00 (3:00 on Fridays), so you can also arrive later for drinks. From Leidseplein it's about a 10-minute walk, or you can hop on tram 1. (Map area A7)

Eat at Jo's - Marnixstraat 409, To 638-3336

Everything. This restaurant is run by a couple who go that extra mile (they're from America or I would have said kilometer) to make sure the food is yummy and the service is good. Full-course, lovingly-prepared meals cost about €11 for a vegetarian set menu and about €14 for meat or fish. The servings are huge and there's plenty of variety: The menu changes regularly and on any given night you might be choosing between a meal that's Italian-themed, Japanese-inspired, or North African-flavored. The homemade desserts are amazing; I had a whopping piece of chocolate cake that was so good I almost cried. The restaurant is located in the Melkweg (see Music chapter) and often the band playing there that evening will be dining at the table next to you. Whether the place is half-empty and mellow or full and hectic, whether you want a full meal or just a snack and a beer, it's always relaxed and comfortable here. You can also order a drink and take it with you into the photo gallery in the next room. Open: Wed-Sun 12-21. (Map area C7)

Burger Bar - Kolksteeg 2, 2 062-416-4117

Burgers. Burger Bar is one of the first and definitely one of the best places to enjoy Amsterdam's new food trend. Choose your roll, the burger size and the sauces you want, and a cooked-to-order burger (chicken or beef) will run you between €3.50 and €5.95. Fresh-cut French fries with a choice of 21 sauces are also on the menu. Take a seat in the charming 17th-century alleyway outside and they'll bring your grub to you. Located off the Nieuwendijk. Open: Sun-Thurs 11-3; Fri-Sat 'till 4. (Map area D4)

Kismet - Albert Cuypstraat 64, 5 671-4768

Turkish. If you've never tried Turkish food, Kismet is an ideal place to start. Much of what's on offer is tantalizingly displayed in the window, but they also have soup, moussaka, Turkish pizzas and other dishes on the menu. Most items cost only a few euros, so it's easy to try several things amongst a group of friends. Or you can order one of their set menus that start at €9.50 for a big plate of stuffed eggplant, assorted veggies, filled grape leaves, rice and potatoes. For the same price, meat eaters can get the eggplant and veggies with chicken and a meatball. You'll be stuffed, but try to save room for some of their delicious baklava with your coffee. When the weather's warm they have tables outside. Avoid the peak meal hours if you can, because this is a small place and they're often full. Open: Daily 8-20.

Addis Ababa - Overtoom 337, 2 618-4472

www.addisababa.nl

Ethiopian. This is a great restaurant to go to with a bunch of friends. The food is served on a giant platter in the traditional way, and everybody eats with their hands. The decor is lively and the owner is a really nice guy. They serve several veggie dishes and something for carnivores too. A full meal and a drink (try the banana beer) will set you back about €12 to €15 per person. Open: Daily 17-23. (Map area A7)

Olive & Cookie - Saenredamstraat 67, 2 470-7190

Considering the small space they have to work in, the variety and array of delicious food produced at this little catering shop is astonishing. The place is simple and clean and the edibles all taste as good as they look. The friendly owners sell everything you need for a complete, gourmet meal: vegetarian tapas. salads, savory pies, casseroles, fresh soups and incredible desserts. It's all organic and sold by weight or by the piece. What's available changes regularly, though there's always a yegan option. and you never know what delight will come fresh out of the oven when you're there. Most of it is take-out, but there are also a few seats and a table if you just can't wait. Snacks and cakes run from €2 to €4, and a full meal will probably add up to between €10 and €15. There's no meat, but they do cook fish. Olive & Cookie is located on a small side street in De Piip neighbor-

Soup En Zo - Jodenbreestraat 94a, T 422-2243

hood. Open: Mon-Sat 13-21.

www.soupenzo.nl

Soup. In a welcome addition to Amsterdam's culinary scene, the concept of the soup stall has arrived. The cooks in this little restaurant use fresh, often organically-grown vegetables in their soups, and there are always several vegetarian options. Prices range from about €2.70 to €5.90 for a bowl and the soups really are delicious. They also serve salads and Brazilian fruit shakes. In nice weather there are tables out front. Soup en Zo is located close to the Waterlooplein market. They have another shop at Nieuwe Spiegelstraat 54, but it's for take-away only. Jodenbreestraat location open: Mon-Fri 11-20; Sat-Sun 12-19. (Map area E6)

Soepwinkel - Eerste Sweelinckstraat 19, 2 673-2293

www.soepwinkel.nl

Soup. The comfy and by Amsterdam standards spacious terrace of the "Soup Store" sits on a side-street between the Albert Cuyp market and Sarphatipark. It's a great spot to kick back and relax while you sample the tasty goods. So far I've tried the Caribbean sweet potato and Tunisian vegetable soups. Both were excellent. The menu changes regularly and the cooks mostly use seasonal, locally grown vegetables. Prices start at €3.95 for a small bowl and bread, and go up to €10.50 for a large, which is huge! There's a set menu for €7.90 that includes a bowl of soup, a small piece of quiche and a drink. They serve sandwiches and cakes too − I'm getting hungry just writing about it! Peppino's (see Street Food, above) is just across the street and their ice cream is also an ideal way to finish off a meal. Soepwinkel open: Mon-Fri 11-20; Sat 11-18.

Eat Mode - Zeedijk 105, 🏗 330-0806

www.eatmode.nl

Asian Fusion. Eat Mode is a clean, modern little restaurant with a fast-food decor that serves a variety of Asian foods based on Thai, Chinese and Japanese recipes. The menu here includes Peking duck, tempura, seaweed salad, curries, sushi and much more. It's not the best food of this sort that you'll ever have, but it's tasty enough and reasonably priced. Meals start at €4.50 and the average price is about €7. Big glasses of fresh fruit and veggie juices are €3, and a bottle of Singa beer costs €2.50. Order at the counter and when your number appears on the digital board your food is ready. Try to grab a table by the window so you can watch the craziness of the Zeedijk while you relax inside to the mellow dance music and ambient sounds. Open: Daily 12-23. (Map Area E4)

La Place Grand Café Restaurant - Kalverstraat 201, 2 622-0171

www.laplace.nl

Everything. Occupying a couple of little 17th-century houses, this department-store food court lacks the usual fast-food crap and atmosphere. Most of what's offered in the main floor *menagerie* – noodle dishes, stir-fries and salads – is prepared in little open kitchens and then invitingly displayed for you to help yourself (€1.25 for 100 grams). Fill up a container and your meal is weighed to calculate the price. They also have sandwiches on panini for €3, pizza for €3.35 a slice, and brownies and cookies. This is actually a take-out area, but if you're discreet you can usually sneak upstairs where there are tables. Also upstairs you'll find elegant little booths that display a wide variety of beautiful fruits and vegetables bought directly from the producers. The menu changes daily and everything is prepared fresh. Here are some of the cheaper examples from the last time I was here: Soup of the day, €3.50; French fries, €1.95; hot chocolate with whipped cream, €1.90. There are also a couple of salad bars – fruit (€3) and vegetable (€3.30) – where you can test your architectural skills by piling a plate as high as possible. Full meals cost between €6-€10. Up another flight there's a small balcony over the Kalverstraat that's great for people watching, if the weather is nice. Open: Sun-Mon 11-20; Tues-Sat 10-20; (Thurs 'til 21). (Map area D6)

Zaal 100 - De Wittenstraat 100, 2 688-0127

www.wittereus.net/zaal100.html

Vegetarian. There are all kinds of cultural events going on in this building, which was squatted in 1984, but to find the food, go in the main doors and turn to your right. The first door on your right, just past the bar, is the one you want. Inside is a crowded, cozy room filled with tables and mismatched chairs. There are stairs in the hallway that lead up to a small balcony with more seating. It's perfectly acceptable to share a table if the place is busy. A full meal of soup, a big plate of food for the main dish, and dessert will usually run you only about €7.50. It's not a gourmet meal, but it is tasty and filling. You don't need to reserve, but you should show up early. Closed in July and August. Only open for dinner on Wednesdays and Thursdays from 18:00 'til they run out of food. (Map area B2)

Einde van de Wereld (End of the World) - Javakade (opposite number 21), KNSM Island

Home Cooking. Some years back, with a lot of hard work by volunteers, the lively atmosphere of this famous squat restaurant was transplanted onto a boat. Step down into the hold of the ship and there's a bright, bustling room filled with great music and the smell of home cooking. Go early as they only serve until the food runs out. There's a choice of a vegetarian (€6) or an organic meat dish (€8) – half plates are also available (lots of kids here: see Kids section). Dessert costs €2. Though the deliciousness quotient varies, it's always a good deal: The servings are huge and there's also bread and garlic butter on the tables. Drinks are cheap. Order your meal at the bar, leave your name, pay, and in about 15 minutes they'll bring you your food. In good weather, take your beer and sit up top overlooking the water. The boat's name is Quo Vadis and there's little sign in front. You can take bus 42 from Centraal Station eastbound (it'll say KNSM Eiland on the front) to the Azartplein. Head towards the big bridge and then turn right and walk along the water. Or better yet, take a bicycle so you can cruise around a bit before or after your meal: The interesting architecture in this newly built neighborhood is world-renowned. Einde van de Wereld is open only on Wednesdays and Fridays from 18:00. (Map area I3)

Toscana - Haarlemmerstraat 130, 🏗 622-0353; Haarlemmerdijk 176, 🛣 624-8358

Italian. I'm always complaining to visitors about how pathetic Amsterdam pizzas are. This place isn't the best in town, but all their pizzas are "half price" and I love a bargain. The cheapest pizza is a thin but big *margherita* for €4.75, which means you can have a pizza and a beer for about €7.50. Some of the pizzas, like the *Yildrim* – blue cheese, pineapple, garlic and oregano – actually rock. If you eat this one, your tastebuds will experience happy confusion but you might not be so kissable later. "When the moon hits your eye, like a big pizza pie, that's amoré...." Open: Daily 16-23. (Map area C2)

Leccornia - Haarlemmerstraat 68, 528-5050

Organic. The food at this European-style deli is so good that I wanted to include it even though Leccornia is really a take-out place rather than a restaurant. Everything sold here is made of organically-grown ingredients, from the veggie soups (€4.50) and sandwiches on fresh-baked ciabatta (€4.€6) to the

vegetarian lasagna and couscous (€8.50). And that's just a small sample of the globally inspired delicacies on offer. There are also meat dishes, tapenades, desserts, and a wide selection of wine, juices and shakes. The menu changes daily and the prices are very reasonable for organic cooking. There are a few stools along one wall if you want to eat in, or let them pack up your meal to take back to your hotel, to the pretty square behind the West-Indisch Huis across the street, or to a bench by the water on the nearby Brouwersgracht. Open: Mon-Sat 12-21. (Map Area D3)

Go Freshshop - Amstelstraat 27, 🕿 428-5264; Vijzelstraat 135, 🕿 528-9865

www.gofreshshop.nl

I don't know if the cooks at these shops adhere to the principles of the slow food movement, but in any case don't expect a speedy meal. But if it's healthy, hearty food you crave, you're in for a treat. The meals here are prepared in an open kitchen, and all the ingredients are super fresh: nothing is chopped, diced, or grated until you order. The menu consists of a wide range of salads, pastas, and meat, fish, or veggie dishes that cost between €9 and €13. For €4 you can choose one of over a dozen sandwiches, both warm and cold. The goat-choose mousse with grilled eggplant and rocket salad is fantastic. They're also known for their fresh juices, like the house blend − orange, apple, carrot, cuke and tomato (small €3; large €4). The newest and nicest location is on the Amstelstraat between Rembrandtplein and the Amstel River. If it's busy, get something to go and take it around the corner to the benches by the famous Skinny Bridge (*Magere Brug*) on the Kerkstraat. Or, order in to your hotel: they deliver. Amstelstraat open: Sun-Thurs 11-22; Fri-Sat 11-24. (Map area D6)

Riaz - Bilderdijkstraat 193, 🏗 683-6453

www.riaz.nl

Surinamese/Indian/Indonesian. Riaz is popular with famous Dutch football players and TV personalities – and me. It's not the decor, which is simple and clean, but the delicious food that keeps celebrities like us coming back. I like the *Pom* (home-made Surinamese yam and chicken casserole, served with rice, green beans and tasty sweet/sour pickles). They offer several dishes that range in price, chicken and lamb curries cost €12.50. The Surinamese and Indonesian food – rice, noodles, rotis – cost €6 for vegetarian dishes and €6 to €11 with meat. There are also lots of snacks and sandwiches. Riaz has been serving up eats here in the west end of town for over 25 years. Open: Sun 14-21; Mon-Fri 11:30-21. (Map area A6)

Bojo - Lange Leidsedwarsstraat 51, 🏗 626-8990 (🕿 694-2864 for hotel delivery)

www.bojo.nl

Indonesian. This place is in all the tourist guides, but a lot of Dutch people go here too because what the food lacks in excitement is made up for by the huge servings and reasonable prices (€8.50 and up). And they're open late. Skip the appetizers: they're not very good. The entrees are pretty good, but if you want a real Indonesian "rice table" (and they're excellent) you have to pay at least €20 per person. If you have the dough try Cilubang (Runstraat 10; 626-9755; www.cilubang.com) where the food is fantastic. Bojo is open: Mon-Thurs 16-2; Fri 16-4; Sat 12-4; Sun 12-2. (Map area C7)

Pannenkoekhuis Upstairs - Grimburgwal 2, 🏗 626-5603

Pancakes. Not having a pancake in Holland would be like coming here and not seeing a windmill – it's part of the Dutch experience. This tiny joint is on the second floor of a very cute, very old house just east of the Spui. Prices start at about €5.50. Toppings include everything from simple powdered sugar to strawberries and whipped cream to bananas with chocolate sauce. A pot of tea costs €2.50. Open: Fri 12-18:30; Sat 12-17:30; Sun 12-17; Mon 12-19. Closed Tues-Thurs and the whole month of January. (Map area D5)

MKZ - Eerste Schinkelstraat 16, 🏗 679-0712

Vegan/Vegetarian. MKZ is an abbreviation of the Dutch word for hoof-and-mouth disease, so it's no surprise that the only things slaughtered here for your eating pleasure are vegetables. Big plates of healthy food are dished up two to four nights a week by volunteer crews that change each evening. For a while, the *Koken met Tieten* night (Cooks with Tits) – where the mostly female chefs worked topless – was very popular. The restaurant is in a great space at the edge of the squatted Binnenpret complex

on the far side of Vondelpark. You might want to combine a meal here with a visit to the sauna (see Saunas, Hanging Out chapter), or a concert at OCCII (see Music chapter). In the summer you can eat out in the courtyard, but in winter it can get very chilly so try to snag a seat near the heater or the open kitchen. The last time I was here, soup and a main dish were only €4.50, and dessert was an extra 50 cents. Drinks are super cheap, too: juice and tea are 50 cents, wine or a bottle of beer only €1! Call in the afternoon to find out if they're open and to make a reservation. Food is served at 19.00. At the moment they're open Tues Wed and Fri, but that can change. They're closed in the summer.

Café de Molli - Van Ostadestraat 55, 🏗 676-1427

www.molli.nl

Vegetarian/Vegan. This place serves up big cheap eats every Tuesday evening – full veggie or vegan meals in a very basic communal setting. The prices are unbeatable for healthy grub. Call the number above in the afternoon to reserve your meal. For a little more info about this squat see the Cafés chapter. Meals are served at 19:00.

The Atrium - Oudezijds Achterburgwal 237, 25 525-3999

Cafeteria food. This is a self-service student *mensa* with cheap meals. Gourmet it ain't, but damn it's cheap. Among the many offerings at lunchtime are salads for €1.25, soup for only 70 cents, grilled cheese for €1, and burgers for €2.75. At dinner you can get a full meal with a main dish of meat, fish, or veggie for around €6.50 (cheaper if you've got a student card). Meals are served on weekdays from 11 to 15:00 and 17 to 19:30 (Friday until 19:00), but it's open the rest of the day for drinks and snacks. Closed on weekends. There's another student *mensa*, Agora, at Roetersstraat 11, that offers the same food. Same hours as the Atrium except on Friday when it closes at 16:00. (Map area D5)

Keuken van 1870 - Spuistraat 4, 2 620-4018

www.keukenvan1870.nl

Cafeteria food. Keuken opened as a soup kitchen in 1870, and though it was recently renovated you can still get a fairly cheap basic meal here. A three-course meat and potato dinner costs about €8. And they always have *stampot*, a traditional Dutch dish that comprises mashed potatoes, vegetables, and sausage or meatballs (€7). They also have an à *la carte* menu with a couple of vegetarian choices, but it's more of a meat-eater kind of place. Anyway, you should be able to get out of here for less than €10. It's close to Centraal Station. Open: Mon-Sat 17-22. (Map area D3)

Koffiehuis Van Den Volksbond - Kadijksplein 4, 622-1209

www.koffiehuisvandenvolksbond.nl

Originally this beautiful old building close to the Maritime Museum was one of many "coffee houses" throughout the city - charitable projects designed by employers and their wives to help combat alcoholism amongst the migrant workforce. The Koffiehuis served cheap meals, coffee and beer (but no hard liquor) at subsidized prices in order to draw the men away from the bars. In the 1980s it was saved from demolition by squatters. Now it houses a comfortable arty restaurant that serves high-quality meals, still mostly to people from the neighborhood. Prices are no longer subsidized, but it's a very pleasant place to splurge on an evening out. The menu changes nightly and features starters like cream of venkel soup with smoked salmon and blue cheese (€4.75) or prawns cooked in garlic and sherry €7.25). Hearty main dishes run €11 to €15 and rich desserts around €6. There are about a half-dozen choices for each course and there's always at least one veggie option. The kitchen is open daily from 18-22; Sundays they open at 17. (Map area G5)

Hap Hmm - 1st Helmersstraat 33; 🏗 618-1884

www.hap-hmm.nl

Dutch Food. Just like dinner in Mom's kitchen. Hap Hmm is a little eatery situated on a residential street that runs parallel to the Overtoom. They serve a lot of meat and fish dishes including veggies and potatoes (average price €6.50), and lately they've been adding different sorts of vegetarian meals to the menu as well. You can also go *à la carte*: they have small salads for €1.75, soup of the day is €1.50, and desserts are cheap too. It's nothing fancy, but it's a good price for a filling Dutch meal in a homey environment. Expect the other diners to be old folk from the neighborhood along with people carrying their copies of *Get Lost!* Open: Mon-Fri 16:30-20. (Map area 7B)

Buffet van Odette en Yvette - Herengracht 309, 🏗 423-6034

www.buffct-amsterdam.nl

Home Cooking. The two women who run this cozy restaurant use as many organic ingredients as possible in their delicious home-cooked breakfasts and lunches. There are several tables of various sizes, but grab a seat at the counter facing the window so you can enjoy the view of the canal. Most of the meals are of the salad-sandwich-and-quiche variety and cost between €4.50 to €10. Be sure to save room for dessert as they bake wonderful brownies and cakes, including sticky toffee cake (warm date cake with caramel sauce) that's joy on a fork. Open: Mon-Fri 8:30-17:30; Sat 10-17:30; Sun 12-17:30. (Map area C5)

Bazar - Albert Cuypstraat 182, To 675-0544

www.bazaramsterdam.nl

North African/Turkish/Middle Eastern. Bazar is located in a huge space that's beautiful in itself, and the decorations – mosaics and colorful lights throughout, giant chandeliers hanging over the upstairs veranda – create a unique dining atmosphere. They serve breakfast (see Breakfast section, above) and lunch until 17:00. Sandwiches start at €4 (the falafel is excellent) and big salads start at €7. They also have tasty soups, Turkish pizzas and other regional snacks. In the evening there's a full dinner menu of big, filling dishes – lots of kebabs, couscous, aubergine, olives and artichokes – that average about €11. There's plenty for vegetarians, and carnivores will love the mixed grill with meat or fish for €14.50. It's a fun and festive place, great if you're going with a gang. Best to reserve during peak hours. Open: Mon-Thurs 8-1; Fri 8-2; Sat 9-2; Sun 9-24.

Special Bite

www.specialbite.co

Want more restaurant suggestions? For extensive, independent Amsterdam restaurant listings in all price ranges, try *Special Bite*. They have an excellent website that's updated regularly and a printed guide that appears quarterly. Both are in English, easy to use, and fun to read.

afés are plentiful in Amsterdam, and they're ideal places to hang out and get a feel for the city. Once you've placed your order, you'll be left alone to read or write postcards or vegetate for as long as you like. Don't be shy to ask to share a table if you see a free chair: This is one of the most densely populated countries in the world (16 million people), and table sharing is customary.

There's been a minor revolution in Amsterdam's coffee scene over the past few years. At one time, if you asked for an ordinary coffee you'd almost invariably be served a watered-down espresso, and a cup of joe to go was very uncommon. Now you can find whatever you desire, from iced mochas to soy lattes, in almost every block in the Centrum. For serious espresso lovers, check out de Koffie Salon (1st Constantijn Huygenstraat 82, map area A7; Utrechtsestraat 130, map area D7). They use Palombini espresso beans that produce a seductive trickle from a vintage hand-pulled Italian machine. Café Latei (see below) also makes a great espresso prepared with Sicilian beans.

Koffie verkeerd ("wrong coffee") is a latté. Tea is charged by the cup, and extra water will be added to your bill. I don't know the reason for this dumb custom. Fresh-squeezed orange juice – commonly referred to in French as jus d'orange – is available in most cafés.

Many cafés also serve snacks such as *broodjes* (small sandwiches) and tostis (usually ham and/ or cheese sandwiches squashed into a sandwich toaster). Prices start at about €2.50 for a plain cheese on white roll or *tosti*. Another popular item is apple pie with whipped cream. It's a delicious Amsterdam speciality that definitely should be experienced.

For internet cafés, see the Hanging Out chapter.

Café Latei - Zeedijk 143, 🏗 625-7485

www.latei.net

Do you ever wake up and think to yourself, "I feel like drinking a cup of coffee and then buying some organic olive oil and a piece of furniture"? Because this cute split-level café's got all that and more. Almost everything in here is for sale: the chair you're sitting on, Finnish wallpaper, '60s Tupperware, knick-knacks, old EPs and Sicilian olive oil. The way everything is scattered about here creates the sensation that you're in someone's very ornate living room. It's a great little place to pop into for a fresh-squeezed juice (€2.30) and a big bowl of vegetarian soup (€4.75), or a sandwich made with organic bread (€1.80 to €3.70). On Thursday, Friday and Saturday nights at 18:00 they serve excellent Indian food (vegetarian €8 and €10, organic meat €12) prepared using only fresh ingredients. Open: Mon-Wed 8-18; Thurs-Fri 8-22; Sat 9-22; Sun 11-18. (Map area E4)

Dwaze Zaken - Prins Hendrikkade 50, 2 612-4175

www.dwazezaken.nl

I'm not sure why this café is called Foolish Things, because they seem to have it together: changing art exhibitions adorn the already pretty space, the food and drinks are yummy, and the bathrooms are spotless. Their terrace is also really nice and if the weather sucks they have comfy couches and chairs inside. Prices aren't super cheap, but the servings are generous. There's a big selection of sandwiches starting at €4, along with soups, wraps, and big salads. Drink-wise they offer delicious tap beer, nice teas, and fresh orange-kiwi-banana juice. In the evenings there's sometimes live music or a spokenword performance, and then there might be a few euros cover. It's just across the street and to the left of Centraal Station. Open: Tues-Sat 12-24; Sun 12-18. (Map Area E3)

De Tuin - 2e Tuindwarsstraat 13, 🏗 624-4559

De Tuin is a spacious, inviting café right in the heart of the Jordaan. It's a traditional "brown café," so called because of the abundance of wood. It's fun to explore this charming neighborhood and then pop in here for a drink and a sandwich. There are usually cool people hanging out and it's a comfortable spot to relax for a while. The view of the Westerkork towor from this shopping street is particularly photogenic. Open: Mon-Thurs 10-1; Fri-Sat 10-2; Sun 11-1. (Map area B3)

Café de Pels - Huidenstraat 25, 2 622-9037

This is another traditional "brown café" with an authentic Amsterdam ambiance and a diverse clientele. It's warm and welcoming in the winter, while in the summer the tiny outdoor tables make for good people-watching on this quaint little street. Open: Sun-Thurs 10-1; Fri-Sat 10-3. (Map area C5)

Villa Zeezicht - Torensteeg 7, 7 626-7433

Often packed, the service here can be a little slow, but Villa Zeezicht remains a cozy, comfortable café. The seats by the big windows are perfect for reading the paper and people watching. In the summer there are tables outside and on the bridge across the street. Sandwiches start at €3.50. They also offer killer homemade apple pie for €4 – a meal in itself. Make sure to ask for whipped cream. Open: Daily 8-22. (Map area D4)

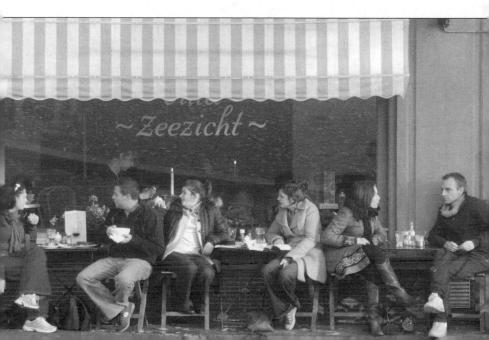

Tony's NY City Bagels - Jodenbreestraat 15, 7 421-5930; Raadhuisstraat 18, 7 638-0186

tonysnycitybagels.nl

I like the bagels at this little eatery. While they won't win any awards, they're still pretty good. A bagel with cream cheese and chives is only €2.45. Soups and salads are €3.65 and €5.45 respectively. And a cup of organic fair-trade coffee is €1.60, with American-style refills for half price. Other potables include espresso, hot chocolate, iced tea, fresh juices and shakes. The baked goods – muffins, cookies, brownies – I'm not crazy about, but sometimes I eat them anyway when I need a sugar fix. The staff is always nice here. Order your food at the counter, grab a table and they'll bring your order. Don't forget to grab a discount card and get it stamped; after nine cups of coffee or nine muffins you get the tenth free. Open: Mon-Fri 8:30-18; Sat 9-18; Sun 10-18. (Map area E5)

Bagels & Beans - Ferdinand Bolstraat 70, ☎ 672-1610; Keizersgracht 504, ☎ 330-5508; Waterlooplein 2, ☎ 428-8906; Haarlemmerdijk 122, ☎ 330-4102; Van Baerlestraat 40, ☎ 675-7050

www.bagelsbeans.nl

Though I prefer the bagels at Tony's (see above), I also like to visit this popular bagel chain at times. The menu is the same, but each location has something unique about it; for instance Van Baerlestraat has a pretty garden out back, and Waterlooplein is right on the market and is great for people-watching. All the locations offer free WiFi. Bagels with cream cheese start at €2.90, but there's a big menu offering all sorts of topping combinations. The warm goat cheese-honey-walnuts-and-thyme is very popular. Opening times vary by location but in general they're open daily 8:30-17:30.

Tofani - Kloveniersburgwal 20

There's nothing pretentious about this Italian shop near the Nieuwmarkt. It's an old-school joint selling great sandwiches and wonderful *gelati*. Five different sandwiches are served on panini bread. A mozzarella-lettuce-tomato-and-basil is €4. There are also hot sandwiches. Order at the counter and have a seat at one of the tables outside. They'll tap on the window when it's ready. It's perfect for a fast lunch, especially when the weather is nice. Open: Mar-Oct only. (Map area E5)

Café Vertigo - Vondelpark 3, T 612-3021

www.vertigo.nl

This café has one of the nicest and busiest terraces in Amsterdam. It's located in the middle of Vondelpark in the Film Museum building (see Film chapter). In bad weather you can duck into the cozy low-ceilinged café. On Saturday nights they have DJs. Sometimes there are slide shows at the back. Open: Daily 10-1. (Map area B8)

De Jaren - Nieuwe Doelenstraat 20, 🅿 625-5771

café de jaren.nl

I'm not crazy about the food here, but I like the spaciousness, which is unusual in this city and means that you can almost always find a seat. In the summer there are two big terraces with a terrific view over the Amstel River. It's right by the university and lots of intellectuals hang out here reading books and working on-line with their laptops. I often stop in to use the toilet. It's located between Waterlooplein and Muntplein. Open: Sun-Thurs 10-1; Fri-Sat 10-2. (Map area D6)

Kromhout - Entrepotdok 36, 🏗 330-0929

www.caferestaurantkromhout.nl

There'snoshortage of charming outdoor Cafés along Amsterdam's canals. But finding one in the Centrum where you're not crammed into a tiny space with traffic whizzing by is another matter. The patio at Kromhout isn't like that at all. It's spacious (for this city), and there's very little traffic except for a steady, entertaining stream of bikes rolling over a little bridge and the comings and goings of the local ducks and swans. Whether you're chilling here with a cold beer or having a romantic, candle-lit dinner with a bottle of wine on a summer night, it's a great spot. The café itself is situated in a row of historic warehouses that are now mostly apartments. They serve an assortment of sandwiches and salads, as well as more filling meals that will run you about €10 to €15. The little bottles of organic apple juice they stock are delicious, and they also make excellent coffee. It's located just north of the Artis prison (oops, I mean Zoo), and the WW2 Resistance Museum. Open: Daily 11-24. (Map area G6)

Skek - Zeedijk 4-8, 🏗 427-0551

www.skek.nl

Skek, a café/bar near Centraal Station on the historic Zeedijk, combines "the culinary with the cultural." They support young, enthusiastic chefs who cook affordable meals made from fresh daily produce. The place is open for lunch and dinner with a diverse menu. Work by new artists is displayed on the walls, and there's a cozy little room up some stairs with a great view of the small stage below where bands, singer/songwriters and upstart jazz cats do their thing weekly, free of charge. Students receive 30% off their meals, all the time. At night the bar gets packed, especially on the weekends. Open: Sun-Thurs 12-1; Fri-Sat 12-3.

De Badcuyp - 1e Sweelinckstraat 10, 🏗 675-9669

www.badcuyp.nl

Neighborhood activists saved this former bathhouse from demolition. Now De Badcuyp is a "center for art, culture and politics" that's partly run by volunteers. It's located in the middle of the crowded Albert Cuyp Market (see Markets, Shopping chapter), and in nice weather there are tables outside. Inside it's spacious and relaxed: Newspapers are scattered around and art exhibits line the walls. The upper level gives you a good view of the shoppers in the market below. They have a café that serves cheap snacks from 11:00, and full meals in the evening from 18 to 22:00. There's often live music, either in the café or in the hall upstairs where they also host popular dance nights featuring salsa, funk, blues, jazz and disco. And once a month they have an open stage. Open: Tues-Thurs 17-1; Fri 17-3; Sat 11-3; Sun 17-1. (Map area E8)

Manege - Vondelstraat 140, 7 618-0942

www.dehollandschemanege.nl

I'd always heard that this riding school had a great café with cheap drinks and snacks. It's true. Vondelstraat runs alongside Vondelpark (see Parks, Hanging Out chapter). Walk through the arch under the huge lamps and enter the school via the big doors. The café is through the door on the left and up a grandiose stairway. There's a balcony with tables overlooking the training area, but if you find the horsey aroma a bit much, you can still see through the windows of the main room of the café. It was formerly very elegant and is now filled with cats. If you're coming from the park, take the exit near the Film Museum. Open: Mon-Fri 14-23 (Wed open at 10); Sat 10-17; Sun 10-17. (Map area A7)

East of Eden - Linnaeusstraat 11A, 2 665-0743

This spacious café is right across the street from the Tropenmuseum (see Museum chapter) and around the corner from the Dapper market (see Shopping chapter). The seating is a mish-mash of couches and easy chairs, and lots of light comes in through the high windows on two sides. It's warm and mellow in the winter, and in the summer you can sit out on the sunny terrace. Open: Sun-Thurs 11-1; Fri-Sat 11-2. (Map area H7)

De Roos (The Rose) - PC Hooftstraat 183 (entrance in Vondelpark), 🏗 689-5477

www.roos.nl

If you're into "creative and spiritual growth" or alternative health care, this center might interest you. It's located at the edge of Vondelpark and is home to a new-age shop, practitioners' rooms and a pretty tearoom. They offer a lunch menu from 12 to16:00 that includes affordable soups, sandwiches, salads, and homemade cakes and pastries. Drinks are also low-priced, making it one of the best deals in this ritzy neighborhood. On weekdays, dinner is served from 17:30 to 20:00. Order downstairs and then take your tray up to the plant-filled solarium where classical music floats in from the adjacent shop. Check the bulletin board for info about events in the community or talk to the staff at the reception desk. Tea-room open: Mon-Fri 9:30-20: Sat-Sun 9:30-16. (Map area B7)

Café Restaurant Noorderlicht - NDSM Werf, T.T. Neveritaweg 15, Amsterdam North,

2 065-059-0958

www.noorderlichtcafe.nl

The original version of this café was cute as hell – until it burned right down to the ground. It's been rebuilt and encased in a transparent shell that keeps things nice and warm in winter and is easy to

open up in the summer. It's way out at the happening NDSM Wharf (see Music chapter) and has a fantastic view over the water and the industrial terrain. *Tostis*, sandwiches, *uitsmijters* and daily specials are all available at a reasonable price. You can also expect all kinds of music, art exhibitions and lively parties. Noorderlicht is a really cool place to hang out when you need to re-fuel. Open: Sun-Tues-Thurs 11-23; Fri-Sat 11-1.

Café de Molli - Van Ostadestraat 55, 2 676-1427

www.molli.nl

This is a volunteer-run café with an emphasis on politics in a building squatted over 25 years ago. They frequently host theme nights with videos and speakers on subjects such as genetically-modified food and the role of Shell Oil (those murdering motherfuckers) in Nigeria. On Tuesday nights at 19:00 they serve super-cheap meals (see Restaurants, Food chapter). On other nights it's just a mellow place to hang out and meet some people. Drinks are very cheap. Tea is free. They also have a feminist café where a vegetarian meal is served every second Wednesday of the month. On Friday nights they show movies. Open: Sun-Fri 21-1.

Dackstage Boutique and Coffee Corner - Unechsedwarssman 67, 22 622 3638

Greg, one of the Christmas Twins (identical twins that were big stars back in the US), died some years back, and he is missed by many, many people. But his brother Gary is still running the Pee Wee-esque café they built together, and its unique atmosphere endures. This place is great! They serve coffees, teas, juices and an assortment of sandwiches and cakes. The bottom of the menu proclaims: "Mama wanted girls!" The walls are decorated with wild sweaters and hats that were designed and made by the twins. If you're lucky, you might even walk out with a souvenir postcard. Gary is super friendly and very funny. Open: Mon-Sat 10-17:30. (Map area E7)

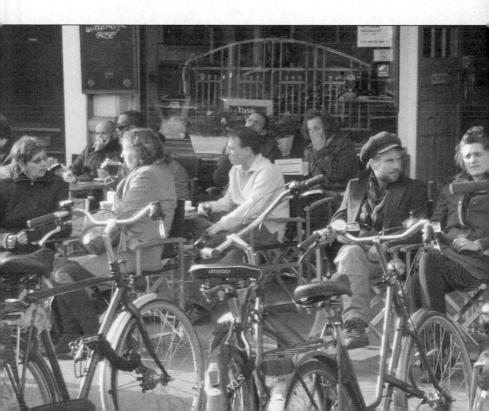

Cannabis

n Amsterdam, you can walk into any "coffeeshop" (a café selling marijuana and hashish) and order a coffee and a joint, then sit back and smoke, listen to music, perhaps have a game of backgammon or chess – without having to worry about being arrested. How civilized!

Almost all coffeeshops have a menu listing the types of smoke available and where each one is from. It's fun to try grass and hash from different parts of the world, but the *nederwiet* (Dutch grown weed) is in a class by itself in terms of getting really high. Prices are usually listed by the gram but the weed is sometimes sold in set-price bags of €10. Some coffeeshops will let you buy smaller amounts, too. Don't be afraid to ask to see the menu: it's there to make it easy for you.

Some strains are listed as "hydro," meaning they were grown hydroponically. Others are listed as "bio," meaning they were grown in soil. Note that "bio" in this case doesn't mean organically-grown – as it does with bio products in grocery stores. However, many coffeeshops are starting to sell organically-grown weed and may list these as bio as well. If you're in doubt, just ask. It's also no problem to ask to see the buds before you buy. Then relax while you roll yourself a number or hit a bong and ponder the absurdity of the repressive and hypocritical "War on Drugs" in North America and the rest of Europe and think about how fantastic it is to be in Amsterdam!

The weed here is probably a lot stronger than what you're used to back home. If you find that a friend of yours is too high, feels a bit sick, or is about to pull a whitey, very often a sweet drink (like an orange juice or a cola) will help bring him or her back. Just thought I'd mention that.

In spite of what some of the tackier shops in the tourist areas might try to imply, you don't have to buy weed every time you go into a coffeeshop, though of course you should buy something – at least a drink or some munchies.

Attention: Don't buy anything on the street! You will definitely be ripped off!

Warning: Space cakes and bonbons containing grass or hash are sold in some coffeeshops. They can be very strong, almost like tripping, so have fun but be prepared for a long, intense high. Also keep in mind that they can take up to a couple of hours to kick in, so don't gobble down another one just because you don't feel anything right away......What?

coffeeshops

Grey Area - Oude Leliestraat 2, 2 420-4301

www.greyarea.nl

This tiny shop is world-renowned for selling exclusive weed strains like Chocolope and Martian Mean Green. It's American-owned and -operated, with a friendly staff that'll gladly let you check out the buds and offers advice like which smoke is uplifting and which fossilizes you. They have a bong bar, free of charge, with choice pieces from ROOR and a Volcano vaporizer. Prices range across the spectrum, but the buds are killer and they give deals - including 1/8ths offered in ziplock baggies. This place gets packed with lines sometimes stretching out the door, but don't be discouraged: the tasty smokeables are worth the wait. Note to pothead punks: the Grey Area is the only Amsterdam coffeeshop regularly playing punk and indie music, from the Ramones to Kings of León. "Hey Ho, Let's Go!" Open: Daily 12-20 (Sometimes closed on Mondays and holidays). (Map area C4)

Amnesia - Herengracht 133, 🏗 427-7874

Situated on a beautiful central canal, Amnesia is a welcoming shop with a splendid sidewalk terrace in warm weather. A friendly staff, a big menu and quality music make this a nice place to have a smoke break while strolling the famous *Jordaan* neighborhood. You can drink a big latte (€ 2,10) and smoke a spliff while grooving to vintage ska and reggae or perhaps some ambient drum and bass. Add Volcano vaporizers and a view of the brothel traffic across the street to all this and you've got the makings of a very fun afternoon or evening. Open: Daily 9-1. (Map area C4)

Basjoe - Kloveniersburgwal 62, 7 627-3858

If you're feeling like a lazy afternoon spent smoking joints, listening to reggae or funk and lounging with a beautiful Amsterdam canal view, then Basjoe's the place. The interior is comfortable and the dudes who run this place are cool and hospitable. They also make an amazing mixed-fruit shake. At €4 it might seem a bit steep, but a smooth mixture of fresh and frozen fruits is lovingly blended at your request. It takes a few minutes, but believe me this yummy vitamin kick is worth it. Besides, you'll be so chilled out that you won't mind. Open Sun-Thurs 10-1; Fri-Sat 10-2. (Map area D5)

The Rookies - Korte Leidsedwarsstraat 145, 🏗 639-0978

www.rookies.nl

Though The Rookies has a neighborhood-bar feel to it, it draws a lively international crowd. This is partly due to its long-standing reputation for being tourist-friendly and for selling good weed and hash, but also because many of the guests from Hotel Rookies (see Places to Sleep chapter) make the coffeeshop their home base while they're in Amsterdam. It's a great spot to kick back, sample the wares and meet other travellers. The shop is well equipped to meet smokers' needs: It was the first coffeeshop in town to sell pure joints, and they have bongs and a vaporizer available for use – just ask at the bar. Since the tobacco smoking ban they've built a plexiglass wall separating the bar (pure weed only) and

cannabis

an adjacent room (tobacco and mixed spliffs). It's kind of a strange atmosphere but you can smoke what you want and remain indoors. In nice weather you can sit out front. Open: Sun-Thurs 10-00:45; Fri-Sat 10-2:45. (Map area C7)

De Rokerij - Lange Leidsedwarsstraat 41, 2 622-9442

www.rokerij.net

Who would guess that in the middle of this touristy strip there's a great coffeeshop selling quality products? The decor in De Rokerij is a mixture of Indian and Nepali motifs, and there are lots of comfortable nooks to settle into while you enjoy the music ranging from spacey to upbeat grooves. It's a popular spot and you can tell that they have a lot of regulars hanging out. On weekends it's packed! My only complaints are that the drinks are pricey, and that they refuse to let anyone wear baseba'll caps – or any sort of headgear – in any of their shops… that's wack. Open: Sun-Thurs 10-1; Fri-Sat 'til 3. (Map area C7)

De Rokerij - Singel 8, 2 422-6643

This Rokerij is one of the nicest coffeeshops in the Centraal Station area. There are African influenced murals on the walls and low cushioned seats that make your ass fall asleep after a bit, so try to grab the padded benches near the door. (For the record, there are also other Rokerijs at Elandsgracht 53 and Amstel 8). Singel branch open: Sun-Thurs 9-1; Fri-Sat 'til 2. (Map area D3)

Dampkring - Handboogstraat 29 / Haarlemmerstraat 44, 2 638-0705

www.dampkring.nl

Even before scenes for *Ocean's 12* were filmed here, the super-funky decor and some killer hash and buds had made the Dampkring a favorite with locals and tourists alike. It can get pretty crowded in here, and if you're looking for a mellow experience the music can be a little loud, but otherwise it's a comfortable shop with friendly, knowledgeable staff. The new Haarlemmerstraat location is a three-storey shop with spacey/chic décor and an amazing neighborhood view from the loungey upstairs room. Unfortunately, this new shop has the ever-increasing lame policy of no hats. Their extensive menu (which they sell as a souvenir) details what type of high you can expect from each of the various strains and includes information on their fair-trade policies as well. Fair-trade cannabis! Only in Amsterdam. Open: Mon-Thurs 10-1; Fri-Sat 10-2; Sun 11-1. (Map area C6) (Haarlemmerstraat: Map area D3)

Tweede Kamer - Heisteeg 6, 2 422-2236

This is a sweet little coffeeshop with the same great menu as the Dampkring. Though the space is small, the shop feels open and inviting. I've also found the staff to be patient and informative with tourists who needed a little time to make up their minds. That's cool. Open: Mon-Sat 10-1; Sun 11-1 (Map area D5)

Siberië - Brouwersgracht 11, 2 623-5909

www.siberie.net

Siberië is a great coffeeshop that caters to an international crowd that appreciates the art exhibitions cool tunes, and of course the terrific variety of smoke in all price ranges. And they also have a computer where you can check your e-mail. Be sure to make time for a walk along the canal where Siberië is located – it's very beautiful. Open: Sun-Thurs 11-23; Fri-Sat 11-24. (Map area D3)

de Republiek - 2e Nassaustraat 1a, 🏗 682-8431

www.republiek.net

This cute shop with connections to Siberië (see above) and Ruigoord (see Festivals, Music chapter) is ar institution in this west-side neighborhood. They've been around for ages, and locals are always dropping by for a smoke and a chat. It's not as busy as Siberië and therefore a little more restful. Upstairs you car check your e-mail. There's also a large assortment of teas, including fresh mint and yogi, and delicious coffee. The prices are good, too. Open: Sun 10-23; Mon-Thurs 9-22; Fri-Sat 9-24. (Map area B2)

Katsu - 1e Van Der Helststraat 70, 2 675-2617

www.katsu.nl

Katsu is a long-standing neighborhood coffeeshop located just off the Albert Cuyp Market in De Pijp. It's got a shabby, homey feel to it, and some wicked grass. They're famous for their Hazes, which give a wonderful cerebral high. Their hash, made with the Ice-O-Later (see Pollinator Co, Shopping chapter), is out of this world. Drinks are reasonably priced, there's a vaporizer, the music is good, and they have a pinball machine. Well worth a visit. Open: Mon-Thurs 11-23; Fri-Sat 11-24; Sun 12-23.

le Supermarkt - Frederik Hendrikstraat 69,

3 486-2497

www.desupermarkt.net

This is another shop in the same family as Siberië and Republiek, but a bit off the beaten track. The Supermarket offers the same products and the same reasonable drink prices – they're one of the few places in town that didn't jack up their prices with the introduction of the euro. There's a computer with free internet access and a big wood table at the front that's warm when the afternoon sun spills in, a tranquil spot to smoke and read a magazine. Hanging by the counter is a diploma certifying that the staff successfully completed "basic cannabis knowledge" at the Cannabis College (see below). Open: Daily 10-23. (Map area A4)

YoYo - 2e Jan v.d. Heijdenstraat 79, 🏗 664-7173

YoYo is a perfect place to spend a mellow afternoon reading or writing while you slowly smoke your joints. The shop is spacious and airy, and in warm weather there are tables out front on a car-free street. You won't find big frosty mega-buds here, but all their weed is organically grown and produces a satisfying, mellow high. As it's a bit out of the center (near Albert Cuyp Market), their prices are low. Buds are sold in €5 and €10 bags. And they might be the cheapest coffeeshop for food and drinks. Open: Mon-Sat 12-19: Sun 16-19. (Map area E8)

La Tertulia - Prinsengracht 312, 2 623-8503

www.coffeeshopamsterdam.com

Plants, flowers and a little fountain give this coffeeshop a tropical feeling, but what I like best about La Tertulia is the outdoor terrace they set up in the summer. It's right at the edge of a busy canal and there are flowers on all the tables. It's easy to find this building: just look for the Van Gogh sunflowers painted all over it. Open: Tues-Sat 11-19. (Map area C5)

Paradox - 1e Bloemdwarsstraat 2, 🏗 623-5639

www.paradoxamsterdam.demon.nl

Not only can you buy and smoke cannabis here, but the Paradox serves up some delicious food in the bargain. Their awesome fruit shakes are a bit expensive, but if you've got the dough they're a real treat. A banana/strawberry shake big enough

to share costs €3.90, and a big glass of fresh-squeezed orange juice is €2.40. They also cook up fresh home-made soup and veggie burgers. The shabby decor is comfortable and warm, and the neighborhood, the *Jordaan*, is particularly beautiful. Open: Daily 10-20, but note that the kitchen closes at 16:00. (Map area B4)

Dutch Flowers - Singel 387, 2 624-7624

www.dutch-flowers.n

A beautiful canal view and a busy little street characterize this shop, located in the city center by Spu Circle. There are jazzy beats on the stereo and a welcome stack of magazines and comics. Their selection of weed and hash is also available in small amounts. Open: Sun-Thurs 10-1; Fri-Sat 'til 2. (Map area C6)

Any Day - Korte Kolksteeg 5, 2 420-8698

The first time I visited this tiny coffeeshop the guy behind the counter welcomed a friend and me with a vaporizer hit before we even had our coats off! Now that's friendly service. For hash heads, a quality selection of clean Morrocan hashhish is available at an affordable price. It's not far from Centraal Station and caters to a local and international crowd. Across the street there's a brothel with girls in the windows. Open: Daily 10-1. (Map area D3)

Kadinsky - Rosmarijnsteeg 9, 2 624-7023

www.channels.nl/kadinsky.htm

This hip coffeeshop is a perfect spot to kick back and smoke that first joint of the day. The music values from rock to reggae to Sinatra – depending on who's working. They've got great discounts on their extensive smoke menu if you buy 5 grams. Delicious cookies and organic apple juice are also on hand It's located on a little street near the Spui, and Kadinsky also has tiny shops at Langebrugsteeg 7 and Zoutsteeg 14. Open: Daily 10-1. (Map area D5)

The Bluebird - Sint Antoniesbreestraat 71, 2 622-5232

www.coffeeshopbluebird.n

The huge old menu at the Bluebird was famous for its variety and the creative way it was displayed Current laws (see below) have forced them to cut back some on the breadth of the selection, but the quality of their wares remains high. The only problem with the Bluebird is that it's small and often get way too packed. Open: Daily 9:30-1. (Map area E5)

Greenhouse - Oudezijds Voorburgwal 191, 🏗 627-1739

www.greenhouse.org

Little lights embedded in the walls gradually change color, and the ceiling, tables and washroom wall are encrusted with sea shells. I'm not sure whether it's the decor or the good weed that draws them but the list of celebrities who've visited this popular shop just keeps on growing. Sometimes it get too crowded in here, but mostly it's an agreeable place to while away some time, especially if you can snag a seat out front on a sunny summer day. If you like their weed you can buy their seeds at the Greenhouse Seed Company (Langebrugsteeg 13). A new roomier Greenhouse is open on Haarlem merstraat with a fish tank under the see-through floor, Egyptian style hieroglyphic wall art and a wide breakfast and lunch menu. Open: Sun-Thurs 9-1; Fri-Sat 9-3 (Map area D5)

The Otherside - Reguliersdwarsstraat 6, 🕿 421-1014

www.theotherside.n

As it's located right in the heart of the gay ghetto, it's mostly men that come here, but women are alswelcome. It's a friendly spot and it's easy to meet people. The only drawback is the dance music that' sometimes played way too loud. Open: Daily 11-1. (Map area D6)

Tweedy - Vondelstraat 104, 🏗 618 0344

www.tweedy.n

Tweedy sits at the edge of Vondelpark just across the street from the Vondel Church. I find it a pleasar place to get stoned, and I especially enjoy sitting at the back in one of the three train compartment complete with overhead luggage racks full of magazines and backgammon sets. They also have a poctable and a good selection of candy bars. Open: Daily 11-24. (Map area A7)

www.420cafe.com

A slightly older crowd hangs here because of the classic rock on the sound system. The shop is clean, comfortable and tourist-friendly, and they don't even mind if you bring in some take-out food. There's a good selection of smoke on offer and it's one of those places where it's always 4:20. Open: Sun-Thurs 12-1; Fri-Sat 12-3. (Map area D4)

Barney's - Reguliersgracht 27, Haarlemmerstraat 102

www.barneys.biz

While I like the original Barney's on Haarlemmerstraat, when I want to smoke a jay and hang out I head for this newer branch. The space has been completely renovated and features soothing colors on the walls, comfortable chairs and Volcano vaporizers. They sell the same high quality buds, like Utopia Haze and Blue Cheese, here like Barney's other locations, plus the usual assortment of coffees, juices and shakes – but no food. There is also a giant screen on one wall – nice if you like to get high while watching films or World Cup football games. Open: Daily 9-1 (Map area D7) (Haarlemmerstraat: D3)

Abraxas - Jonge Roelensteeg 12, 2 625-5763

www.abraxasparadise.nl

The three floors of this old house each have their own style and ambience. Sitting in the uppermost room feels like you're visiting an elf's treehouse (though that floor's not always open). The second floor has lots of couches for lounging about, and the ground floor has an Arabian-style chill room and, near the bar, computers with free internet access. Abraxas serves the usual assortment of drinks, plus hash shakes, hash coffee, and weed tea. Several DJs work here, so the music is usually interesting. It also gets very crowded. Open: Daily 10-1 (in summer 9-1). (Map area D5)

De Overkant Hortus - Nieuwe Herengracht 71, 🏗 620-6577

This shop is located right across the canal from the Botanical Gardens (see Museums chapter) and close to the Waterlooplein market (see Shopping chapter). It's a small shop with a simple, uncluttered interior – so simple, in fact, there aren't any chairs! I guess they don't want anyone hanging around. But smoking a joint here and then exploring the Gardens is a great way to spend an afternoon. Open: Daily 10-24. (Map area F6)

Dolphins - Kerkstraat 39, 2 625-9162

This split-level shop sells its wares in small paper bags that read: "This bag is earth and dolphin friendly" and "Don't mix this with alcohol"! There's free WiFi and you can smoke mixed spliffs or cigarettes in the downstairs den. Upstairs is pure weed and hash only. The music can be a bit too Top-40 for my taste, but this is a good shop for a clean piece of Moroccan hash or a quick smoke while in the Leidseplein area. Open: Sun-Thurs 10-1, Fri-Sat 10-3 (Map area C6)

Happy Feelings - Kerkstraat 51, 2 639-1154

www.happyfeelingsamsterdam.nl

Happy Feelings is Amsterdam's first automated coffeeshop. Machines with drinks (chocolate milk €1.50, coffee €2.00) are set against the back wall, and even papers are sold out of a machine. The dealer, however, is real and although the menu can vary in quality, tasty smoke like Diesel Haze is also available. He'll gladly let you have a look at the buds and the bags are weighed to order. Although this shop is centrally located, it's a family-run business and has an unpretentious feel. If you need a break from the bustling Leidsestraat, Happy Feelings is a nice stop. Open daily: 13-1 (Map area C 6.7)

Amsterdam Coffeeshop Directory

www.coffeeshop.freeuk.com

With over 1000 pages of info about Amsterdam's soft drug scene, this website is a great place to find out more info about the coffeeshops I recommend, as well as many others. It's been online since 1998 and features photos, reviews, maps and more.

seeds and grow shops

There are numerous reputable places to buy seeds around town, but over the past few years a lot of fly-by-night companies have also appeared, selling inferior products. The best companies have spent years developing their strains in order to produce a stable, reliable seed. I've listed a few of them below. Remember that while it's legal to buy cannabis seeds in the Netherlands, it's illegal to import them into most other countries. You've been warned.

T.H.Seeds - Nieuwendijk 13, 2 421-1762

www.thseeds.com

Hemp Works (see Hemp Stores, below) sells its own in-house line, T.H.Seeds. They've been in business since 1993 and are well respected amongst growers in the know. Strains available include the incredible Sage 'n Sour, Kushage, Rambo and their delicious resiny MK Ultra. Make your purchase during their 4:20 happy hour, mention *Get Lost!* and get 10% off! That's also when you're most likely to find Adam, their resident seed expert, in the house. He knows a fuck of a lot about growing and is happy to share his knowledge. Open: Daily 12-19. (Map area D3)

Sensi Seed Bank - Oudezijds Achterburgwal 150,

624-0386

www.sensiseeds.com

The people who brought you the Hash Marijuana Hemp Museum run this business too. You'll find everything you need for growing on sale here, starting with seeds. Some of the seed prices may seem a bit high, but they have proven genetic quality and that attracts a lot of professional growers. They're always big winners at the Cannabis Cup Awards (see below). You can also buy Sensi Seeds at their museum, and at their new shop (the old Sensi coffeeshop) nearby on Oude Doelenstraat 20. They also have a small outlet near Centraal Station at Nieuwendijk 26. Open: daily 10-23. (Map area E5)

DNA - Sint Nicolaasstraat 41, 778-7220

www.dnagenetics.com

DNA (Don 'N' Aaron) has earned a reputation as one of Amsterdam's premier breeders. Along with notorious cannabis strains like Martian Mean Green and L.A. Confidential they stock several othe outstanding seed varieties. The centrally located shop is a welcoming place with a curved bar-style counter and a fresh-water fish tank built into the back wall. Along with the seeds DNA sells T-shirts hoodies, hemp caps and various bongs and glass pipes. They have grab bags for €5 that are guaranteed to hold at least €10 worth of DNA merchandise. One in five bags have seeds. You can drop by and have a chat or a smoke − these guys are seriously knowledgeable about their award-winning strains. They also can recommend which types of cannabis are good for various ailments. Sometimes they bust ou the ping-pong table and stoney tournaments ensue. If you're really lucky you'll get to try some of Don's mom's vegan potato salad. Yum! Open: Daily 12-6. (Map area D4)

Pollinator Company - Nieuwe Herengracht 25, 2 470-8889

www.pollinator.nl

This inviting shop caters to almost all your pre- and post-harvest needs, but their specialty is the manufacturing of hashish. To this end, owner Mila Jansen invented the amazing Pollinator, and the incredible Ice-O-Lator. Her latest invention is The Bubble-ator, the ultimate tool for cold-water crystal extraction. It's un-fucking-believable how good the hash is that this simple-to-use device makes from marijuana shake and other plant discards. Mila's also selected seeds from several top seed companies of what she believes are some of the world's best strains to use for making hashish, and these are all available here. Cool. Inside the door on your right (and on-line) is the Hall of Fame, a display of hash from around the world. They also sell books, hemp products, smoking accessories, vaporizers, and – as the space is shared by the Botanic Herbalist – psychoactive plants (see Smart Shops, Shopping chapter). Open: Mon 12-19; Tues-Fri 11-19, Sat 12-19. (Map area E6)

Sagarmatha Seeds and Psychedelic Gallery

www.highestseeds.com

This company's motto, "highest on earth," refers in part to their name: Sagarmatha is what they call Mount Everest in Nepal. The 100% organically-produced seeds they sell are aimed at connoisseurs who will appreciate the end result. They sell some very tasty seed strains including Bubbleberry and Yumbolt.

Soma Seeds

www.somaseeds.nl

Over the years, I've had the pleasure of smoking several varieties of weed grown from Soma's organically-bred seeds – absolutely delicious. They're available on-line and around town at places like the Seed Boutique (see below).

The Flying Dutchmen - Oudezijds Achterburgwal 131, 🏗 428-4023

www.flyingdutchmen.com

This company sells its seeds from a easy-going shop with the same name which is located in the Red Light District just across the canal from the Cannabis College (see box). You can choose from the Flying Dutchmen's own line, or from one of the other companies' products that are also available here. And check out their impressive selection of glass pipes. Open: Daily 11-19. (Map area E5)

hemp stores

Hemp Works - Nieuwendijk 13, 🏗 421-1762

www.hempworks.nl

This hemp store sells designer clothing it calls "industrial organic wear." Most of the clothes in stock – jeans, dresses, shirts, hoodies and more – carry their own label and include classy, unique touches like their patented sewn-in rolling-paper dispensers. Their popular winter coat, The HoodLamb, even has secret-stash, iPod, and PSP pockets. (Snoop Dog has one, but his is bulletproof.) Several artists, like NYC's Stash, have custom-painted garments, one-of-a-kind pieces that adorn the shop and will eventually be auctioned. Hemp skate-shoes from IPATH are available here, made entirely of sustainable materials with bonus features like coconut honeycomb soles and stash pockets. Other labels stocked here include KanaBeach, Livity, and Hemp Valley. They also sell a wide variety of hand-blown glass pipes, grinders, and a choice selection of knick-knacks that make good gifts for discerning smokers back home. You'll also find flyers for clubs and parties and information about coffeeshops, all displayed against a backdrop of hemp walls and tripped-out tunes. Open: Daily 12-19. (Map area D3)

Pollinator Company - Nieuwe Herengracht 25, 2 470-8889

www.pollinatorcompany.com

This shop really is unique. As if all the other great stuff available here isn't enough (see Grow Shops, above), they're also well stocked with hemp products: food (try the delicious hemp-burger mix), oils, clothing from Euro-American Marketing (www.hemp-amsterdam.com), and lots more. Open: Mon-Sat 11-20. (Map area E6)

Hempshopper - Nieuwezijds Voorburgwal 80, Singel 10; 🏗 528-5556

These guys have crammed everything associated with hemp and cannabis into one shop, with a vast selection of seeds, clothes, soap, papers, tea, backpacks, literature, lollipops – the list is endless – on sale here in this hemp-shopper's mini-emporium. The Nieuwezijds shop is quite small and filled to the rafters like a green version of some stuffed Turkish market stall. The guys who run this place are cool and informative. Both shops are centrally located. Singel: Open: Daily 10-22; Nieuwezijds: Open: Mon-Fri 10-20; Sat-Sun 10-22. (Map area: D4, D3)

cannabis competitions

High Life International Hemp Fair - Mid-January

www.highlife.nl

This annual celebration of all things cannabis has been around for more than 10 years. And it's big: The three-day hemp fair was most recently held at the giant RAI convention center (Europaplein 22) where there were thousands of visitors and over 100 booths from a dozen countries. The High Life awards given to coffeeshops and seed companies for the best weed and hash from the past year's crops, happen on the first night – and then it's party time. Tickets cost €15 per day.

420 Grower & Breeder Cup - April 18,19... and 20 (of course)

www.icmag.com/ic

It's been a bit of a bumpy start for the organizers of this cannabis competition, but the G&B Cup is still a young event and each year sees more participants and greater improvements. The main focus is or the growers and breeders rather than seed companies and coffeeshops, but the three-day event also includes parties and entertainment. Judging passes cost €215 to €255, which apparently come with a shitload of weed for your personal edification, and there are day passes available for €30.

www.hempcity.net

Okay, it's not in Amsterdam, but Haarlem is only 15 minutes away by train. And with contests that include joint rolling, hash cutting, and speed vaporizing, this one is worth the trip. Victors are awarded gold, silver and bronze medals. It takes place over a weekend in October at the three coffeeshops owned by the organizer, and it costs only €25 to be a judge or €10 for entrance to their harvest party.

High Times Cannabis Cup - Third week of November

www.cannabiscup.com

If you're visiting Amsterdam during American Thanksgiving week (the prizes are awarded on Thanksgiving night), check out the Cannabis Cup Awards. *High Times* magazine hosts this annual marijuana harvest festival. It's mainly an American affair that celebrates the Dutch weed-growers with several days of cannabis-related events that culminate in the actual awards given for the best strains of grass and hash, best seed companies, and best coffeeshops. There are related parties around town every night, often with hot bands playing, and an award ceremony grand finale at the Melkweg. There's also a Hemp Expo that's definitely worth a visit. Judges' passes bought in advance are \$200 US, but day-passes to the Expo are only €10 − well worth it for the amount of free smoke on offer. I got a free nugget of the Chiesel at the last cup, two months before its coffeeshop debut. Amazing!

a note on drugs in Amsterdam

When it comes to cannabis, Holland leads the western world in progressive thinking and action: Soft drugs like cannabis and hashish have been decriminalized for almost 30 years. Small amounts of these harmless substances can be bought, sold, and consumed without interference by the police.

Trafficking in hard drugs is dealt with seriously, but addiction is considered a matter of health and social well-being rather than a criminal or law-enforcement problem. The number of addicts in Holland – where they can receive treatment without fear of criminal prosecution – is much lower than in other countries where the law is used to strip people of their human rights (not to mention their property).

Along with the U.S., some member states of the European Union

are putting pressure on Holland to conform to their own repressive drug laws. This has resulted in the introduction of new drug policies that, while still more liberal than elsewhere, reflect a regressive trend in the Dutch authorities' thinking.

The Cannabis College (O.Z. Achterburgwal 124; 423-4420; www.cannabiscollege.com) is a non-profit organization formed a decade ago to educate the public about the cannabis plant and all its uses. Volunteers who run the college are dedicated to ending the insane and unreasonable punishments inflicted throughout the world on those who choose, for whatever reason, to use cannabis. They're located in a 17th-century canal house. Stop in to look at the exhibits and see what events are going on. If you want to visit their beautiful garden in the basement, they ask for a suggested donation of €2.50, which is used to help fund the college. Open: Daily 11-19, and possibly longer in summer, shorter in winter. (Map area D5)

tores in the parts of Amsterdam designated as "tourist areas" – most of the Centrum, that is – are now allowed to open on Sundays. Some, however, still hold to tradition and lock their doors from 17 or 18:00 on Saturday until after lunch on Monday. Thursday night is *koopavond* – shopping evening – in Amsterdam, and the streets and stores are bustling 'til 21:00.

Areas particularly popular with shopaholics are: the Kalverstraat & Nieuwendijk – car-free and crowded with big chain stores (map area D5-4); the *Negen Straatjes* (Nine Streets) – nine charming little streets filled with small independent boutiques that are gradually being forced out by gentrification (map area C5); and the Haarlemmerstraat & Haarlemmerdijk, just west of Centraal Statior – pleasant, busy, and full of shops and cafes.

markets

Albert Cuypmarkt - Albert Cuypstraat (between Ferdinand Bolstraat & Van Woustraat)

www.albertcuypmarkt.com

It's big and it's great! Amsterdam's most famous market is crowded with stalls and shoppers. You'll find everything here, from fruit and veggies to clothes and hardware. There's one guy selling warm, freshly made *stroopwafels*, a thin, chewy, syrupy cookie of love – the ultimate sweet Dutch experience. Blank CDs are cheap here. Underwear is a good deal, and so are plain cotton T-shirts (if yours are getting smelly) Just remember that at many of the stalls you don't pick your own fruit and some of the vendors are ask holes who will routinely slip a couple of rotten pieces into each bag. This happens to tourists and Dutch shoppers alike, so don't take it personally and don't be afraid to complain. To pick your own produce, shop at the Turkish stores that are found around most markets. Open: Mon-Sat 9-16. (Map area E8)

Organic Farmers' Market - Noordermarkt

www.boerenmarktamsterdam.nl

The Organic Farmers' Market is open on Saturdays from 9 to 16:00. Its location at the foot of the Noorderkerk (North Church, Map area C3) lends a medieval feel to this fantastic organic market. The booths sell healthy produce and other products, used records and books, second-hand clothing, bric-a-brac and antiques. There's a playground for kids and an organic pancake stand to keep their little bellies full. There are lots of free samples, and street musicians often perform. Right around the corner, on the same day, is the Lindengracht market (see below). Another organic market that also takes place on Saturdays can be found in the Nieuwmarkt (see Public Squares, Hanging Out chapter) from 9 to 16:00.

Lindenmarkt - Lindengracht

This is an all-purpose market that's a bit more expensive than Albert Cuyp but still has some good deals. It's in a beautiful neighborhood right around the corner from the Organic Farmers' Market (see above). An easy way to get to this and the Noordermarkt is on the *Opstapper* mini-bus from Centraal Station, Waterlooplein, or anywhere along the Prinsengracht (see Public Transport, Getting Around chapter). Open: Sat 9-15. (Map area C3)

Noordermarkt - Noordermarkt

This is the ideal destination for die-hard shoppers who are frustrated by all the shops closing on Monday morning. Here there are new and used clothes, books, records, and lots of junk: great for bargain hunting. After it closes you can often find good stuff in the garbage. And just for the record, there have been markets at this location since 1627. Open: Mon 9-14. (Map area C3)

Dappermarkt - Dapperstraat

A lot of immigrants from North Africa and the Middle East shop at this all-purpose market – the cheapest in Amsterdam. There's also an Egyptlan guy there who sells tasty falafold. It's close to Qosterpark (see Parks, Hanging Out chapter), the Tropenmuseum (see Museum chapter), and the windmill (see IJ Brewery, Bars chapter). Open: Mon-Sat 9-16. (Map area H7)

Ten Kate Market - Ten Katestraat

It's a bit out of the way for most tourists, but if you're in the area, pay a visit to this lively neighborhood market. Kinkerstraat, the main shopping street running by Ten Katestraat, lacks much charm, but the streets and canals behind the market are pretty. It's near the Kashmir Lounge (see Bars chapter) and the sublime Planet Rose (see Restaurants). Open: Mon-Sat 9-17. (Map area A6)

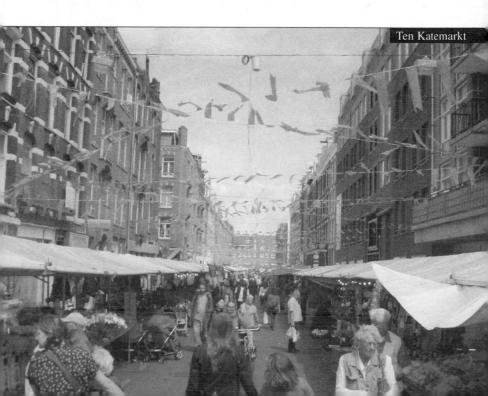

Waterlooplein Market - Waterlooplein

This square is home to a terrific flea market where you can find new and used clothes, jewellery, turntables, spray paint and all kinds of junk. There's a great stall near the market's waterside selling navy/airforce surplus and used shirts, jackets and hoodies. You can replenish your wardrobe here for cheap. It's easy to spend a couple of hours wandering around, and unlike other Amsterdam markets you can try bargaining. Open: Mon-Sat 10-17. (Map area E6)

Flower Market - Singel

This pretty market is full of flowers and plants sold from barges on the Singel canal between Koning-splein and Muntplein. Cut flowers are a good deal, but in recent years the quality of tulip bulbs sold here has gone way down. And nowadays you can probably get them just as cheap at home. But even if you're not planning on shopping here, it can be an interesting market to wander through despite the fact that it's ultra-touristy. (Map area D6)

IJ-Hallen - NDSM Werf - T.T. Neveritaweg 15, Amsterdam North

www.ij-hallen.nl

Serious bargain hunters arrive early at this giant flea market in order to get the best deals. But with over 600 stalls selling practically anything you can think of, good finds can be made throughout the whole day. I once scored a vintage pair of shades here for 50 cents! The free ferry you have to catch to get here leaves regularly from behind Centraal Station and takes about 10 minutes. It's a fun trip. When you need a break from the crowd at the market, grab something to eat at the Noorderlicht (see Cafes), or check out the Skatepark (see Hanging Out chapter). The market takes place over the first weekend of every month – inside in winter, outside in summer – from 9-16:30. Admission is €2.50.

books and magazines

Book lovers will have a great time in Amsterdam. There are tons of new and second-hand bookstores that sell mainly English titles, and browsing for European editions can be rewarding and fun. If you're here in May, be sure to look into the Amsterdam Literary Festival (www.amsterdam-literaryfestival.com), a multi-day celebration that showcases both local and international authors inspired by Amsterdam. It takes place in interesting venues around town and includes readings, workshops and parties. Another exciting development on the Amsterdam literary scene is the Britlit series of talks (www.britlit.info) by such well-known British authors as David Mitchell and Jeanette Winterson. These readings are very popular so be sure to reserve in advance.

The American Book Center - Spui 12, 2 625-5537

www.abc.nl

This multi-level store is one of the largest English-language book sources in Europe. Everyone who works here is knowledgeable, and they all seem to really care about what goes on in their workplace. They stock a lot of hard-to-find items as well as all the best sellers. They also carry a large array of magazines, comics and toys, as well as a few shelves of American junk food for those pathetic souls who actually crave Butterfingers (guilty as charged). This is one of the cheapest bookstores in Amsterdam, especially for students, who get a 10% discount. Non-students can buy a discount card valid for one year entitling the user to 10% off every purchase, including their big discount section. While you're here, pick up a free copy of Amsterdam Weekly and The Amsterdam Times (see Practical Shit chapter). The American Bookstore also hosts an interesting project called the ABC Treehouse in a small gallery, nearby, (Voetboogstraat 11; www.treehouse.abc.nl) where volunteers from the bookstore present au thor lectures, writers' workshops, and – on the last Friday of every month – a lively open-mike night Bookstore open: Mon-Sat 10-20 (Thurs 'til 21); Sun 11-18:30. (Map area D5)

Waterstone's Booksellers - Kalverstraat 152, 7 638-3821

www.waterstones.com

This august but bustling British bookstore chain has its Amsterdam outlet on the Spui square at the corner of the Kalverstraat. There are four levels stuffed with books of all sorts, from current best sellers to the classics, and the store offers frequent readings and authors' talks in a cozy space on the top floor. If they haven't got the book you desire in stock they'll order it for you if necessary. Next to the English language newspaper rack inside the front door are always *Amsterdam Times*, *Amsterdam Weekly* and other local newspapers. Open: Tues-Sat 10-18 (Thurs 'til 21); Mon-Sun 12:30-18 (Map area: D5.6)

The Book Exchange - Kloveniersburgwal 58, 🏗 626-6266

There's none of that mustiness one associates with so many used bookstores in this clean, well-organized shop where you're bound to find something of interest. They have a big travel section with both guides and literature, and there's a German and French section, too. If you have some books to sell, they pay some of the fairest prices in town. Open: Mon-Sat 10-18; Sun 11:30-16. (Map area E5)

Kok Antiquariaat - Oude Hoogstraat 14-18, 2 623 1191

www.nvva.nl/kok

This is another pleasant used bookstore with a lot of English titles. It's spacious and well organized: English literature is upstairs. Open: Mon-Fri 9:30-18; Sat 9:30-17. (Map area D5)

De Slegte - Kalverstraat 48-52, ☎ 622-5933

www.deslegte.nl

Some good deals on remainders can be found at this big store on the Kalverstraat, a long, car-free shopping street. It lacks the charm of Kok Antiquariaat (see above), but upstairs you'll find a huge selection of used books, many in English. (A friend of mine found a rare Philip K. Dick novel for €4). Open: Mon 11-18; Tues -Fri 9:30-18 (Thurs 'til 21); Sat 9:30-18; Sun 12-17. (Map area D5)

The English Bookshop - Lauriergracht 71, 🏗 626-4230

www.englishbookshop.nl

Thanks to the hard work of its friendly new owner, this pretty bookstore is finally living up to its full potential as a literary hangout. Book clubs and writers' groups meet here, and there are also regular poetry and prose readings. Upstairs there's a select collection of contemporary and classic works. Downstairs they have a fine selection of children's books, and it's a great place to pick up a souvenir for little ones back home. It's located on a corner overlooking the Laurier canal and it's just two short blocks from the Elandsgracht, a charming shopping street. Open: Tues-Sat 11-18 (Thurs 'til 20). (Map area B5)

Evenaar - Singel 348, 🏗 624-6289

http://travel.to.evenaar

This travel bookshop has a fascinating collection of works organized by region and including guides, journals, novels, history and political analysis—many by lesser-known authors. Worth visiting for a browse if you're travelling onward from Holland. Open: Mon-Fri 12-18; Sat 11-17. (Map area C5)

Athenaeum Nieuwscentrum - Spui 14, 🏗 624-2972

www.athenaeum.nl

For new magazines and international papers, this is one of the best stores in Amsterdam. Check the bargain bin at this news shop on Spui Circle for cheap mags – old music magazines sell here for 50 cents to €2. Athenaeum's sister bookstore next door is excellent and carries a fair number of English titles. Open: Mon-Sat 8-20 (Thurs 'til 21); Sun 10-18. (Map area D5)

The Bookshop - Leidsestraat 106, 2 624-0002

This shop also has a big inventory of English-language magazines and daily newspapers from exotic, faraway lands like England and America. They're open early if you want to grab a paper and catch up on the news from back home over breakfast. They also sell snacks and postcards. Located right by the Leidseplein. Open: Mon-Fri 7:30-22; Sat-Sun 8:30-22. Map area (B7)

De Boekenboom - Spuistraat 230

De Boekenboom is like a San Francisco-style beat bookstore in the heart of Amsterdam. There's a well picked used selection of William Burroughs, Henry Miller and Aldous Huxley, to name a just a handful. A big poster of beat granddaddy Burroughs, pistol in hand, guards the front door. Dusty, cool and owned by a passionate collector. Next door to Wolf and Pack (see Shopping, Miscellaneous.). Open: Whenever the owner's not off restocking his supply. (Map area: C5)

Vrolijk - Paleisstraat 135, T 623-5142

www.vrolijk.nu

This shop just off Dam Square advertises itself as "one of the biggest and best-known gay/lesbian bookshops in Europe." Along with the books they stock DVDs, magazines and postcards. If you're looking for something in particular, the staff is helpful. Open: Mon 11-18; Tues-Fri 10-18 (Thurs 'til 19); Sat 10-17; Sun 13-17. (Map area D5)

Intermale - Spuistraat 251, 🏗 625-0009

www.intermale.nl

In case you couldn't tell from its name, this is a gay bookstore. It's a nice space with a good selection of books, magazines and movies. You can pick up gay guides to countries all around the world, an out-of-print book of photos by Larry Clark, or Bruce LaBruce's latest DVD. Open: Mon 11-18; Tues-Sat 10-18; (Thurs 'til 21). (Map area C5)

Book Traffic - Leliegracht 50, 🏗 620-4690

The owner of this used bookshop's got lots of English books and sometimes puts a bargain bin out front. There are a few other used bookshops located on this beautiful canal as well. Open: Mon-Fri 10-18; Sat 11-18; Sun 13-18. (Map area C4)

Het Fort Van Sjakoo - Jodenbreestraat 24, 🏗 625-8979

Het Fort specializes in "libertarian and radical ideas from the First to the Fifth World and beyond." This volunteerrun shop has political books from around the world, a whole wall of fanzines and magazines, and lots of info on anarchism and squatting. They've got cheap new and used records and CDs, mostly punk and hardcore, plus cards, stickers and shirts (www.silly-screens.org). On the wall by the front door there's a list of squats that serve meals. The basement houses a T-shirt shop. Het Fort is open: Mon-Fri 11-18; Sat 11-17. (Map area E6)

would you buy an anarchist book from this man?

Muzikat - St. Antoniesbreestraat 3G, 2 320-0386

You'll find this unique little shop that specializes in music books hidden away on an ugly stretch of road near the Nieuwmarkt. Its shelves are full of biographies, lyrics, photo books, and histories of bands and genres. There are also some magazines and posters and a couple of crates of vinyl. Who knows, you just might find that Moon Dog biography.

or Serge Gainsbourg interview you've been looking for. Across the street at number 64 is a cool vinylonly shop called Record Friend, with over 20,000 new and used records. Muzikat open: Tues-Sat 12-18. (Map area E5)

Henk Lee's Comics & Manga Store - Zeedijk 136, 2 421-3688

www.comics.nl

Located in Amsterdam's tiny Chinatown, Henk's store is stuffed full of comics, toys, trading cards and DVDs. Thousands of used records filter through here – hours worth of digging, especially if Henk lets you in the crammed basement. His specialty is *manga*, so you can find it here or look into the bookshop in the basement of the Japanese-owned Hotel Okura (Ferdinand Bolstraat 333; 679-9238). Honk Lee open: Mon-Sat 11-18 (Thurs 'til 21); Sun 12-18. (Map area E4)

Lambiek - Kerkstraat 132, 2 626-7543

www.lambiek.net

This is the oldest and most famous comic store in Amsterdam. Lambiek carries a huge selection of new and used books, both mainstream (though not superhero) and underground, as well as a lot of collectables like first editions and signed posters. It's interesting to look over all the European comics and graphic novels, but they ain't cheap. Check out their on-line "Comiclopedia" for a treasure trove of cornic-lore that contains entries on more than 7,000 artists. Open: Mon-Fri 11-18; Sat 11-17; Sun 13-17. (Map area C7)

Vandal Com-x - Rozengracht 31, 7 420-2144

www.vandalcomx.com

Definitely check this place out if you're into action figures: they've got them from floor to ceiling. You can find everything from Radioactive Cornholio to Nightmare Before Christmas to Judge Dread. (Another good place for TV and film toys is Space Oddity. It's just around the corner at Prinsengracht 204.) Vandal also sells trading cards, shirts, and more. The comix are at their other shop a few doors down the street. This is where I pick up my Freak Brothers. Open: Tues-Fri 11-18; Sat 11-17; Sun 12-17. (Map area B5)

Cultural - Gasthuismolensteeg 4, 🏗 624-8793

This hole-in-the-wall bookstore has a few shelves of English paperbacks and a few piles of old *Lifes* and other magazines from the 1950s and '60s. They cost only a couple of euros. You can even find '60s newspapers published by the Black Panther Party. It's not far from Dam Square, so you might pass it while wandering in this attractive area. Open: Mon-Sat 11-18. (Map area C5)

Oudemanhuis Boekenmarkt - Oudemanhuispoort

This little book market is situated in a covered alleyway that runs between Oudezijds Achterburgwal and Kloveniersburgwal in the neighborhood of the university. Used books and magazines in several languages are spread out on tables and stands. There are also maps, cards and, occasionally, funny pornographic etchings from centuries past – just a couple of euros each. In the middle of the hall there's an entrance to a pretty courtyard with benches where you can rest your legs. Open: Mon-Fri 11-16. (Map area E5)

Devotees of crime fiction freak when they visit Alibi. It's wall-

Alibi - Willemsstraat 21, 🏗 625-0676

www.crime.nl/alibi

to-wall crime, thrillers, suspense, and more crime. There's a huge selection of both new and used English books, and the owner is happy to help if you're looking for something special or just need a suggestion. She can also show you books by Dutch writers translated into English. Fans of the genre meet on the premises every Sunday at 16:00 for an afternoon of "crime and wine" where they can catch a buzz and then stalk others who share their literary interests. Open: Tues-Fri 11-18; Sat 11-17; Sun 12-17. (Map area C3)

records and cds

Many of my favorite record shops have shut their doors and gone on-line, which I find a shame. Nothing is more satisfying than fingering your way through a fat row of records and finding that elusive gem – and there are still a few fine shops around to satisfy vinyl junkies and import fetishists.

Concerto - Utrechtsestraat 52-60, T 623-5228

www.concerto.nu

Attention collectors: Don't miss this fantastic shop that sells new and used LPs and CDs from a row of old storefronts along a bustling commercial street. It's a big, crowded space full of vinyl, and prices are pretty good on used stuff. It's well worth checking out. Open: Mon-Sat 10-18 (Thurs 'til 21); Sun 12-18. (Map area E7)

Distortion Records - Westerstraat 244, 🏗 627-0004

www.distortion.nl

This store advertises "loads of noise, lo-fi, punk rock and indie," but you'll also find jazz, soul, reggae and more. Record collectors will love this place. The owners here are multi-genre vinyl-heads and boast a fine selection of dance music too. They're located just up the street from the Noordermarkt (see Markets, above). Open: Tues-Fri 11-18 (Thurs 'til 21); Sat 10-18. (Map area C3)

Flesch Books & Records - Noorderkerkstraat 16, 2 622-8185

www.fleschrecords.com

This high-quality collectors' shop is run by a guy who lives in a world where turntables still rule – preferably with mono pickups – and you can hear what 50-year-old records really sound like. Folk, classical, Jazz, '60s Beat and Garage are just some of the genres on offer, in editions from incredibly rare presings to well-known titles. You can dig around, listen to some records on vintage turntables or chat with the owner, a person blessed with encyclopedic music knowledge. Racks of old 45s and music books also abound. Out front there are a couple of bargain bins and inexpensive bags of locally grown apples and pears available. Open: Mon 10-16; Thurs/Fri 13-17; Sat 10-18 (Map area C3)

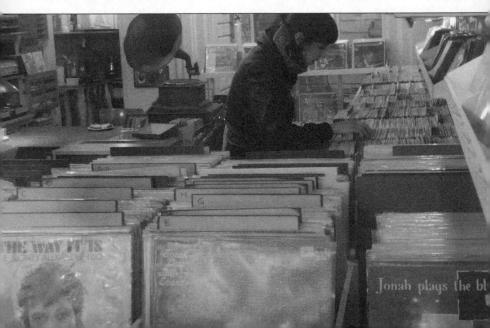

Record Palace - Weteringschans 33, 2 622-3904

www.record palace.com

Record Palace has sections for most kinds of music and it's a good place for collectors – their jazz collection is unparalleled. They're a bit pricey but might have that gem you're looking for. Check out their display of autographed record covers on the wall. Across the street from the famous Paradiso concert hall (see Music chapter). Open: Mon-Fri 11-18; Sat 11-17; Sun 12-17. (Map area C7)

Record Mania - Ferdinand Bolstraat 30, 2 620-9912

www.recordmania.nl

Although they do carry some CDs, vinyl rules at this pretty shop in De Pijp. It's wonderful to find yourself surrounded by full racks of LPs and singles just waiting to be discovered. They also have some seriously cheap bargain bins. Open: Mon-Sat 12-18. (Map area C8)

Back Beat Records - Egelantiersstraat 19, 2 627-1657

www.backbeat.nl

Blues, Afrobeat, R&B, jazz, funk, soul: there are a lot of records and CDs packed into the three levels of this glorious store. It's not cheap, but what a selection! Located in the *Jordaan*. Open: Mon-Fri 11-18; Sat 10-17. (Map area C4)

Second Life Music - Prinsengracht 366, 🕿 064-542-6344

www.secondlifemusic.nl

Second Life has an excellent collection of music, and their prices are very reasonable. They sell mainly vinyl, though there are a few CDs. There are lots of bargain bins to peruse, and old turntables piled in the back. Open: Tues-Sun 13-18. (Map area B6)

De Plaatboef - Rozengracht 40, 🏗 422-8777

www.plaatboef.nl

"The Record Thief" has several stores around Holland. The Amsterdam store is very popular. They buy and sell new and used LPs and CDs. My friend snagged a really hot Fela Kuti record here for a good price in the used vinyl bins. There's also a small box in the back which occasionally has old issues of *Mojo* and other music magazines for €1 to €2.50. Open: Mon 12-18; Tues-Sat 10-18 (Thurs 'til 21). (Map area B4)

Rush Hour Records - Spuistraat 98, 🏗 427-4505

www.rushhour.nl

Apparently this is a really popular place with DJs who come to hear what's new and hot. The owners have their own label and distribute at least a couple of dozen others. There are also bins full of used records: funk, soul, dub and other genres with a dance beat. And they sell a small selection of books, shirts, slip-mats and record bags. Other shops selling dance music in the neighborhood include: Killa Cutz at Nieuwe Nieuwstraat 19; InDeep'n Dance at Rozengracht 60; Groove Connection at St. Nicolaasstraat 50. Rush Hour is located right next door to Female and Partners (see Sex chapter). Open: Mon 13-19; Tues-Sat 11-19 (Thurs 'til 21); Sun 13-18. (Map area C5)

Independent Outlet - Vijzelstraat 77, 🏗 421-2096

www.outlet.nl

IO is punk and hardcore central, with loads of vinyl (of course) and CDs. It's an excellent store (see Misc, this chapter). Open: Sun-Mon 13-18; Tues-Sat 11-18 (Thurs 'til 21). (Map area D7)

7

used clothing stores

In Amsterdam, like everywhere else, the moment that the term vintage took off, the price of second-hand clothing skyrocketed. Nevertheless, here are a few shops where you might still find some good deals.

Noordermarkt

Noordermarkt - Noordermarkt

There's lots of used clothes at this great market (see above), but go early for the bargains. Open: Mon only, 9-14. (Map area C3)

Episode - Waterlooplein 1, 🕿 320-3000; Berenstraat 1

Both of these shops have a good selection of clothes and accessories, a lot of it from the seventies. It gets picked over pretty fast, but because they're so busy, new stuff is being unpacked all the time. One is located at a corner of the Waterlooplein flea market (there's lots of used clothing there, too - see Markets, above), The other is in the pretty neighborhood called the 9 Streets. Open: Mon-Sat 10-18. (Map area E6)

Zipper - Nieuwe Hoogstraat 10, 2 627-0353

It's worth visiting this split-level shop because, even though it's not super cheap, the owners know what style-conscious shoppers are looking for and stock accordingly. They also have another store, in the 9 Streets, at Huidenstraat 7. Open: Mon 13-18; Tues-Sat 11-18; Sun 13-17. (Map area D5)

Wini - Haarlemmerstraat 29 - 2 427-9393

Wini is a popular shop just a few minutes walk from Centraal Station. It's packed full of retro fashion, including plenty of seasonal accessories (in case you didn't pack right for the weather). Again, it's not cheap, but they do have some nice stuff. Open: Mon 11-18; Tues-Sat 10:30-18 (Thurs 'til 20). (Map Area D3)

Vind It -Tweede Egelantiersdwaarsstraat 7, 🏗 063-839-6106

www.vinditvintage.nl

Vind it means "find it" in Dutch. Finding this tiny shop located in the picturesque Jordaan neighborhood can be a challenge, but a worthwhile one. Fans of vintage clothing, especially in a rockabilly and skatype vein, will dig this place. A few racks of clothes are there for perusing, along with a CD wall full of mostly unknown local bands. Grab a CD, support local talent and brag to your friends back home about the hip new Dutch band you're into. The owners are a friendly couple that throw parties and know a great deal about the Amsterdam music scene. Open: Tues-Thurs 12-18; Fri-Sat 11-18. (Map Area C4)

tattoos and piercing

Tattoo Peter - Nieuwebrugsteeg 28, 🏗 626-6372

www.tattoopeter.nl

This famous studio, one of the oldest in the world, is located on the edge of the Red Light District – one of Amsterdam's oldest historic areas. Sailors used to line up to get tattooed here and you can still almost smell the blood and ink. Check out Peter's website for some classic old pics. The studio enjoys an international reputation, and the quality of its work is first-rate. Open: Daily 12-20. (Map area E4)

House of Tattoos - Haarlemmerdijk 130c, 🕿 330-9046

www.houseoftattoos.nl

Sjap, who opened this studio, used to work at Tattoo Peter (see above). He specializes in one-of-a-kind pieces. The artists here are talented, the environment is relaxed, and walk-ins are also welcome. This place gets pretty busy, so an appointment may be a good idea. Open: Mon-Sat 11-18; Sun 13-18. (Map area C2)

Derma Donna - Kloveniersburgwal 34, 773-6614

www.dermadonna.com

This relaxed little tattoo shop, owned by an artist who specializes in unique custom work, is set in a beautiful old canal house near the Nieuwmarkt. Cool jazz was playing the last time I visited as Rosana colored a tattoo in progress vibrant blue. Some striking examples of her work are on the wall, and she offers a personal consultation about your idea before starting to ink you. She once tattooed Thai food – including shrimps, lime wedges and chili peppers – on a cuisine-obsessed customer! Check out her website for examples of her work. She's becoming world-renowned and books out at least two months in advance, so it's wise to make an appointment. Derma Donna also has rotating guest tattoo artists who take walk-ins. Open: Daily 12-19 (Map area D5)

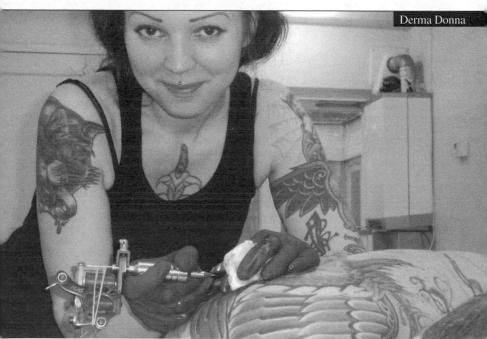

Vibes - Kerkstraat 113, 🏗 626-8908

www.myspacecom/vibes studio

Vibes, a tattoo and piercing shop cum art gallery, is a cool source for all your ink and needle needs. The bright, spacious front room has art installations and hip locally produced T-shirts. Several volumes of tattoo research books, from Borneo tribal to modern street text, are there for perusing. Custom work is the order of the day here, but they also do walk-ins. The owner is Italian and makes a mean espresso, black as ink; you can sip a cup while planning your new tattoo or new scar – they brand here, too. Open: Daily 12-20 (Map Area C6,7)

Dare 2 Wear - Buiten Oranjestraat 15, 2 686-8679

www.dare2wear.info

For the highest-quality piercings in Amsterdam, look no further than this sweet little studio just off the Haarlemmerdijk. It's a clean, professional shop, with a welcoming, restful atmosphere. Most of the piercers are women, and they're more than happy to talk to you about the procedure and what pain (if any) is involved. They also have one of the largest collections of ethnic jewellery in Europe, including beautiful pieces made of stone, wood, horn and bone. Sample prices for a piercing, including jewellery: €25 for an ear, €45 for one nipple (€80 for two), €50 for a tongue, and €60-€70 for genitals. It's €5 extra if you want a bar instead of a ring. There are lots of other options, of course. Have fun! Open: Sun 13-18; Mon 13-19; Tues-Sat 12-19. (Map area C2)

Classic Ink & Mods - Spaarpotsteeg 2, 753-9652

www.classicinkandmods.com

This is a new tattoo/piercing parlor started by the woman who owns Dare 2 Wear. You'll find this multi-level shop tucked into a narrow alley and you can see people getting tattooed through a panoramic window at the entrance. The front room boasts some fantastic paintings on its walls, from sexy ink-covered pinups to Bali demons. There's a very relaxed vibe here emanating from the friendly staff and the team of highly respected female piercers, including the master herself, who work on the second level. The top story houses another tattooing space, a light-colored wooden interior with beautiful Japanese prints. They also do body modification, splitting, implants – anything your tender flesh desires. Open: Mon-Sun 12-19; Thur 12-21. (Map area C, D 5)

hair

Chemical Blond - Nieuwe Nieuwstraat 14, 528-7389

www.chemicalblond.nl

When it comes to hair, this cool shop does it all – from basic cuts and afro hair to colors—and they do it right. All the stylists here are talented and enjoy good reputations. Prices start at €35. You can enjoy a drink – perhaps a wine – and catch a little buzz while getting your head cut. They also stock clothing and exhibit art here. Open: Mon 13-21; Tues, Wed, Fri, Sat 11-19; Thurs 13-21; Sun 13-17. (Map area D4)

Barrio Mixstore - Voetboogstraat 20, 2 663-2918

www.barrio.nl

You'll find this hair salon/clothing shop located in an historic little building on an alley just off the Spui. The cutting and styling is done upstairs and on Friday nights you can get a "Cut'n Go" for €22. Other offers include a student discount and color treatments starting at €37. Downstairs you can check out the threads on offer like small designer brands and street-wear names such as Trainerspotter and Boxfresh. They also have a good selection of books, magazines and lots of flyers promoting local parties and hip Amsterdam happenings. Open: Tues-Wed 11-7; Thurs-Fri 11-9; Sat 11-7; Sun 1-6. (Map Area C5,6)

Salon Haar & Gezondheid - Amstel 186, 🏗 427-2477

www.salonhaarengezondheid.nl

This is kind of interesting – you can get your hair colored here with dyes made exclusively from vegetable products and without the use of any artificial chemicals. There are 40 colors from which to choose. Open: Tues-Fri 10-18; Sat 9:30-17. (Map area D6)

Free Haircuts - Voormalige Stadstimmertuinen 1, 🏗 530-7230

You can get a free haircut from a grateful student at this academy. There are always supervisors nearby so you shouldn't come out looking like Crusty the Clown, but it might take a while. Call for an appointment. (Map area F7). There's another hair school at Weteringschans 167 (626-3430) that has a pretty good rep and cheap prices. You don't need to call in advance. (Map area D8)

chocolate

Pompadour - Huidenstraat 12, 🅿 623-9554; Kerkstraat 158, 🕿 330-0981

Cocoa lovers have been making their pilgrimage to this mecca of chocolate for over 40 years. There are cakes, cookies and croissants to choose from, as well as almost 50 different bonbons. The staff exhibits remarkable patience as they go over what's what for the umpteenth time, though it doesn't take long to fill up a box with chocolate treats – or to buy just one or two for a taste. In the back there's an old-fashioned tearoom where you can linger over a hot drink and something sweet. They have a newer, trendier shop in the Kerkstraat, too. Open: Mon-Fri 9-18; Sat 9-17. (Map Area C5)

Puccini Bomboni - Staalstraat 17, 626-5474; Singel 184, 62427-8341

www.puccinibomboni.com

Puccini's luxurious bonbons are created right on the premises at this small but swanky houtique on the Staalstraat near the Waterlooplein market. They include strange flavors like black pepper, chili and lemongrass on their menu, and their gin variety is a mouthful of joy. Chocolates are sold by weight and they aren't cheap, but a small box costs about €10 and makes a sweet present for someone back home. Puccini also has a shop on the Singel across the street from the Grey Area (see Coffeeshops). Staalstraat Open: Sun-Mon 12-18; Tues-Sat 9-18. (Map area D6)

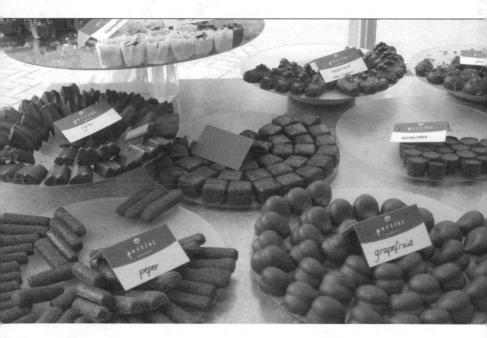

Unlimited Delicious Haarlemmerstraat 122, 🅿 622-4829

www.unlimiteddelicious.nl

Adventurous chocolate fans will probably enjoy exploring the many unconventional flavor combinations like "tomato balsamic pimento" offered here, but wimps like me will find plenty of traditional bonbons to make us happy too. They also sell homemade ice cream and some amazing-looking cakes and tarts, which you can enjoy on the premises with an espresso. Open: Mon-Fri 9-18; Sat 9-17. (Map area D3)

Leonidas Bon Bons - Schiphol Airport, arrivals level, 2 653-5077

www.leonidas.com

Didn't make it to any of the shops above, but still need to buy a couple of gifts? Belgian chocolate, even from a big corporation like this one, is delicious. Their small box of assorted chocolates makes a nice present, and the price at the airport branch is the same as in the city. Grab some for yourself, too, and you won't have to eat that crappy airplane food. Open: Daily 7-22.

smart shops

good ole 'shrooms

Some years ago, the Dutch Ministry of Health decided that hallucinogenic mushrooms are not hazardous when used responsibly. For a while, dried and fresh mushrooms were sold openly in specialized "smart shops" all around the country. But for the past few years – perhaps due to the influence of that former Shrub in the White House – they've been declared illegal. At the time of this writing, the Dutch government has ended its tolerance and banned all mushrooms, even fresh ones. Smart shops had 'shroom clearance sales to get rid of their stock before the ban took place. Other psychoactive plants and cacti are still available, as well as herbal stimulants, relaxants, aphrodisiacs and

natural mixtures

Conscious Dreams Dreamlounge - Kerkstraat 113, 2 626-6907

to turn you on or lay you down. Here are a few reputable shops.

www.consciousdreams.nl

This was the first smart shop in the world – they pioneered the concept and it's always worth dropping in to see what's new. They stock a good selection of smart drugs, and they're happy to advise and inform you about their different uses. You can also check your e-mail or do some gaming at one of several high-speed computer terminals and always find lots of flyers for local parties. It's a very trippy place. Come in... and be experienced. Open: Daily 11-19 (in summer 'til 22); closed Sundays in the winter. (Map area C7)

Kokopelli - Warmoesstraat 12, 🏗 421-7000

www.consciousdreams.nl/shops/amsterdam/kokopelli

Opened by the Conscious Dreams crew, this is one of the hippest smart shops in Amsterdam. The space is beautiful, with a very mellow area at the back where you can drink a tea, surf the net, listen to DJs and enjoy the beautiful view over the water. The staff is tourist-friendly, so feel free to ask for info on herbal ecstasy, smart drugs, or any of the other products on offer. There's talk of turning the basement into a living-room-like chill space for meditation and Ayahuasca sessions. Located very close to Centraal Station. Open: Daily 11-22. (Map area E4)

The Botanic Herbalist - Nieuwe Herengracht 58, 🏗 470-0889

www.pollinator.nl

The Botanic Herbalist is a center for people interested in psychoactive plants. Many are on sale here, including peyote, the rare Salvia (both leaves and extract), and many more. The employees at this laid-back shop know all the plants and their uses. There are also loads of books on the subject and lots of hemp products from companies like Euro-American Marketing (www.hemp-amsterdam.com). They

share the space with the Pollinator Company (see Grow Shops, Cannabis chapter) Open: Mon 12-19; Tues-Fri 11-19: Sat 12-19. (Map area E6)

Shayana Shop

www.shayanashop.com

This is the best on-line smart shop. Their site is very professional, well laid out and easy to navigate. They sell psychedelic herbs, legal joints, Ayahuasca kits, aphrodisiacs, cannabis seeds, books and much more. I've ordered from them and my package arrived discreetly only a couple of days later. Check their site to find out what products can be sent to your part of the world, and then enjoy. Open: Always.

miscellaneous

The Headshop - Kloveniersburgwal 39, 🏗 624-9061

www.headshop.nl

All your drug paraphernalia needs can be met in the shops on the street heading east off Dam Square past the Grand Hotel Krasnapolsky (which, by the way, has very nice clean toilets upstairs to the left off the lobby). Lots of them call themselves headshops, but this is the real deal. It's been in business since 1968 and stocks a myriad of pipes, bongs, papers, books, magazines, postcards, stickers and the required collection of incense and Indian clothing. They have a good reputation, and sometimes it gets very crowded. Open: Mon-Sat 11-18. (Map area E5)

Independent Outlet - Vijzelstraat 77, 7 421-2096

www.outlet.nl

IO is a way cool store selling punk and hardcore records, skateboards, shoes, hard-to-find fanzines and magazines, great lunch boxes and more. Even the doors of the dressing rooms rock! The stylin' clothes on offer are pretty cheap for Northern Europe. This is also a good place to find out about skate events and where punk and hardcore bands are playing. And if you're lucky, you might be here when they have an in-store show: ask at the counter. Open: Mon 13-18; Tues-Sat 11-18 (Thurs 'til 21); Sun 13-18. (Map area D7)

Wolf and Pack - Spuistraat 232, 7 427-0786

www.wolfandpack.com

This small split-level shop features limited edition T-shirts, sweatshirts, caps and sneakers direct from New York City. The vibe is street – grafittied walls adorn the space, including a fantastic mural with the message *Do It Yourself*. Upstairs is a small exhibition space where artists, like Amsterdam spray paint philosopher Laser, display their work for two months at a time. They sell their own Wolf and Pack brand and produce one-of-a-kind collaborations with other labels. Open: daily 11-19. (Map area C5)

Aboriginal Art and Instruments - Paleisstraat 137, 2 423-1333

www.aboriginalart.nl

This is the only store of its kind in Europe, so it's no surprise that I'd never seen such beautiful didgeridoos until I wandered into this shop/gallery. The owner travels to the outback of Australia and hand picks these unique instruments to get only the highest-quality pieces. Some of the world's most famous didgeridoo players have performed using instruments from this shop. Also for sale are CDs and Aboriginal artwork. If you already have a didgeridoo, stop by for info about jam sessions and workshops. Open: Tues-Sat 12-18; Sun 14-18. (Map area D5)

Vega-Life - Blauwburgwal 13

www.vega-life.nl

This place is a little paradise for vegetarian and vegan shoppers interested in sweatshop-free clothing, shoes and accessories. They also stock organic wine, anarchy-emblazoned baby clothes, vegetarian dog food and vegan vitamin supplements. Opened by a member of Holland's political group "Party for Animals," Vega-Life is pro-active in bringing nature and commerce together. Open Tues-Fri 10-18; Sat 10-17 (Map area: C,D4)

The Fair Trade Shop - Heiligeweg 45, 2 625-2245

Crafts, clothes and jewellery from developing countries are sold here, as well as fair-trade coffee, tea, chocolate, nuts and wine. It's not the cheapest store but there are some good deals, and the money is going back to the right people. You'll find lots of unusual gift items. Open: Mon 13-18; Tues Fri 10 -18 (Thurs 'til 21), Sat 10-17:30; Sun 12-17. (Map area D6)

Baba Souvenir Shop - Warmoesstraat 47, 2 428-2504

www.babashops.com

This is a clean, well-stocked shop full of drug paraphernalia, hemp accessories, books and more. Everything is nicely displayed, including a wide assortment of glass pipes. Open: Daily 9-22:30. (Map area E4)

China Town Liquor Store - Geldersekade 94-96, 🏗 624-5229

For some reason I think that this liquor store is cheaper than others, but I don't really know if it's true Anyway, this sleazy strip is where I buy my booze, and a couple of doors down is a great Chinese supermarket, Wah Nam Hong. There's a swankier liquor store in the basement of the Albert Heijn or Nieuwezijds Voorburgwal, and one in the Dirk van den Broek at the Heinekenplein (see Supermarkets Food chapter) that are open later. The China Town Liquor Store: Open: Mon-Sat 9-18. (Map area E4)

Dodo - 1e Van Der Helstraat 21, 2 671-2151

There are some gems among all the old clothes, books, toys, and records at this grungy second-hand shop, and prices are low, but you'll have to dig to get lucky – most things are crap. One friend of mine found an excellent '70s Telly Sevalas country record here, with songs about driving trucks and popping pills. If you're wandering though the busy streets off of the Albert Cuyp Market, then this place is worth a look, but don't go out of your way. For a bigger thrift store, check out De Lokatie (Beijersweg 12) in the east end of the city, or the Juttersdok (below). Dodo: Open: Mon 13-18; Tues-Fri 10-18; Sat 10-17.

Juttersdok - Zeeburgerpad 90; Postjeskade 23

www.juttersdok.n

These shops are the closest you'll get to an authentic American-style thrift store in Amsterdam. They're filled with clothes, records, books, videos, furniture, appliances and everything else. Prices are chear and profits go to a variety of good causes. If you're into this kind of bargain hunting, then these are fur places to poke around. Zeeburgerpad is in the east, past the IJ Brewery (see Bars). Postjeskade is ir the west, near Rembrandtpark. Open: Mon 13-17:30; Tues-Fri 9:30-17:30; Sat 9:30-17. (Map area J6)

Donalds E Jongelans - Noorderkerkstraat 18, 🏗 624-6888

You know when you walk into an old-style corner store and find a great pair of sunglasses in a dusty display case? That's what this store feels like, except it's not dusty. They have a fantastic selection of old (but not used) sunglasses and frames at reasonable prices. The owner once repaired my broken shades for free; that's cool, and not common in this city. It's right behind the Noorderkerk, so you can stop in if you're at either of the markets held here (see Markets, above). Open: Mon-Sat 11-18. (Map area C3)

De Witte Tandenwinkel - Runstraat 5, 2 623-3443

www.dewittetandenwinkel.nl

I love the window of this store. They have the world's largest collection of toothbrushes—all shapes, sizes and styles. They make unusual gifts, and they don't weigh much – a bonus when you're travelling. Take a look if you're in the Nine Streets neighborhood. Open: Mon 13-18, Tues-Fri 10-18; Sat 10-17. (Map area C5)

Studio Spui - Spui 4, 🏗 623-6926

www.studiospui.com

For those of you still using film in your cameras, check this shop for good specials on rolls close to their expiration date. The studio also stocks loads of accessories for digital cameras. Open: Mon 10:30-18; Tues-Fri 9:30-18 (Thurs 'til 21); Sat 10-17:30. (Map area D5)

Photo Processing - Kruidvat, Nieuwendijk 160, 🏗 423-0385

If you've got the time, this drug store is one of the cheapest places to get photos processed in Amsterdam. It usually takes two days. The Dirk van den Broek supermarket at Heinekenplein also develops film cheaply. One-hour processing is available at Hema Photo near the Muntplein (Kalverstraat 208; 626-8720), where 24 single prints cost about €11 − cheaper than the tourist places on the Damrak and Rokin. Hema Photo also does film developing. Photo booths where you can take passport-sized photos can be found at Centraal Station. (Map area D8)

Free Postcards

If you don't care whether Amsterdam is pictured on the cards you send home, look for the Boomerang free postcard racks in movie theatre lobbies, cafés and bars all over town.

This is the chapter for people who enjoy wandering the streets, seeing who's around, listening to music in the park, and for those of you who are really broke. During the warm months the streets and parks of Amsterdam come alive and you don't need a lot of money to find entertainment. I've also got a couple of suggestions for when it's rainy or cold.

parks

Amsterdam has many beautiful parks that are well used throughout the year, but particularly in the summer months when the sunset lingers for hours and the sky stays light 'til late. Picnics are very popular in Holland – you can invite all your friends at once, instead of just the small number that would otherwise fit in your apartment. After dark, however, it's best not to hang out in any of these parks alone.

Vondelpark

www.vondelpark.org

When the weather is warm this is the most happening place in the city, especially on a Sunday. Crowds of people stroll through the park enjoying the sunshine and the circus-like atmosphere. Little paths lead through leafy woods and out into fields where people are throwing discs and kicking footbags. Old men fish in quiet ponds only minutes away from live music being performed in the bandshell. There's a gorgeous, fragrant rose garden, a sculpture by Picasso, and a meadow with cows, goats and llamas Brightly colored parrots sit in the trees, and everywhere else people recline half-naked on the grass reading, smoking joints, playing chess, and sleeping. Trams: 1, 2, 5. (Map area A8)

Amsterdamse Bos (Woods)

www.amsterdamsebos.amsterdam.n

It's a bit of a trek to get out to this big patch of green, but what a gorgeous place. There are lots of winding bike and hiking paths, waterways, a gay cruising area, cafés, an open-air theater, a Japanese garden complete with blooming cherry blossoms in the spring, a farmhouse pancake restaurant (see Kids) and some wild parties when the weather is nice. In another part of the *Bos* there's a big field where you can lie on your back and jets from nearby Schiphol airport fly really low right over you: not exactly peaceful, but I enjoy it. In the summer it's a great place to trip. You can rent bikes, canoes and kayaks here, and free maps and information are available from the visitors' center (on Bosbaanweg 5; 545-6100; open daily from 12 to 17:00). Buses: 170, 172 from Centraal Station.

Oosterpark (East Park)

Lots of ducks and lots of toddlers waddle around this great park. It's also full of people just strolling along the water's edge or playing soccer in the big field. A variety of festivals and parties are held here including the Oosterpark Festival in the first week of May and the fantastic Roots Festival in June (see Music chapter). At the last couple of Holland Festivals (also in June; www.hollandfestival.nl) they see up huge screens in the park and broadcast live opera to crowds of picnickers. Near the gazebo there's a

new "speaker's corner" where on Sunday afternoons anyone can get up and start blabbing. And, since drums of any kind were banned in Vondelpark, Oosterpark now draws plenty of drummers. It's right by the Dappermarkt (see Markets, Shopping chapter), and the Tropenmuseum (see Museums chapter). Trams 3, 7, 9. (Map area G8)

snackbar in Oosterpark

Sarphatipark

This pretty little park in *De Pijp* is really close to the Albert Cuyp Market (see Markets, Shopping chapter) and Katsu and YoYo (see Coffeeshops, Cannabis chapter). If you get picnic fixin's you can come here to pig out and smoke. Trams: 16, 24, 25.

This small park, Napoleon's gift to Amsterdam, is located on a canal just a couple of blocks away from the Waterlooplein flea market (see Markets, Shopping chapter). It's peaceful under the big trees by the water, and it's an ideal place to cool your heels and catch your breath after battling the market crowds. It's also just across the street from the Botanical Gardens (see Museums chapter). Tram: 9. (Map area F6)

Westerpark - (West Park)

A huge, open lawn full of sunning, frisbee tossing, football playing folks bustles during the summer. There's something for everyone here: tapas style eats and lounging at the Westergasterras, Italian coffee at the Espresso Fabriek, the hip music venue Pacific Parc (see Music chapter), a kiddy wading pool, a pond full of ducks and geese and plenty of trails to explore. In winter the aquaduct-like pond turns into an ice skating rink when the weather dips below freezing. Many famous artists like Radiohead, Björk and Leonard Cohen have given summer concerts on the big lawn. (Ticketless visitors can relax on the upper lawn with a beer or a joint and hear the tunes for free.) Located just west of the Centrum, 5 minutes past Haarlemmerpoort.

public squares

Begijnhof

www.begijnhofamsterdam.nl

The Begijnhof is a famous old courtyard in the center of Amsterdam. Look for an entrance behind the Amsterdam Historical Museum on the Gedempte Begijnensloot just above the Spui. Inside, there's a plaque describing the interesting history of the churches and residential buildings that surround the pretty garden-filled courtyard. Amsterdam's oldest house is also located here. The visiting hours are now limited because busloads of loud tourists were disturbing the elderly residents, but it's still open daily from 8 to 13:00. (Map area C6).

Leidseplein

At the far end of this popular square, in front of the pancake house, are some cool bronze lizard sculptures. And just across the street from there, carved high up on the marble pillars, is that age-old proverb: Homo Sapiens Non Urinat In Ventum, which is Latin for "don't piss in the wind." If the weather is good there are sure to be street performers at the other end of the square by the tram stops. A lot of these artists are talented, working the crowds between each unicycling, fire-eating or juggling trick, and sometimes there are so many they have to line up for their chance to entertain the throngs of tourists and make some dough. In the wintertime there's an ice-skating rink too. Trams: 1, 2, 5, 7, 10. (Map area 7B)

Museumplein

Some of Holland's most famous museums are situated around this giant square. Recent major renovations have generated all sorts of problems on the Museumplein, but except for the underground parking garages, it's pretty nice. There's a new extra-wide mini-ramp with multiple transitions for skaters and bladers, and the basketball courts are back if you want to

shoot hoops. Sometimes in winter there's an ice-skating rink, with skate rental available. Trams: 2, 3, 5. (Map area C8)

Dam Square

This huge historic square in front of the palace was completely renovated a few years ago, and it looks good. It's quiet in the winter, but there's almost always something going on in the summer. Unfortunately, a lot of pickpockets and other sleazy creeps like to hang around here. Keep your eyes open and don't buy drugs from any of the scummy dealers: you'll definitely get ripped off. (Map area D4)

Nieuwmarkt

You're pretty sure to come across the Nieuwmarkt during your wanderings through the city. It's located just at the edge of the Red Light District with a beautiful 15th-century castle-like building smack dab in the middle. It used to be a weigh

station and upstairs in one of the turrets was one of Europe's first autopsy and surgery theaters – they used to open up criminal corpses here and diagram their insides. Now it just houses one of the many busy cafés in the area. Small shops, bars and restaurants surround the entire square. The numerous outdoor terraces here are especially lively on sunny days and become popular drinking spots at night. There's an organic market on Saturdays (see Markets, Shopping chapter). And on New Year's Eve, thousands of people gather here to party and set off one of the most intense fire-works displays you'll ever witness. (Map area E5)

libraries

Public Library - Oosterdokskade 143, 🏗 523-0900

www.oba.nl

This seven-story monster library is Europe's largest. Only members can borrow books, but there are lots of interesting happenings and exhibitions here, and it can be great on a rainy day. In case you need a little lubrication, there's a fully stocked bar to the right once you get inside. Between the ground and first floors is an international newspaper and magazine reading room where worldwide print media is delivered daily. There's a café where you can get a coffee and croissant for about €3.50 and catch up on current events where you're from - nice to have if you've been traveling a while. A great view of the train tracks is on one side of the room and the giant atrium-like library on the other. Further up the escalator are the various sections: On the music floor, live concerts and performances from classical quartets to jazz pianists to Hawaiian guitar bands take place, and there's a reading plaza here named after famous artist-composer-rock & roll junkie Herman Brood that displays several of his paintings. The OBA also has free internet access and music-listening facilities for auditing the thousands of CDs in stock. On the top level is a La Place restaurant with its fresh, made-to-order cafeteria feel and extensive menu selection - everything from multi-fruit smoothies to noodle dishes to apple pie. A terracel with a stunning city view awaits you. If you're traveling with kids, they have a full children's section downstairs with individual little open-roofed houses where youngsters may read, surf the internet, and even climb around in different spaces like the two-level "Dream House." (Map area: E4)

Pintohuis Library - Sint Antoniesbreestraat 69, 624-3184

The city had plans to demolish this 17th-century house in the early 1970s in order to widen the street. Fortunately, activists who squatted the building saved it. After a complete restoration it was re-opened as a library. The little rooms, old wooden furniture and high ceilings covered with frescoes make it a wonderfully peaceful place to read or ponder for a while. Upstairs they host art exhibitions – the last one I saw was of erotic paintings. Open: Mon-Wed 14-20; Fri 14-17; Sat 11-16. (Map area E5)

internet cafes

The Mad Processor - Kinkerstraat 11-13, 🕿 612-1818

www.madprocessor.com

The two front rooms of this comfortable joint are set up for surfing and checking e-mail. Printers and scanners are available (scanning is free if you do it yourself), and you can upload pics from your camera and burn them for just the cost of the disc (€1). Internet use costs 50 cents for 10 minutes, but you can buy three hours pre-paid for €7.50, or 5 hours for €10. The popular back room is set up for gaming, both face-to-face and on-line, and you can smoke cannabis while you play. It costs 75 cents for 10 minutes or €4 an hour. There's not much available here in the way of food and beverages, but there's a candy-vending machine to fuel your killing frenzies and they serve non-alcoholic drinks at the counter. Open: Daily 12-2. (Map area A6)

free concerts

Het Concertgebouw - Concertgebouwplein 2, 🏗 671-8345

www.concertgebouw.nl

Every Wednesday at 12:30 this famous concert hall, world-renowned for its acoustics, throws open its doors to the proletariat for a free half-hour performance. These concerts are extremely popular, so whether it's in the main hall (2000 seats) or the smaller one (500 seats), you should get there early. Closed in the summer.

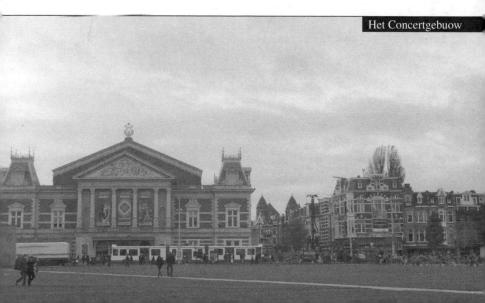

Stopera Muziektheater - Waterlooplein 22, 2 625-5455

www.stopera.nl

Every Tuesday at 12:30 this modern concert hall – home to Amsterdam's ballet and opera – presents a free half-hour concert in its Boekman Zaal. It's regularly well attended, so go early. Also closed in the summer months. (Map area E6)

Vondelpark Bandshell - Vondelpark

www.openluchttheater.nl

Free concerts are presented here during the summer (see Parks, this chapter). There's a stand with benches and a café with picnic tables on the roof that overlooks the stage. Programming here was once great – Bob Marley even graced this open stage in the '70s – but it slipped into lameness for many years and is only now booking cool acts again. You'll find a schedule posted at the main entrance to the park: Most performances are in the afternoon and evening. (Map area A8)

Club 3VOOR12 - Desmet Studios - Plantage Middenlaan 4a, 🏗 671-2222

http://3voor12.vpro.nl/3voor12

I was sad when the Desmet movie theater – where I saw Faster Pussycat Kill Kill on the big screer – closed down, but at least the space is still used for cultural events like the taping of the live radio show Club 3VOOR12. Every Wednesday from 10 to 1:00 bands and solo performers play short sets in front of a studio audience. Both local and international artists play all types of music, from emo to live techno Sometimes a band doing a show at the Melkweg or Paradiso will do a set here. Tickets are free, but you have to e-mail or call to reserve. There are no concerts in the summer. While you're there, check out the schedules of the other radio and TV shows that are taped on the premises. (Map area F6)

Het Bethaniënklooster - Barndesteeg 6B, 2 625-0078

www.bethanienklooster.n

Walking down this grey alley in the Red Light District it's easy to miss the low-key entrance to the centuries-old cloister. But inside, the building has been beautifully restored and maintained, and it now houses a concert hall. Students from the Amsterdam Conservatory play a lunchtime rehearsal concer every Friday at 12:30 under a row of chandeliers hanging from the old, wood-beamed ceiling. There's no charge, but a hat is passed around at the end. There's also a regular program featuring chambe music and, twice a month, "Jazz at the Monastery." Closed in summer. (Map area 4E)

snowboarding and skateboarding

Much of Holland is below sea level, so you probably wouldn't expect to ski or snowboard here. Bu if you need a fix, Snow Planet (Heuvelweg 6, 025-554-5848; www.snowplanet.nl) has two indoo slopes and a small terrain park complete with hits and obstacles that you can use for €19 an hour

Equipment rental is €7.50. It's out of town: To get there, take the Metro to Sloterdijk station and catch bus 82 (towards ljmuiden). Open: Daily 9-23 (Sept-Apr); shorter hours in summer.

As for skateboarding, your first stop should be Skatepark Everland at NDSM Werf (T.T. Neveritaweg; 064-170-0767; www.skateparkamsterdam.nl). (See Live Venues, Music chapter.) Skaters designed the entire park, which includes a half-pipe, a mini-ramp pool and obstacles galore. The space is actually suspended from the roof of the massive NDSM building – an amazing sight. The easiest way to get there is to take the ferry behind Centraal Station to NDSM. It leaves every 30 minutes at a quarter past and a quarter to the hour. Then it's just a few minutes walk to the skatepark. Look for lots of graffiti and the black-and-yellow doors at the entrance. Open: Tues-Fri 15-22; Sat-Sun 12-20.

Here are a few outdoor skate spots around town:

Skatescape - This figure-eight-shaped pool on the Eerste Marnixplantsoen is a hot spot these days. No vert.

Flevopark - A giant half-pipe: east of the park, under the highway bridge. Scary metal ramp with lots of vert.

Museumplein - Two wide mini-ramps connected, spine in the middle, various heights.

Oosterpark - A small street course with some nice obstacles (see Parks, above).

Java Island - A course that's similar to Oosterpark but a bit better - and easier on your board.

Olympiaplein - A long quarter, some pyramids and other ramps. Nice, but all metal.

Orteliuspad - A small park with a cement quarter-pipe, hip, spine, and some street obstacles.

For more detailed advice and info on skateboarding in the city, your best bet is to stop in at Independent Outlet (see Shopping chapter), or Reprezent (Haarlemmerstraat 80; 528-5540): they know what's up.

kite flying and juggling

Because it's flat and windy, Holland is a great country for kite flying, especially at the beach. Some pretty cool compact kites are available these days, and a growing number of people actually travel with them. Try Joe's Vliegerwinkel (Nieuwe Hoogstraat 19; 625-0139; www.joesvliegerwinkel.nl). They sell all kinds of kites, discs and footbags too. (Map area E5)

For any juggling props you need, from balls and clubs to diabolos and torches, as well as info about uggling events around Holland and the rest of the world, stop by The Juggle Store (Staalstraat 3; 120-1980; www.juggle-store.com). They've also got an awesome selection of yo-yos. Open: Tues-3at 12-17. (Map area D6)

tower climbing and view gazing

Great views! Good exercise! Get off your ass!

Westerkerkstoren - Westermarkt

www.westerkerk.nl.

The highest. Open: Apr-Sept: Daily 11-15; €5. (Map area C4)

hanging out

Zuiderkerkstoren - Zuiderkerk

The oldest. Open: Jun-Sept: Wed-Sat 14-16 (on the hour); €3. (Map area E5)

Great views! No exercise! Sit on your ass!

Kalvertoren - Singel 457

Cafe on top of a shopping center. Open: Daily 10-18:30. (Map area D6).

Metz & Co. - Leidsestraat 34

Cafe on top of a department store. Open: Mon 11-18; Tues-Sat 9:30-18 (Thurs 'til 21); Sun 12-17. (Map area C6)

Openbare Bibliotheek Amsterdam - Oosterdokskade 143

A restaurant/café occupies the top floor of Europe's largest library (see Libraries, this chapter) with a panoramic city view.

NeMo - Oosterdok 2

If it's not too windy, the big deck over the science museum isn't a bad place to hang for a bit and look at the beautiful old boats in the surrounding docks. Just climb the big steps out front and remember to take some munchies. In the summer they put out a bunch of beanbag chairs and a bar and charge admission (it includes a drink) to go up. Sometimes there are DJs, too. Open: Daily 10-17 ('til 21:00 in July and August). (Map area F3)

cloud gazing

Holland is as flat as its famous pancakes and clouds – from wispy to fat and fluffy – can move through the sky fast as time-lapse film. On a warm day you can lay on your back in one of Amsterdam's parks (Westerpark's big, open lawn, for instance) and space out on the sky.

Just north of Amsterdam you'll find the real authentic windmill-dotted countryside for which Holland is famous. This landscape was inspirational for many great Dutch painters and a perfect spot to cloud gaze. If you rent a bike, the shop will have detailed maps and routes to 15th-century villages like Durgerdam, where the picturesque sky meets the famous Dutch inland sea.

saunas and massage therapy

Sauna Fenomeen - 1e Schinkelstraat 14, 🏗 671-6780

www.saunafenomeen.nl

Despite being in a squat – now legalized – this health club is clean, modern, and well equipped. People of all ages, shapes and sizes come here. Give your name when you enter and get a locker key from the reception. There's a changing room on the left with instructions and rules in both English and Dutch. You can bring your own towel or rent one here. Then get naked, have a shower and try out the big sauna or the Turkish steam bath. They've got a café serving fresh fruit, sandwiches, juices and teas. It's a relaxing place to unwind and read the paper or just listen to music and veg out. Massages, tranquillity tanks and tanning beds are available at extra charges. Monday is for women only, and the rest of the week is mixed. If you're finished before 17:00, the price is €7. If you stay later it's €8 and after 22:00 nly €4. If you're going to go regularly, buy a pass: it costs €3, you need to bring a small photo, and you get €1 off admission. It's located just past the far end of Vondelpark. Since it's a bit out of the center, you might want to consider combining a visit here with dinner at MKZ (see Restaurants, Food chapter) or an event at OCCII (see Live Venues, Music chapter). Open: daily 13-23. Closed in August.

Sauna Deco - Herengracht 115, 🏗 623-8215

www.saunadeco.nl

Want something a bit more luxurious? Art Deco fans should try out this sauna. Almost everything here, from the lamps and railings to the wainscots and staircases, was rescued from a 1920s Parisian department store that was being renovated – and it's beautiful. They have two sauna rooms, a steam bath, a cold-water pool, a cafe, and an outdoor terrace lounge. As long as you're splurging, pay a bit extra for a soft robe to wear. Entrance is €19 (€16, Mon-Fri 12-15). Open: Mon and Wed-Sat 12-23; Tues 15-23; Sun 13-19. (Map area C4)

Energy Revival Health Company - Nieuwe Nieuwstraat 12, 🏗 625-2985

Led by professor and traditional Chinese doctor Jian Ming Gu, a staff of massage therapists awaits your tired travel muscles – at a very reasonable price. A half-hour foot massage costs €9.50 and a full Chinese body massage is only €14 for a half hour or €28 for an entire hour. An acupuncture session will run you €35. This is a great way to get rid of all your kinks. Open: Daily 11-23.

swimming pools

Zuiderbad - Hobbemastraat 26, 678-1390 90 years old. Beautifully restored. Naked swimming Sunday afternoon 16:30-17:30. And occasionally, live jazz while you swim! (Map area C8) Mirandabad - De Mirandalaan 9, 646-4444 ndoor/outdoor. With whirlpool, wave machine and ropical bath. South.

Flevoparkbad - Zeeburgerdijk 630, 🏗 692-5030 Heated outdoor pool. Open mid-May to early Sept. East.

Bijlmerbad - Bijlmerpark 76, ☎ 697-2501 Disco swimming on Sunday afternoon. South east.

Marnixbad - Marnixplein 9, 🏗 625-4843 Brand-spanking-new.

hanging out

beaches

Zandvoort and the Coast

Trains to Zandvoort (on the coast) leave from Centraal Station approximately every half hour. In the summer there are direct trains and on sunny days they're very crowded. Off-season you have to change trains in Haarlem. The trip takes about 30 minutes and costs €4.50 one-way or €8.20 round-trip. You can bring your bike for an extra charge. Zandvoort can get very crowded, the water isn't exactly clean, and it's often very windy. But the beach is big, wide and white, and a day trip there can be a lot of fun. Women go topless on all the beaches, but South of Zandvoort is a section for nudists. If you want to party, Bloemendaal aan Zee is a 45-minute walk north along the beach from Zandvoort. Several pavilions host regular parties, both wild and chilled. Sometimes there's a beach shuttle that'll take you there, but usually you have to hoof it along the beach. Remember to check the departure time of the last train back to Amsterdam.

Amsterdam Plage - Stenen Hoofd

www.amsterdamplage.nl

Creators of the Amsterdam Plage took an empty waterfront lot west of Centraal Station and transformed it into Amsterdam's first – and still one of its best – city beaches. The harbor water is polluted, but there's an inflatable pool that's great on a hot day. You can rent a beanbag chair or just plop down on the sand with a cocktail. The busy water traffic is always interesting to observe, but especially entertaining when the humongous cruise ships pass. Also on site is a cool little Ferris wheel that you can stay on as long as you like, slowly rotating and ordering drinks or cheap snacks as you pass the ground level. If you're still hungry afterwards, there's a canteen with a large selection of munchies on offer, plus beer, soft drinks and fantastic fruit shakes. At night there are often DJs and parties, and in August they screen movies under the stars (see Pluk de Nacht, Film chapter). From Centraal Station you can take bus 48 and get off at Barentzplein, or you can walk it in about 25 minutes. Open: Daily (in summer) 11-23.

Blijburg - Haveneiland, ljburg, 🏗 416-0330

www.blijburg.nl

Blijburg is probably the most beloved of the Amsterdam beaches. It's relaxed, funky, and popular with all sorts of people. There are often parties on the beach and in the busy café, but it's lively and fun anytime – even when the weather's crap. Lots of comfortable nooks and crannies make for great lounging, both inside and on the terraces, or just bring your blanket and a picnic lunch and flake out on the sand. The water is clean, the beach is great, and there are art installations and vendor stalls in the area. It's a bit of a trek by bike, but tram 26 from Centraal Station will take you right there. Open: Daily in summer (not sure about winter).

Strand West - Stravangerweg 900, 7 065-475-0183

www.strand west.nl

Maybe it's the industrial terrain that surrounds it, but the couple of times that I dropped in here it felt a little cold and desolate. However, it's open all year round, has a stylish beach club, and if you're a fool for sand, it might be worth a trip out here – especially on a sunny off-season day when all the other places are closed. There's no swimming but plenty of beanbags, couches and hammocks. It's located about a kilometer further west along the water from Amsterdam Plage (see above). From Centraal Station take bus 22 or 48 to Spaarndammerstraat and ask for directions. Open: Daily (year round) 10-24.

Stand Zuid - Europaplein 22, 25 544-5955

www.strand zuid.nl

This urban beach is situated along a canal south of the giant RAI convention center. There's a pretty view of Beatrixpark across the water, but this beach is over-priced and definitely courting a more upscale crowd. If you're out this way for some reason, it's fine for lounging a bit with a drink – or just skip it and have a picnic in the park. Open in summer Mon-Thu 10-23. Fri-Sat-Sun 'til 24:00.

Het Twiske - North of Amsterdam, near Landsmeer

Het Twiske is a recreation area close to Amsterdam with picnic areas, hiking paths and lots of beaches. The water here is clean, and you can rent canoes, sailboats, kayaks and surfboards. On the east side of the park is a nude beach (Wezenland Strand). You can easily take a day trip here on your bike, or take bus 92 from Centraal Station and get off at Kerkbuurt in front of the visitor's center.

street festivals

Queen's Day - April 30, Everywhere in Holland

The biggest and best street party of the year happens in celebration of the Queen's birthday – or actually her mother's birthday, because Beatrix's is in January, a bad time for an outdoor party. Amsterdam becomes one big orange-colored carnival of music, gallivanting and dancing in the street, plus the world's biggest flea market is open for business and almost anything can be bought or sold. Despite a slew of ridiculous new rules and regulations imposed by the City Council over the last few years, it's still unbolievably fun. Type "Queen's Day Amsterdam" into any search engine and you'll find hundreds of photos online.

Bevrijdingsdag - May 5, Museumplein

www.amsterdamsbevrijdingsfestival.nl

Bevrijdingsdag celebrates Holland's liberation from the Nazis at the end of WW2: something worth celebrating. If you're interested in seeing some of the country's bigger bands for free, check this out. It's always a fun party. Fuck the Nazis!

97

Positive Rave Organization Street Party - Late May-Early June

http://legalize.net

Because the cops get nervous when the streets are liberated, this annual street rave protesting the global war on drugs has been forced out of the city center and the permit for their famous free afterparty cancelled. But the struggle continues – people and sound-systems will still gather every year. Check their website, or ours, for info about the next event.

Kwakoe Festival - July and August, Bijlmerpark, Amsterdam Zuid-Oost

www.kwakoe.nl

With over half a million visitors, mostly of Surinamese, Antillean and Ghanaian origin, this is Holland's biggest multicultural festival. It takes place over six weekends every summer and admission is free. The soccer games are the biggest draw, but there's also lots of music, food and art. Visit their site or call 416-0893 for details.

Gay Pride Parade - First weekend in August

www.amsterdampride.nl

If you're here at the beginning of August, make sure to see this fun, extravagant and risqué procession of queer-filled boats cruising the canals. Street parties and cultural events, including open-air film screenings, happen over the entire weekend. Call the Gay & Lesbian Switchboard (see Phone Numbers chapter), or stop by Pink Point (see Practical Shit chapter) for route information.

Hartjesdag dates back to the middle ages when everyone would dress in drag every year at this time. It's a lively weekend that culminates on the Sunday when the Zeedijk and the Nieuwmarkt (see Hanging Out chapter) are packed with partying drag queens and drag kings.

New Year's Eve - uh...

If you're coming for New Year's Eve and want to be at an organized party, you should start checking the club and AUB websites at least a month in advance. All the popular venues sell out fast. Thousands of people also celebrate on the streets, especially at Nieuwmarkt (see Public Squares, above). It's wild.

kids

Traveling with kids is fun, and like a friend of mine put it: "Not all people with children are squares." Definitely not. Amsterdam, known for its debauchery and mind-twisting tourism, is also a great place for the little ones.

You can take a cruise on a **pancake boat**. De Pannenkoekenboot departs at 16:30 and 18:00, Wed.-Sun. from NDSM werf. Take the ferry behind Centraal Station marked NDSM and 10 minutes later you're there, ready to board a river cruiser for a one-hour pancake-filled munch-out, buffet style. It costs €14.50 for adults and €9.50 for children. They recommend you reserve during the busy summer months at *www.pannenkoekenboot.nl* or call 636-8817.

Another pancake-filled adventure is to visit Boederij Meerzicht, a farmhouse in a huge park in south Amsterdam called the Amsterdamse Bos where the peacocks and various farm animals will watch you eat. (Buses 170, 172 from Centraal Station.)

If you want to eat pancakes or tasty little *poffertjes* – mini-pancakes with butter and powdered sugar – but remain in the Centrum, check out De Carousel (Weteringcircuit 1, tel: 625-8002). It's a big round restaurant with lots of windows and a roomy terrace. Little kids love this place. Big kids too – my editor swears these are the best pancakes in town; he chows down here at least once a week. (Map area C,D8)

Got kids that **ride bikes**? Why not rent a few for the family? Most shops have a variety of sizes and possibilities – like bike seats for toddlers. (See Getting Around.) Bicycle rental shops also have tour maps showing routes to beautiful old villages located just north of Amsterdam.

There's a great **outdoor market** Saturdays at the Noordermarkt. (on the Prinsengracht) that's got organic munchies, clothing and craft stalls and a playground for kids in the middle.

Museums can be a good rainy-day destination for people with children, and Nemo Science Museum (see Museum chapter) is a perfect example. There are interactive exhibitions especially for children – even a real Tesla ball. If the weather's good, you can eat lunch on the giant rooftop terrace. The Tropenmuseum (see Museum chapter) is fun for children and adults. They have interactive displays of developing countries, including models of villages and fantastic art expositions.

Amsterdam's huge **public library** is another rainy-day possibility with plenty for kids and adults to do and explore (see Hanging Out, Libraries). (Map area F4)

hanging out

Kid-friendly restaurants can be challenging to find in this city. How about dinner on a boat? At the Einde van de Wereld, opposite Javakade 4, on board Quo Vadis, you can eat organic meat or vegetarian meals for a good price. Kids have their own space here to frolic and play (see Restaurants). (Map area I3)

Café Restaurant Amsterdam (Watertorenplein 6, 682-2666) is in the Westerpark neighborhood outside of the Centrum. It's not cheap, but for a special treat this is a fantastic kid-friendly locale. Kids are free to run wild in this huge space, the staff doesn't care at all – even when all 100+ tables are full. The menu is French meets modern and classic Dutch with steaks, fresh seafood and a good selection of vegetarian options. Everything from the bread to the mayonnaise is made in-house. Price-wise, you can go as tame or extravagant here as you desire. Take tram 10 west to the end of the line at Van Hallstraat, walk west two minutes into a square called Watertorenplein (Watertower Plain) surrounded by apartments. The Café is on your left in an old milk factory next to a white water tower. Reservations are recommended on weekends or you'll have to wait a while for a table.

On sunny days **parks** (see this chapter, parks) are always great for kids. Westerpark, located just west of the Centrum, has big open lawns, a kiddy wading pool, plus cafes and restaurants. Vondelpark, Amsterdam's busiest, has a huge playground near the *Melkhuis* café, about a 10-minute walk from the park's main entrance, on the right. You can also rent in-line skates or roller skates here (see Inline Skates, Getting Around.)

For a **old-style carnival** experience in mid-August go to the *Openhavenpodium* at Java Eiland (see Music Festivals, Music chapter). You'll find plenty of delicious food, funny and entertaining performances, and other attractions for young and old.

Museums & Galleries

There are so many museums and galleries in Amsterdam it could take you weeks to see them all. I'm going to concentrate on those that are unusual or lesser known. If you want to know about the big ones like the Rijksmuseum and the Van Gogh Museum, check the end of this chapter. They all have websites that are jam-packed full of additional information.

the unusual ones

The Sex Museum - Damrak 18, 🏗 622-8376

www.sexmuseumamsterdam.nl

It's true that just about everything that's on display here can be seen in the Red Light District for free, but admission is only €3 and it's fun to tell your friends you went to the Sex Museum. The exhibits, which were getting pretty run-down over the years, have been fixed up and are looking a lot better. I particularly like the pornography from the turn of the century. And the two 7-foot high penis chairs that you can pose on – don't forget your camera! Open: Daily 10-23:30. (Map area E4)

The Erotic Museum - Oudezijds Achterburgwal 54, 🏗 624-7303

This varied collection covers five full floors, but unfortunately much of it is unlabelled. They have drawings by John Lennon, collages from Madonna's *Sex*, and a very ugly, very funny pomotion from Germany. You can also push a button that sets a dozen or so vibrators into action. There's a floor with hardcore videos and samples of phone sex, and above that a rather tame S-M room. There's only one reference to gay male sex in the entire museum, however – a surprising omission considering Amsterdam's status as the gay capital of Europe. Open: Sun Thurs 11-1; Sat-Sun 11-2. (Map area E4)

The Hash Marihuana Hemp Museum - Oudezijds Achterburgwal 130, 🏗 623-5961

Despite its name, this is more than just a required stop on every smoker's list of places to visit: It's an informative collection that'll intrigue anyone interested in alternative forms of energy, medicine or agriculture. The exhibit comprises photos, documents, videos and artifacts dealing with all aspects of the amazing hemp plant: history, medicinal uses and cannabis culture. There's even a grow room. If you're hungry for more info you can peruse their small reference library or pick up one of the free pamphlets on hemp and its uses available by the entrance. They also sell books, magazines and hemp products, including seeds. Visitors who do smoke will be interested in learning about vaporizers: pipes that use a powerful heat source to "vaporize" the THC-bearing resin without actually burning the weed in the bowl. It's a healthy alternative to filling your lungs with smoke, and it gets you wasted! Eagle Bill, who popularized the method and used to vaporize visitors daily here, passed away in 2005. Now Joseph, a vaporizer disciple, carries on Bill's tradition. He's sitting at a table by the grow room and will gladly give you a taste for a small donation. The museum is located in the Red Light District. A few doors down is the new Hemp Museum Gallery with great displays, like mid-19th-century medicine bottles with "extract of cannabis Indica: for coughs, colds, bronchitis, asthma, nervous debility etc." The Gallery also sells limited-edition hand-painted posters. A €7.50 ticket gains you entry to both museum and gallery. Open: Daily 10 -23. (Map area E5)

Electric Ladyland - The First Museum of Florescent Art - Tweede Leliedwarsstraat 5, 🏗 420-3776

www.electric-lady-land.com

It took seven years to complete this very tiny, very trippy museum in a *Jordaan* shop basement, and when you see it you'll know why. It includes an intricate cave-like environment where you can push buttons that light up different areas of the space and hear Jimi Hendrix. Display cases with minerals and fluorescent artifacts from all over the world are displayed under lights of different wavelengths to reveal startling hidden colors. A €5 donation gets you access to the collection and an informative booklet. Open: Tues-Sat 13-18. (Map area B4)

The Torture Museum - Singel 449, 2 320-6642

www.torturemuseum.n1

Don't leave Amsterdam without visiting this unique and very educational collection of torture instruments. You'll learn where expressions like "putting the pressure on" and "going medieval" originated. The museum is nicely laid out in an old house and barely illuminated by dingy dungeon lighting. Detailed drawings illustrate each objects purpose, with a small plaque explaining its function and or whom it was used. The bloody history of Christianity is graphically documented here – atrocities in flicted upon people in the name of God. (And speaking of "god," what do you get when you cross ar agnostic, an insomniac, and a dyslexic? Someone who stays up all night wondering if there really is a dog.) Open: Daily 10-23. (Map area E4)

Tropenmuseum - Linnaeusstraat 2, 2 568-8215

www.kit.nl/tropenmuseum

Tropenmuseum is one of the big ones in every guidebook, yet many visitors choose to skip it. I'm including it here because it's such an amazing place. This beautiful old building in eastern Amsterdam houses a fantastic collection of artifacts and exhibits from the developing world. The permanent exhibition uses model villages, music, slide shows, and lots of push-button, hands-on displays to give you a feel for everyday life in these distant lands, and there are exhibitions in the central hall and in the photogallery that change regularly. At the entrance you'll find info on films and music being presented in the adjoining Souterijn theater (see Film chapter), though they're not included in the admission price Admission: €8 (Under 18: €4). Open: Daily 10-17. (Map area H7)

De Poezenboot (Cat Boat) - a houseboat on the Singel opposite #20, 🏗 625-8794

Attention cat lovers! This isn't really a museum, but what the fuck. Spend some time on this boat play ing with dozens of love-hungry stray cats that now have a home – thanks to donations from the public and local volunteers. The boat is free to visit, but you're expected to make a contribution on your way out. Grab a postcard for your cat back home. Open: Daily 13-17. (Map area D3)

Woonboot Museum (Houseboat Museum) - Across from Prinsengracht 296, 🏗 427-0750

www.houseboatmuseum.n

The 89-year-old ship that houses this museum illustrates what it's like living on one of Amsterdam's approximately 2500 houseboats. There are also scale models of other boats, photos, a slide show, and displays to answer questions you have about life on the canals. If you print the map on their website and bring it along, they'll give you a free poster of Amsterdam. Admission: €3.50, kids €2.75. Open Mar-Oct, Wed-Sun 11-17; Nov-Feb, Fri-Sun 11-17. (Map area C5)

W 139 - Warmoesstraat 139

www.w139.n

This large exhibition space and production facility located on the edge of the Red Light District is oper daily from 11-19:00 and offers free admission as part of its mission "to be as public as the post of fice" – contemporary art for the masses. W 139 exhibits artists from around the world and even host fashion shows with singing and guitar-playing models wearing locally-created, one-of-a-kind designs

Sometimes there are parties with hip underground bands. It's a cool vibe: You can just walk in and look at unpretentious cutting-edge art or grab some flyers for happening parties in and around the city. Check out their website for information on upcoming exhibitions and other activities or even tips on available accommodations for visiting artists. (Map area: D4)

Illuseum - Witte de Withstraat 120, 770-5581

www.illuseum.com

Illuseum is a small freaky gallery, performance space and hangout located in a west-end storefront. Inside is a warren of dark hallways and rooms where weird, wonderful paintings and sculptures by underground artists are displayed. Sometimes they show movies or have bands jamming in the basement. If the weather's nice, grab a glass of wine or beer and relax in the backyard: It's as uniquely decorated as the rest of the space. And be sure to check out the cool tunnel for the resident cats. Open: Wed, Sat, Sun 14-21.

The Chiellerie - Raamgracht 58, 🏗 320-9448

www.chiellerie.nl

Alternative and underground, this little DIY gallery is truly accessible to artists of all stripes. Those so inspired can sign up to be "artist of the week" and have their work featured at a Friday night opening. The shows are fresh, inspiring, and often interactive, drawing a wide range of people who come to mingle and enjoy a drink at the bar. It's a comfortable, shabby, non-commercial space on a pretty residential street. Open: Sun, Wed 14-18; Fri 17-22 for the art openings. (Map area E5)

Heineken Brewery - Stadhouderskade 78, 🏗 523-9666

www.heinekenexperience.com

I used to recommend this famous place but the price has gone way up, it's no longer a working brewery, and you can't get all you can drink for free anymore, so I'm not sure why you'd want to go there now. Open: Tues-Sun 10-18, with last tickets sold at 17. (Map area D8)

Condom Museum - Warmoesstraat 141, 2 627-4174

www.condomerie.com

Housed in a small glass case at the Condomerie (see Sex Chapter) is a colorful assortment of condom packages from around the world. It doesn't take long to view the collection, but checking out the names and slogans on the boxes (like the camouflage condom: "Don't let them see you coming") is good for a few laughs. Open: Mon-Sat 11-17. (Map area D4)

The Smallest House In Amsterdam - Singel 7

In earlier times, property taxes were based on the width of the front of the house, so the architects who designed this residence were pretty clever: The front of the house is only 1.01 meters wide! It's not a museum – people live there – so you can't go inside, but it's still cool to look at when you're walking by. There are other tiny houses around, including: Haarlemmerstraat 43 (1.28 meters wide); Oude Hoogstraat 22 (2.02 meters wide); and Singel 166 (1.84 meters wide). (Map area D3)

Botanical Gardens (Hortus Botanicus) - Plantage Middenlaan 2A, 2 625-8411

www.dehortus.nl

Established in 1638, this is one of the world's oldest botanical gardens. Their collection includes thousands of plant species displayed in various greenhouses and landscaped gardens. The largest building has both desert and rain-forest environments, but my favorite is still a beautiful old building called the palm house. Next to that, in a locked cage, is a Wollemi Pine – a species of tree that dates from the time of the dinosaurs and was thought until recently to be extinct. Peyote grows in the cactus greenhouse, and a visit to the butterfly room is a fun experience. Their café, the Orangerie, is airy, light, and full of plants and little birds hunting for fallen crumbs. Classical music is performed on occasion. Admission is €7, but if you're staying nearby consider an annual pass for €23. Then you can drop in whenever you like and make full use of those comfy hothouse benches—particularly nice during winter. Trams: 7, 9, 14. Open: Mon-Fri 9-17; Sat-Sun 10-17 (Dec-Jan 'til 16; Jul-Aug 'til 21). (Map area F6)

De Burcht (National Trade Union Museum) - Henri Polaklaan 9, 🏗 624-1166

www.deburchtvakbondsmuseum.nl

In the late 1800s, the famous architect Hendrik Berlage was commissioned to design the General Dutch Diamond Cutters Union's head office – the first union in The Netherlands to win its workers the right to a vacation, and the first in the world to attain an eight-hour working day! It's fitting that this beautiful building now houses the Dutch trade union movement museum. Most of its exhibits, which include displays about union activities of the past and present, are in Dutch, but a free English guide is available at the front desk. The environment here makes you want to hear some old, scratchy Woody Guthrie albums. Admission is €1.25 for card-carrying union members and €2.50 for the unorganized. Take tram 9 to Plantage Kerklaan. Open: Tues-Fri 11-17; Sun 13-17. (Map area F6)

Museum Het Schip - Spaarndammerplantsoen 140, ☎ 418-2885

www.hetschip.nl

The Ship is an awesome residential building designed in the early 20th century by Michel de Klerk, who was part of a famous architectural movement known as the Amsterdam School. The Ship's collection, located in a corner of the building that used to be a post office, consists of a short film, interactive programs accessible on several computer terminals, and the amazing interior itself. You'll learn the fascinating history of the controversial Amsterdam School and the parallel rise of the social housing movement in Holland. It was radical stuff comrades... and it still is. Take bus 22 from Centraal Station. Admission: €5; students €2. Guided tours cost an extra €2.50 and begin at 13:30. Open: Thurs-Sun 13-17

FOAM - Keizersgracht 609, 25 551-6500

www.foam.nl

Amsterdam's newest photography museum is in an old canal house renovated with an open, airy, and welcoming contemporary style. The exhibitions represent all aspects of the art and change frequently.

My museum card and I are regular visitors. Admission is €7.50. Trams 16, 24, 25. Open: Sat-Wed 10-17; Thurs-Fri 10-21. (Map Area D6)

Huis Marseille Foundation for Photography - Keizersgracht 401, 25 539-8989

www.huismarseille.nl

A French merchant built this grand house in the 1600s. Now it's been restored to its original state and houses a center for photography. The spacious rooms and long hallways are perfect for presenting the exhibitions. There's also a big library open to the public. Because the building is a monument, it's free to visit on Open Monument Day (see below). Admission: €5 (free for 17 and under). Open: Tues-Sun 11-18. (Map Area C6)

Open Monument Day - Early September, throughout The Netherlands

www.openmonumentendag.nl or www.bmz.amsterdam.nl

On Open Monument Day over 3000 historical monuments in Holland usually not accessible to the public—homes, windmills, courtyards and churches – open their doors. On this day you can pop into any building that flies a flag with a key on it. For more info call 627-7706 or visit the websites above.

the big ones

Here is some basic information on Amsterdam's biggest and most famous museums. They all have impressive collections and can get quite crowded during peak season. Once a year, in mid-April, there's a Museum Weekend when all the big ones are free. Most of these museums are closed on December 25, January 1, and April 30 (Queen's Day – See Hanging out chapter).

A Museum Card good for one year costs €39.95 (under 25: €22.45) and is available at most of these museums. It gets you in free or at a substantial discount to almost all the famous Dutch museums. If you're planning to go to more than a few of these, are visiting other cities in The Netherlands, or are returning within a year, then it's a very good deal.

The Museum Nacht (www.n8.nl) is a very cool annual happening that's enormously successful. For one night in early November over 40 Amsterdam museums are open after hours and provide visitors with unconventional atmospheres in which to view the collections. In the past, the Stedelijk Museum has been transformed into a club lounge, there's been line dancing in the Rijksmuseum,

museums & galleries

and the Botanical Gardens offered a tour of the hallucinogenic plants in their collection. More recently, the Nemo had a large Tesla ball sparking synthetic lightning on their famous terrace. The €13.50 Museum Night pass includes entrance to the museums as well as transport on historic trams and buses. It's a great deal.

Rijksmuseum - Stadhouderskade 42, 🏗 674-7000

www.rijksmuseum.nl

Still renovating, but one wing is open for viewing their most famous works. Open: Daily 09-18. €10 (18 and under: free). Trams: 2, 5. (Map area C8)

Vincent van Gogh Museum - Paulus Potterstraat 7, T 570-5200

www.vangoghmuseum.nl

Frequently there's free live music or DJ sets in the lobby on Friday nights. Open: Daily 10-18 (Friday 'til 22:00). €12 (ages 13-17, €2.50). Trams: 2, 3, 5, 12. (Map area B8)

Anne Frank House - Prinsengracht 263, 2 556-7105

www.annefrank.nl

Open: Daily 9 -19 (Apr-Aug 31 'til 21). €7.50 (ages 10-17: €3.50). Trams: 13, 14, 17. (Map area C4)

Stedelijk Museum of Modern Art - Oosterdokskade 5, 25 573-2911

www.stedelijk.nl

You can find this museum's current events online.

Rembrandt House - Jodenbreestraat 4, 2 520-0400

www.rembrandthuis.nl

Open: Mon-Sat 10-17; Sun 11-17. Admission: €8; students €5.50; ages 6-15, €1.50. Trams: 9, 14. (Map area E6)

Amsterdam Historical Museum - Kalverstraat 92, 🏗 523-1822

www.ahm.nl

Open: Mon-Fri 10-17; Sat-Sun 11-17. €10 (ages 6-18, €5). Trams: 1, 2, 5. (Map area D5)

Jewish Historical Museum - Nieuwe Amstelstraat 1, 🏗 531-0310

www.jhm.nl

Open: Daily 11-17. €7.50 (ages 13-17: €3). Trams: 9, 14. (Map area E6)

Portuguese Synagogue - Mr. Visserplein 3, 🏗 624-5351

www.esnoga.com

Open: Sun-Fri 10-16 (Apr 1-Oct 31); Sun-Thurs 10-16; Fri 10-15 (Nov 1-Mar 31). €6.50 (ages 10-15: €4). Trams: 9, 14. (Map area E6)

WW2 Resistance Museum (Verzetsmuseum) - Plantage Kerklaan 61, 🏗 620-2535

www.verzetsmuseum.org

Open: Tues-Fri 10-17; Sat-Mon 12-17. €6.50 (ages 7-15: €3.50). Tram: 9. (Map area F6)

Willet-Holthuysen Museum - Herengracht 605, 🏗 523-1822

www.willetholthuysen.nl

A 17th-century canal house. Open: Mon-Fri 10-17; Sat-Sun 11-17. Trams: 4, 9, 14. (Map area D6)

Hidden Church (Amstelkring) - Oudezijds Voorburgwal 40, 2 624-6604

www.museumamstelkring.nl

Open: Mon-Sat 10-17; Sun 13-17. Admission: €7; students, €5; ages 5-18, €1. (Map area E4)

Maritime Museum (Scheepvaartmuseum) - Kattenburgerplein 1, 523-2222

www.scheepvaartmuseum.nl.

A museum on an old Dutch ship. €5 for old and young. Docked near NeMo.

NeMo (Science Center) - Oosterdok 2, 2 531-3233

www.e-nemo.nl

Open: Tues-Sun 10-17, €11,50, Bus 22, (Map area F5)

Hermitage Amsterdam - Nieuwe Herengracht 14, 2 530-8755

www.hermitage.nl

Branch of the State Hermitage Museum in St. Petersburg. Open: Daily 10-17. Admission €8 (Under 17: free). (Map area E6)

out of town

Escher In The Palace - Lange Voorhout 74, The Hague, 🏗 070-427-7730

www.escherinhetpaleis.nl

Like most acid heads I have a fondness for the art of M.C. Escher, so when they opened this museum in an 18th-century palace a few years ago I immediately jumped on the train to check it out. It was worth the trip. Paintings, sketches and archive materials are displayed over the museum's four floors. There's also an optical-illusion room that makes you look either really tall or about the size of Gary Coleman. And perhaps best of all, there's an amazing virtual-reality experience where, with the help of a helmet, earphones and a computer, you can go right into one of Escher's paintings! Admission €7.50. Open: Tues-Sun 11-17.

Kröller Müller Museum - Hoge Veluwe National Park, ☎ 031-859-1041 or ☎ 031-859-1241

www.kmm.nl or www.hogeveluwe.nl

This museum with a big, trippy sculpture garden and a fantastic Van Gogh collection is located in a Dutch national park. Visitors may explore many kilometers of well-maintained bike paths through beautiful forests and dunes on bikes provided free of charge. The park is open during daylight hours; the museum, Tues-Sun 10-17. Admission to the park and the museum is €14; the park alone, €7; parking, €6. There are buses to the museum from the town of Apeldoorn.

Keukenhof - Lisse (southwest of Amsterdam), 2 025-246-5555

www.keukenhof.nl

Flower-lovers from around the world converge on this 32-hectare park every spring to see Holland's finest bulbs a-blooming. There are kilometers of grand avenues and winding forest paths, fountains of every size and shape, a Japanese garden, a maze, and many special pavilions for indoor plants – plus over 6 million flowers, most of which are tulips. On a sunny day the colors and scents are breathtaking. Don't forget your camera. Getting there involves a train journey to Leiden and then a bus ride through an area filled with commercial bulb fields – also an impressive sight. Admission is €12. Open: Daily 8-19:30 from the end of March 'til mid-May.

Many guidebooks say that Amsterdam, unlike some of its neighboring capital cities, doesn't have a "world class" music scene. What a load of shit, but that's not surprising using such a snobbish term. In fact, even if you're here only for a couple of days you can find all kinds of music in great venues from community-run squats and old churches to dance halls and large clubs.

how to find out who's playing

A.U.B. - Leidseplein 26, ☎ 0900-0191 (40¢ per minute)

www.amsterdamsuitburo.nl

The Amsterdams Uitburo (AUB) is the place to find who's playing in town. Listings of musical happenings in and around the city are displayed here, along with schedules for the Paradiso, Melkweg, and other bars and clubs that feature live music (see below). There are also racks full of flyers and info about theater and film events. It's convenient to buy advance tickets here, in person or by phone, but there's a service charge of about €2 per ticket. Buying them directly from the venues or from record stores (see Shopping chapter) will usually save you a bit of money. Note that you can't buy tickets to concerts at the H******n Music Hall here – you need to go to the post office or the tourist office (see Ticket Service, below). Open: Mon-Sat 10-19:30; Sun 12-19:30. (Map area C7)

Last Minute Ticket Shop - Leidseplein 26, 🏗 0900-0191 (40¢ per minute)

www.lastminuteticketshop.nl

Also located in the AUB is this last-minute service that offers tickets to concerts, theatre performances, movies and other events at 50% off the regular price. And if you pay cash, there's no service charge. You can see what's available on their site, but you have to buy the tix in person. It's definitely worth checking out. Open: Daily 12-19:30.

Shark

www.underwateramsterdam.com

This popular webzine has info on what's happening at music spots all around the city – alternative venues as well as mainstream. *Daim's Gig Guide* gives you the scoop on who's coming to Amsterdam each month, and the site has a searchable database of all current cultural events. They also feature short articles, reviews, horoscopes, and queer info. Check it out.

Amsterdam Weekly

www.amsterdamweekly.nl

Pick up this free paper at coffeeshops, clothing stores, cafes, bars, bookstores and record stores around Amsterdam – they have weekly concert listings.

Irie Reggae Web Site

www.irielion.com/irie

If you're into reggae, take a look at this comprehensive up-to-date listing of reggae bands and sound systems playing around Holland.

Ticket Service (sucks) - To 0900-300-1250 (45¢ per minute)

www.ticketmaster.nl

Ticketmaster is a huge corporate entity that uses its monopoly on ticket services to rip us off. But their site will tell you who's playing where and enable you to order tix to shows that might be sold out by the time you arrive. Ticket Crapster also has outlets in the main post offices here and at the Amsterdam Tourist Office at Centraal Station (see Practical Shit chapter).

live music and party venues

Paradiso - Weteringschans 6-8, To 626-4521

www.paradiso.nl

Since hearing Bad Brains *Live at the Paradiso* I'd always wanted to see a show there. So when I first visited Amsterdam I went straight to this legendary spot, a squatted old church transformed into a club The former pulpit is now the main stage, decorated with the original stained glass, and there's a big dance floor surrounded by three balconies. Everyone imaginable – from Willie Nelson to the Roots, Sonic Youth to Funkadelic – has played here over the years. Upstairs, a smaller room hosts separate gigs and midnight sets by bands playing directly after the main show. Food is available in the basement, where smaller soirees and DJ sets also happen. Crazy parties and performance art are also welcome here: I've seen joint-filled balloons drop from the ceiling and a guy play a slide guitar solo with his dick ensconced in a Jack Daniels bottle while scantily-clad go-go girls held his instrument. Tickets range in price from about €7 for shows in the small hall to €30 for a big-name show on the main stage. There is an additional charge of €2.50 which buys you a membership card that's valid for one month. If you're going to a sold out concert it's a good idea to purchase your membership card in advance at the AUB to avoid the long line at the door. Both are located just a stone's throw from the Leidseplein. (Map area C7)

Melkweg (Milky Way) - Lijnbaansgracht 234, 2 531-8181

www.melkweg.n

The Melkweg – Amsterdam's other classic venue – is in a big warehouse (which used to be a dairy on a canal near the Leidseplein. Prices, including a membership fee, are about the same as the Para diso, and – also like the Paradiso – the staff here is really nice. You'll find bands playing in the old hal most nights, or in the bigger, recently renovated "Max" (shamefully named after its corporate soft drink sponsor). The café/restaurant Eat at Jo's (see Restaurants, Food chapter) and an adjacent photo gallery are also located on the ground floor; admission to the gallery via the restaurant entrance a Marnixstraat 409 is free from 13 to 20:00 Wednesdays thru Sundays. Upstairs there's a video room, a playhouse for live theater (which is often performed in English), and a cinema (see Film chapter), which you can no longer explore before and after concerts: you have to pay a separate admission to each Flyers listing Melkweg events are available by the front door of the club (even when it's closed). The box office is open from 19:30 on every night that there's a show and: Mon-Fri 13-17; Sat-Sun 16-18 (Map area C7)

OCCII (Onafhankelijk Cultureel Centrum In It) - Amstelveenseweg 134, 🏗 671-7778

www.occii.org

This cool squat club has been open for more than 20 years. There's always something going on here live music of all types, cabarets, readings and other happenings. Their small hall has a bar, a nice-sized stage and a dance floor. It has a comfortable, divey atmosphere. Back by the entrance an old stairway leads to the Kasbah café on the second floor. The music and crowds are diverse and fun. Admission is usually only €3 to €6. Look for posters advertising their events or wander by. It's part of a complex called the Binnenpret (http://binnenpret.org) that also houses a sauna (see Sauna, Hanging Out chapter), a restaurant (see MKZ, Food chapter) and Café de Bollox. It's located at the far side of Vondelpark across the street and to the left. They usually close for a while in the summer. Tram 2.

OT301 - Overtoom 301, **T** 779-4913

squat.net/overtoom301

The Academie – so named because it formerly housed a film academy – was sitting empty until a bunch of squatters moved in, fixed it up, and made it available to the public. Despite pressure to evic the squatters from those who would rather see this building rot than be used for non-profit purposes volunteers have managed to create one of Amsterdam's most important cultural centers here. Now new projects are being launched all the time: There's a restaurant/bar (see De Peper, Food chapter) a movie theater (see Film chapter), a darkroom and printing press, and studios used for radio, dance performances and workshops. There are also some great parties happening in both the restaurant and the big studios. DJs play regular gigs and musicians perform all styles of music. OT301 is underground

Amsterdam at its accessible best. Look for their schedule online or pick one up at the AUB (see above). Tram 1. (Map area A7)

H****** n Music Hall - Arena Boulevard 590, ☎ 409-7900

www.heinekenmusichall.nl

Since we have no real say in where our tax euros go, funding for this huge music hall was left to a corporation. Enter Heineken. The idea is to bring bands to Amsterdam that draw more people than the city's clubs can handle – and it's doing just that. The problem is that it sucks. It's a big, cold, undecorated box with absolutely no soul, but having said that, they still book some damn good shows – Pixies, Queens of the Stone Age, Nick Cavo, Mos Def et al – so it's worth checking out who's playing here while you're in town. It's located way out by the Amsterdam Arena stadium: From Centraal Station take Metro 54 (direction Gein) to Bijlmer station; from there it's just a two-minute walk.

Maloe Melo - Lijnbaansgracht 163, 🏗 420-4592

www.maloemelo.nl

They call this dive the "home of the blues," but you're just as likely to catch a band playing punk, country, cajun or rockabilly. There's live music here every night, often with no cover. When there is, it's usually €5 or loss. Walk to the back of the bar and you'll find the entrance to another room where the stage is. Don't be shy to push your way up to the front where there's usually a bit more space. This is a good spot to check out local talent, though occasionally they pull in some big names – like the Patti Smith band playing acoustic! If the band is bad, you can always wander next door and see what's happening at the Korsakoff (see Bars chapter). The bar is open from 21:00 (music room from 22:30) until 3 on week nights and 4 on the weekends. Trams: 7, 10, 13, 17. (Map area B5)

Winston International - Warmoesstraat 123-129, ☎ 623-1380

There's all sorts of great stuff happening at this art hotel (see Hotels, Places to Sleep chapter) and nightclub: parties, poetry, art exhibitions, live music. It's a lively, fun spot. They program everything from lounge nights to hip-hop to punk rock to cabaret. The Winston is also the home of several long-running events that have a great reputation and draw loyal regulars, such as the drum'n bass night Cheeky Mondays. The space has been redecorated with a quality sound system, fantastic murals, a wall covered in old speakers, and a multi-functional back-stage room with a remote-controlled sliding wall. It's definitely one of the cooler places in the Red Light District. Cover is usually €5. The entrance is just to the right of the hotel. Open: Sun-Thurs 20-3; Fri-Sat 20-4. (Map area D4)

Bimhuis - Piet Heinkade 3, 🏗 788-2150

Amsterdam's most famous jazz club is in the Music Building (*Muziekgebouw*), about a 20-minute walk east along the water from Centraal Station. Go in the front doors and the Bimhuis is up the stairs to the left. The performance space and café with its view over the water has a fresh, sterile feeling though it still retains a little bit of the intimacy that the old location was known for. The sound quality is excellent. Ticket prices average €10 to €20 and some super-hot musicians play here. There are also regular free events like Tuesday night jams, late night dancing to rare grooves, and laptop/turntable sessions. Concerts at the Bimhuis start at 21:00. From Centraal Station take tram 26 to the first stop east. (Map area G3)

Pacific Parc - Polonceaukade 23, Cultuurpark Westergasfabriek

www.pacificparc.nl

Pacific Parc is one of Amsterdam's most happening newer venues. Bands and DJs perform at this club/café Thursday through Sunday weekly. I saw garage-rock one-man-band gurus King Khan and BBQ performing here together for free (that's a nice price). Local DJ Bone and his trail of bands are regulars. He's known to spin a melange of '60s punk and garage, raw rockabilly, old school hip-hop and skuzzy-sounding beat. Located in Westerpark (see Hanging out) at the Westergasfabriek (see this chapter below). (Map area A1)

Sugar Factory - Lijnbaansgracht 358, 7 627-0008

www.sugarfactory.nl

The Sugar Factory is a small and nicely laid out space that's hip but unpretentious. They present all kinds of music, theater and film, often in an intriguing mix. This is the home of Wicked Jazz Sounds, whose Sunday night parties have become legendary. On other nights the stage is used for plays and videos. And of course there's always dancing. It's right across the alley from the Melkweg (see above). (Map area C7)

Bitterzoet - Spuistraat 2, 2 521-3001

www.bitterzoet.com

The crazy antics of the Drugs Peace House squat that used to be housed in this building are long gone, but the organizers of this intimate club ensure happenings seven nights a week. You can drink and dance to up-and-coming bands and DJs. There's also a theater where innovative performances are staged. And you can use the upstairs pool table for free! The cover charge is usually not more than €5. It's just a few minutes walk from Centraal Station. Open: Sun-Thurs 20-3; Fri-Sat 20-4. (Map area D3)

Pakhuis Wilhelmina - Veemkade 576, 2 419-3368

www.cafepakhuiswilhelmina.nl

There's live music several nights a week in this little venue on the waterfront east of Centraal Station. Bands and DJs play all kinds of music here – bluegrass, rock, funk, country...whatever. The small stage contributes to the intimacy and attitude-free atmosphere of the place. The music usually starts at 21:00 and the cover is around \mathfrak{E} 5. It's close to the Music Building (see Bimhuis, above) and De Cantine (see Bars chapter). From Centraal Station take tram 26 to Rietlandpark, then cross the busy street and walk to the water. The entrance is at the top of the small staircase you'll see in the middle of the Wilhelmina artists' warehouse.

Studio K - Timorplein 62, 🏗 692-0422

www.studio-k.nu

This huge space in Amsterdam's *Indische buurt* in the east is a live-music venue, movie theater, community arts center and café. Currently, Monday night has *Gekkenhuis* (fools house) with DJs spinning "hip-hop, funk, soul etc." – and entrance is free. They also have unknown bands and singer/songwriters who perform here to gain exposure. Check out their site for more info. Located just around the corner from the new Stay Okay hostel (see Places to Sleep). Camping Zeeburg is not far away. (Map area J7)

The Waterhole - Korte Leidsedwarsstraat 49, 2 620-8904

www.waterhole.nl

Tucked away in a little side street off the Leidseplein, this old-school bar has presented lots of live music over the years, although mostly in its former Red Light District location. Bands play every night starting at about 22:30 and there's never a cover charge. It's a rock-and-blues-covers jam-session kind of place. They have a pretty good sound system and a few pool tables in the back. Happy hour when pints are cheap is from 18-21. Open: Sun-Thurs 16-3; Fri-Sat 16-4. (Map area C6)

Goth Stuff - Various Locations

There's not a huge goth scene here, but that just makes it more underground – which is cooler anyway. The first thing you should do is go to the Kagen site (www.kagankalender.com) for listings of goth and goth-related parties and concerts all over Holland and Belgium. It's in Dutch but easy to figure out. Another useful site updated regularly is www.gothicnederland.nl. The infamous Bal du Masque parties are amazing costume affairs with absinthe bars, satanic puppet shows, live bands and people dressed in authentic Renaissance garb. These parties always sell out, so check out www.baldumasque.nl for details and advance tickets.

King Shiloh Sound System - Various Locations

www.kingshiloh.com

This international roots-reggae sound system has been around for years presenting dances on a regular basis and operating a recording studio, a record label and a program on pirate Radio 100 (see Radio, below). They play regular gigs at their home base NDSM, the Paradiso (see above) and after most big reggae shows. Admission is usually about €7. Check their website for more info. Stay positive.

Volta - Houtmankade 336, 7 682-6429

www.jcvolta.nl

Free Friday-night parties have been happening every week at this west-side youth center lately. The building's not too big, which makes for a nice, intimate atmosphere, while the high ceilings give some breathing space when it's crowded. On other nights, DJs spin hip-hop, reggaeton, jungle and Brazilian music to a young local crowd. There's often live music of some sort on Thursday nights, and if you're traveling with an instrument, swing by for their free Wednesday night jam sessions. When there is a cover, admission to Volta is usually a very reasonable €5. It's close to Westerpark. (Map area B1)

Westergasfabriek - Haarlemmerweg 8 10, 🏗 586-0710

www.westergasfabriek.nl

This old factory complex consists of 15 recently renovated industrial monuments and their surrounding grounds. It's a fantastic site that hosts music and film festivals, parties and performances. There's a music venue (see Pacific Parc above), movie theatre (see Film), a bakery and a couple of restaurants and cafés. There's also lots of parkland that's popular with picnickers, dog-walkers and stoners tossing discs. It's a 30-minute walk from Centraal Station, or take bus 18 or 22. (Map area A1)

Akhnaton - Nieuwezijds Kolk 25, 🏗 624-3396

www.akhnaton.nl

Well-known for its African and Latin American music nights, Akhnaton also features hip-hop and techno parties, dancehall and reggae nights and the occasional jazz/funk jam. And Angela Davis spoke here once! African and salsa nights tend to draw a more smartly dressed crowd and it's a bit of a pick-up scene, but the music is really good. It's only a five-minute walk from Centraal Station. Open most Friday and Saturday nights. Admission is usually €7 to €10. (Map area D4)

Theater de Cameleon - Derde Kostverlorenkade 35, ☎ 489-4656

www.decameleon.nl

Theater de Cameleon hosts non-commercial alternative performances on the west side of the city. They present plays, concerts, and regular improv comedy nights with the Easy Laughs crew (www. easylaughs.nl). Every month there's an open stage with comedy, street theater, performance art, and anything else anyone wants to do. It's an international scene, English is widely spoken, and it's always a laugh. Call ahead if you'd like to perform. Admission ranges from €2.50 on the open-stage night up to €10 for other events. Tram 1. Closed in August.

Ruigoord Festival - June 21 and other dates, Ruigoord

www.ruigoord.nl

Almost 30 years ago this town just west of Amsterdam was squatted and turned into a very cool community of artists and free-thinkers. Now, due to a sleazy harbor development project – which turned out to be just an excuse to bury toxic waste! – most of the beautiful nature around the town has been bulldozed and the inhabitants evicted. But there's still a small community of artists here, and they host frequent parties – especially on full-moon nights. Their psychedelic outdoor Summer Solstice bash is legendary as are their *Landjuweel* and *Virige Tungen* festivals. There are also a cafe and regular happenings – including poetry readings, Sunday afternoon singer/songwriter and Americana shows – at the church there, which managed to escape the wrecking ball. For news and directions check their website.

ADM - Hornweg 6, 2 411-0081

www.contrast.org/adm

This huge building on the harbor west of Amsterdam was squatted in 1997 after sitting empty for years. Their opening party featured performances by Bettie Serveert (who played a fantastic set of Velvet Underground covers) and The Ex. ADM is still here, and I've been to some great parties and festivals over the years. In addition to their special events, they also serve a three-course vegetarian meal in their café every Wednesday, Friday and Sunday from 18:00. Because the owner of the building is an evil little fucker, the effort you make to get out here and support the residents will be especially appreciated. If you're not up to the long bike ride, there's usually a shuttle bus that leaves from behind Centraal Station when they have parties. Call in the afternoon to reserve and for directions.

NDSM Werf -T.T. Neveritaweg 15, Amsterdam North, 330-5480

www.ndsm.nl

After forcibly closing most of the affordable spaces for artists and their audiences in the Centrum, the City Council is now helping to fund this complex on the site of a squatted wharf in North Amsterdam, and it's turned into a happening place. The area is still being developed, but there are already big art and theater festivals here, a fantastic skate-park (see Hanging Out chapter), cafes, galleries, and a big monthly flea market (see Shopping chapter). The culture ship Stubnitz docks here yearly from September to December and throws some great parties. There are also plans for more performance spaces, cheap studios and a cinema. A direct ferry leaves regularly from behind Centraal Station and takes about 10 minutes. It's a pleasant ride and the view over the water is gorgeous.

Club 8 - Admiraal de Ruyterweg 56B, 🏗 685-1703

www.club-8.nl

The last couple of times that I played pool at this laid-back west-end club, they were playing killer funk and soul. But whatever the music, it's a cool place to shoot snooker (€9.50/hour) or pool (€8.50/hour), especially for students: for each student who plays a table before 19:30 there's a 25% discount, so if four students play, it's free! There's also a full bar and a restaurant that serves cheap snacks as well as full meals for less than €10. Up one floor via the completely graffiti-laden stairwell is the rest of the club where they present theater, indie dance nights (Club Rascal), queer parties, and a monthly roller disco (www.krupoek.com) where DJ's spin Nu-Soul, Hip-Hop and R&B. Bring some ID for the skate rental. On Friday nights new-agers gather here for barefoot dance meditation. Tram 13. Open Sun-Thurs 12-1; Fri-Sat 12-3.

Plantage Doklaan - Plantage Doklaan 8

www.plantagedok.nl

There hasn't been too much happening lately at this legalized squat, but the space – especially the big hall – is amazing. Past events here include alternative book fairs, student fashion shows, underground restaurants and some great parties. It's not the kind of place you'd just drop into, but if you see flyers around town for an event, check it out.

www.buitenland.org

Way the hell out by the *Amsterdamse Bos* (see Parks, Hanging Out chapter) and the *Nieuwe Meer* (New Lake) is an area squatted by a small group of people who have created "free states" in which to live and work. In terms of public events, *Het Buitenland* is the most active these days. They throw parties along the water, cook up meals, show films (see Film chapter), present bands, and a lot more. It's a fun place to visit if you need a break from the crowds of the city: Even though you're still in Amsterdam, there's a rural feel. Nearby is the Rijkshemelvaartdienst (*www.rijkshemelvaart.com*), an old military compound that was squatted in 1989 and now houses studios and living spaces. Occasionally they present art exhibitions and have been known to throw a whopper of a party. They also have a cheap vegetarian restaurant that's open from time to time. In the past they've combined meals with DJs, films and video reruns of *The Love Boat*. Another squatted terrain in the neighborhood is the Nieuw en Meer (www.nieuwenmeer.nl) that's also an artists' community that sometimes opens its doors to show the residents' work. If you're going to visit out here, make a day of it and explore the Bos. It's tricky to find your way though, so get directions from one of the websites first.

dance clubs

Clubs usually open at about 23:00 and close around 4 or 5:00. Most have a dress code. A group called Unitelife (www.unitelife.nl) sometimes organizes open-house weekends where for a set price (about €20) you can party at over 20 clubs. It's a good deal. For underground parties or events at other locations, you can pick up flyers at bars, coffeeshops and record stores around town. Techno, drum'n'bass, house, electro, trance, hardcore and multi-genre parties are happening frequently, especially in Summer. The Amsterdam Dance Event (www.amsterdam-dance-event.nl), one of Europe's biggest dance and electronic conferences, happens in late October. 5 Days off (www.5daysoff.nl) is an amazing and diverse dance festival happening in mid July at various local venues.

Club More - Rozengracht 133, 🕿 344-6402 www.expectmore.nl

Trendy, Open: Wed-Sun. (Map area B4)

Panama - Oostelijke Handelskade 4, 2 311-8686 www.panama.nl

Trendy. Also a theater. Open: Thurs-Sun. (Map area 14)

De Trut - Bilderdijkstraat 156 www.trutfonds.nl

Gay (mixed). In a legalized squat. Admission is only €1.50. Sunday nights only. Doors open at 23:00 and close at 23:30. (Map area A6)

Jimmy Woo - Korte Leidsedwarsstraat 18, 🏗 626-3150 www.jimmywoo.com

Trendy. Tight door. Open: Wed-Mon. (Map area 7B)

Escape - Rembrandtplein 11, 2 622-1111 www.escape.nl

Popular, especially on Saturday. Open: Tues-Sun. (Map area E6)

Sinners in Heaven - Wagenstraat 3 7, 2 620-1375 www.sinners.nl

Trendy. Open: Thurs-Sat. (Map area E6)

Club Magazijn - Warmoesstraat 170 www.clubmagazijn.com

Relaxed door. Located under a parking garage. Open: Daily. (Map area D4)

Odeon - Singel 460, 2 521-8555 www.odeontheater.nl

Three floors. Also a concert hall. Open: Thurs-Sun. (Map area C6)

Tonight's - Gravesandestraat 51, \$\overline{\alpha}\$ 820-2451 www.hotelarena.nl

In the Hotel Arena (see Places to Sleep chapter). (Map area G8)

Kingdom - Jan Van Galenstraat 6, 2 488-9888 www.kingdomvenue.com

Big space.

The Mansion - Hobbemastraat 2, 616-6664 www.the-mansion.nl

Rich people. Open: Fri-Sat 9-3. (Map area B7)

C.O.C. - Rozenstraat 14. 623-4079 www.cocamsterdam.nl

Amsterdam Roots Festival - Mid-June, Oosterpark

to give some support or receive updated information.

Gay. Mixed dance on Friday nights. Saturday nights are women only. (Map area C4)

music festivals

Amsterdam and the surrounding area have festivals year round, both indoor and outdoor. Most of the ones listed here are free.

Www.amsterdamroots.nl

Music from every corner of the world has been showcased over the years at this amazing festival. Concerts
are staged in several venues around town for which
you need tickets—most notably the Melkweg (see
above)—but there's always a day of free performances on seven stages in the Oosterpark (see Hanging
Out chapter). It's fantastic: there's music, films, Moroccan tea tents, food, and more music. Definitely
try to catch this one. Note: The incompetent Amsterdam City Council that pumps money into ridiculous building schemes has cut funds for the arts. The
Roots festival is in jeopardy. Check out their website

Park Pop - Late June, Zuiderpark, Den Haag

www.parkpop.nl

Europe's biggest free pop festival happens annually at this park—and over 300,000 people usually turn up. Every year sees an interesting line-up of performers playing all kinds of music, but you'll have to truck out to The Hague for this one.

African Music Festival - First weekend in August, Delft

www.africanfestivaldelft.nl

Here's another festival outside of Amsterdam. It's an incredible feast of African music—some of the continent's best and most famous stars play here. Tickets are about €15 if you buy them in advance. There's camping nearby or you can hop a train back to Amsterdam (they run all night).

Parade - Mid-August, Martin Luther King Park

www.deparade.nl

As the sun sets at this old-style European carnival, barkers and performers compete to draw you inside circus-style tents where you'll witness strange, otherworldly spectacles, live slap-stick physical theater and all kinds of weird shit. Admission is free until around 17:00 and then it's about €5. Once inside, most of the attractions also charge an admission fee, but it's fun just to hang out and people-watch, too. The park is in south Amsterdam, along the west side of the Amstel River.

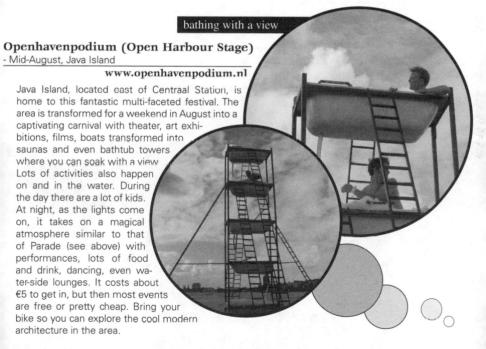

Uitmarkt - End of August, in the City Centrum

www.uitmarkt.nl

To celebrate the beginning of the new cultural season, Amsterdam's streets overflow with theater, dance, film and live music. King Sunny Adé, Redman, and Dick Dale have all played big outdoor shows in recent years. There's something for everyone, and almost everything is free.

Seven Bridges Jazz Festival - Early September,

Reguliersgracht

www.sevenbridges.nl

Amsterdam's youngest jazz fest is a one-day affair that brings together Dutch and international groups. It's a free event that takes place on a floating stage in a canal famous for its picturesque seven-bridges view.

Gospel Festival - Early September, CEC Gebouw, Bijlmerdreef 1289 (Amsterdam Zuid-oost)

www.gospelfestival.nl

This annual event features a wide range of musicians, both local and international, bringing a myriad of styles to a weekend of musical praise. Solomon Burke headlined a few years ago.

musicians

Travelling musicians can rent rooms, for instance with a drum kit, for discount prices. The Jam (Haarlemerweg 315, ☎ 682-2877) has several fully equipped rooms available for individual rehearsal or with a band. They cost €10 an hour for a full band and €3-€4 an hour for solo sessions. A drum kit, PA and amps are included.

Jam sessions happen around town, but most of them are based on cover tunes. Jazz and experimental sessions happen once a week at veggie restaurant/cultural center Zaal 100 (see Restaurants).

street performance

Leidseplein and Dam Square are the two main spots for catching break-dancing, juggling acts, living statues and other street shows. If you're a street artist, these two squares are the places to perform during the summer. Leidseplein can get crowded with groups waiting to do their acts, and sometimes a mafia mentality takes hold and it can be difficult to get a slot from the regulars. Street music is basically acoustic instruments only and no drums of any kind. The cops can be real uptight about these rules and sometimes ask for a permit. But Noordermarkt on Saturdays and Mondays is a great place to busk if you have a small acoustic act.

underground radio

Radio Patapoe - 88.3 FM

http://freeteam.nl/patapoe

Power to the pirates! Except for a few brief down-times, Patapoe has been broadcasting diverse programming over the airwaves since 1989. Most afternoons and evenings (and 24/7 online) they play all kinds of cool music, from psychedelic underground to industrial lounge to the excellent "Punk as Fuck" hardcore show on Friday afternoons. All with no commercials. Yes!

Radio de Vrije Keyser - 96.3 FM

www.vrijekevser.nl

Born out of the late-1970s' radical squat movement, these old-timer ether pirates became famous for their diverse, sometimes crazy programming. They broadcast a mix of politics, squat news and punk music every Tuesday from 12 to 20:00, and they're often on the scene, broadcasting live from demonstrations and squat evictions around town. They also present a great TV show on the local station Salto A1 on Tuesday nights at 20:00.

Radio 100

www.desk.nl/~radio100

Long live Radio 100: Free the airwaves! Until they were forced off the air by greedy pigs who believe the world can never have enough commercial radio, this pirate broadcaster was Amsterdam's biggest independent radio station. They've now merged with on-line partner DFM and continue to transmit a wide range of shows on the internet. They cover many subjects and all types of sounds.

Radio Free Amsterdam

www.radiofreeamsterdam.com

This on-line radio station broadcasts a growing number of shows produced in Amsterdam. They include the John Sinclair Radio Show, for which the famous activist, former manager of the MC5, musician, blues scholar and "Hardest Working Poet in Show Business" travels the world recording shows with killer tunes and an eclectic variety of interviews.

BBC World Service - 648AM

www.BBC.co.uk/worldservice

It's not exactly alternative, but they do have news in English every hour on the hour.

Het Blauwe Theehuis (The Blue Teahouse) - Vondelpark, 2 662-0254

www.blauwetheehuis.nl

This circular spaceship of a building is docked smackdab in the middle of Vondelpark (see Hanging Out chapter). If it's sunny, the outdoor terrace is packed all day with people soaking up the rays. There's a full bar, they serve snacks in the €3 to €5 range from 9 to 16:00, and there are complete meals after that. The bar upstairs opens in the late afternoon, and it's fantastic to sit amongst the treetops as the sun slowly sets. Occasionally there's live jazz upstairs, and on the weekends sometimes there's a party scene with DJs playing anything from rare grooves to soul to Afrobeat. Note that if you stay real late and the park is deserted when you leave it's best not to wander about on your own, however tempting a moonlit stroll might be. Open: daily 9-24, though if it's busy on the weekends they sometimes stay open til 3. (Map area A8)

Cafe the Minds - Spuistraat 245, 🏗 623-6784

www.theminds.nl

This is a comfortably run-down bar with a lot of character – like the collection of combat boots hanging from the ceiling – that's located not far from Dam Square. They have a pool table (only 50 cents!), a good pinball machine (5 balls), and they play punk rock. It's a fun place to hang out and have a drink (beer is €1.25) while you decide where to go next. Open: Daily 21-3 (or until the owner decides to close.) (Map area D5)

Nieuwe Anita - Frederik Hendrikstraat 111

www.denieuweanita.nl

You have to ring a doorbell to enter this squatted hot spot, but once inside it's like drinking in someone's cozy living room. There's a semi-circular bar featuring cheap drinks and plenty of comfy couches. They have a larger back room for bands and parties. The Big Lebowski Night – complete with a movie screening, White Russians and even virtual bowling – and other theme Parties have happened here. You can also catch some of the city's finest established and new underground bands. The Nieuwe Anita is located west, just outside the city center. (Map area A4)

Jet Lounge - Westermarkt 25, 🏗 624-7744

This place might remind you of a small Mediterranean disco with its white walls, neon blue lighting and glitter ball on the ceiling, but Jet Lounge is actually one of the best cocktail bars in the city. Their margaritas, shaken on the rocks, are unbeatable! Happy Hours − all cocktails are €5 − are from 18-21:00 (also 23-24 weekends). A friend of mine swears by the Raging Alcoholic, made with various sorts of rum, orange and pineapple juice and served in a paper bag wrapped bottle. This is a friendly

joint popular with expats, where the American owner is always willing to demonstrate his customized California-style cocktail-mixing skills. Music ranges across the board from 80s punk and metal to minimal techno or whatever fits the mood. Thursday night is like a variety show where bands play acoustic sets and you might even catch some stand-up comedy to put a giggle in your glass. Open Tues-Thurs. 18-1 Fri.-Sat. 18-3 (Map Area C4)

Zool - Oude Leliestraat 9

Located in Amsterdam's historic center, Zool is a small, cozy joint with an incredible selection of alcohol, including at least 16 tequilas, 30 margarita varieties, even a pair of cannabis-infused spirits: vodka and absinthe. During the week it's a daytime bar/café with a varied food menu, coffee and fresh juice. Saturday nights Zool is jumping until late. This place is a comfortable spot to catch a buzz while listening to some rare groove, funk and soul. Need herbal refreshment? The Grey Area is just across the street (see Coffeeshops). Open: Mon-Fri 10-19; Sat 11-late; Sun 11-19 (Map area C4)

De Zotte - Raamstraat 29, 2 626-8694

www.dezotte.nl

This Belgian bar has 130 beers on its menu, most of them ales brewed by Trappist monks. The staff is cool and the music last time I was here ranged from Blondie to the Strokes. It's a loud and fun place that also serves food − veggie meals, steaks, homemade Belgian fries, Trappist cheese plates − nightly from 18-21:30. Food prices are pretty reasonable, starting at around €8,50. De Zotte is conveniently located just around the corner from the Melkweg (see Music) and is a great place to enjoy a nice strong brew before heading to a gig. Open: Daily 16-1; Weekends 16-3 (Map area B6)

Batavia - Prins Hendrikade 85

This roomy Dutch bar/cafe can be found next to the Gothic-style church just across from Centraal Station. The place has two levels complete with a smoking lounge where you can kick back, puff a spliff or a smoke and look out of the big windows over one of Amsterdam's oldest canals. The massive wooden bar was actually delivered in pieces from another Dutch city, reassembled and made into a beautiful piece of work. Batavia has a good selection of bottled beers and sub-zero Jaegermeister on tap. They also offer a full breakfast, lunch and dinner menu plus homemade soups and pies. Sometimes they throw big parties with bands and DJs, like their infamous Halloween bash. (Map area E4)

Weber - Marnixstraat 397, T 622-9910

Before you leave this hangout near the Leidseplein because it seems too crowded, take a peek downstairs and you'll find a basement room decked out with old couches, big armchairs, lots of candles and a little greenhouse. It's a great place to sit around and shoot the shit with some friends, even if the beer is a bit overpriced. Open: Sun-Thurs 20-3; Fri-Sat 'til 4. (Map area B7)

Lux - Marnixstraat 403, 2 422-1412

This funky place is just a few doors down from Weber and done up in much the same style. DJs play here several nights a week, spinning stuff from electro to new wave to drum&bass. Open: Sun-Thurs 20-3;Fri-Sat 'til 4. (Map area B7)

Belgique - Gravenstraat 2, 🏗 625-1974

www.cafe-belgique.nl

This tiny popular bar has eight beers on tap and more than 30 bottled – specializing in Belgian brews. A local and expat crowd regularly spills out on the tiny old alley where Belgique is located. It gets packed! Grafitti artists, such as the London Police, have decorated the outside walls with some incredible pieces. Located off the Nieuwendijk, a five-minute walk from Centraal Station or the Dam. Open: daily 15-1 (Map area: D4)

more A lotiny ked! have dible inute daily

De Koe (The Cow) - Marnixstraat 381, ☎ 625-4482

www.cafedekoe.nl

One block further along the Marnixstraat you'll find this very friendly and unpretentious joint – a warm, pleasant place to escape from

the crowds of nearby Leidseplein and hear some blues or rock. On Sunday afternoons they have live music from 16 to 18:00. There are backgammon sets and other games in the front and they serve inexpensive meals downstairs after 18:00. Open:Sun 15-3; Mon-Thurs 16-1; Fri-Sat 16-3. (Map area B7)

Soundgarden - Marnixstraat 164, 🏗 620-2853

The giant photos of Iggy Pop and Henry Rollins on the wall set the stage for music that's played loud and fast, much to the appreciation of the scuz-lovin' dudes and chicks that hang here. Actually, all kinds of people drop in for a night of pool, darts and pinball. Comfy chairs are scattered about, and the terrace out back, situated on a canal, is a great spot to smoke a joint and have a drink in the summertime. DJs regularly play surf music, garage rock, etc. and Soundgarden occasionally has live bands. Open: Sun 15-1; Mon-Fri 13-1; Sat 15-3. (Map area B5)

Brouwcrij 't IJ - Funenkade 7, 🏗 622-8325

www.brouwerijhetij.nl

For those of you who are in town for only a short time, here's your chance to fulfil two tourist essentials at once: drink a Dutch beer other than Heineken and see a windmill. The *Brouwerij* (brewery) is built into an ancient bathhouse next to this beautiful old mill and sells its delicious draft (with alcohol content up to 9 percent!) to a grateful crowd of regulars in its noisy pub. They also brew a 100% organic white beer and several seasonal beers. On sunny days the terrace is packed, but it's nicer to take your glass across the street, grab a spot at the edge of the canal, and dangle your feet. It's a bit out of the center, not far from the Dappermarkt (see Markets, Shopping chapter) and the Tropenmuseum (see Museums chapter). Open: Wed-Sun 15-20. (Map area H6)

Korsakoff - Lijnbaansgracht 161, 🏗 625-7854

www.korsakoffamsterdam.nl

The Korsakoff is always fun if you're looking to dance to pop-punk, raucous rock, industrial, metal and the odd tune by Prince. Traditionally, a fairly young crowd comes here and it gets packed on the weekends. But there's music every night, drinks are cheap, and upstairs is another cool bar if you just want to hang out and listen to the tunes. Buzz to get in. Open: Sun-Tues 23-3; Wed-Thurs 10-3; Fri-Sat 10-4. (Map area B4)

bars

Kashmir Lounge - Jan Pieter Heijestraat 85-87, 2 683-2268

The Kashmir Lounge is entirely adorned with Indian metal-work lampshades, embroidered fabrics, and colored-glass candle holders. One incense-drenched room is furnished with patterned carpets, pillows decorated with mirrors, and low wooden tables. This place was a bar/coffeeshop until a couple of years ago, when the city banned the sale of weed and alcohol in the same establishment. It's still smoker-friendly – you can bring your own or grab a bag across the street at one of the tiny neighborhood coffeeshops. DJs play from time to time and then the place gets pretty packed. In the afternoons the music usually has a good groove and it gets very mellow. There's a little terrace out front that opens in the summer. Kashmir Lounge is located not too far from the Ten Kate Market (see Shopping chapter). Open: Mon-Thurs 10-1; Fri-Sat 10-3; Sun 11-1. (Map area C6)

Kingfisher - Ferdinand Bolstraat 24, 🏗 671-2395

Located in a district known as *De Pijp* (pronounced Pipe), the Kingfisher is an ideal place to plop your ass down and rest a bit after exploring the neighborhood. Light streams in through the corner windows during the daytime, and it's a casual, comfortable place to linger over a light meal and a drink. In the evenings, it's a warm and mellow hangout. And at night, when the alcohol starts flowing, it becomes a lively local bar. Open: Sun 12-1; Mon-Thurs 11-1; Fri-Sat 11-3. (Map area C8)

Getto - Warmoesstraat 51, 2 421-5151

www.getto.nl

This queer hangout is very different from the famous leather bars that share this strip of the Red Light District. It's a restaurant and bar that's decked out in an arty, comfortable style and it draws a fashionable mixed crowd. In fact, in stark contrast with all the other bars in the area, there are probably more women here than men. Occasionally there are special theme nights, and anytime there's bingo expect a full house. Getto is open: Tues-Thurs 16-1; Fri-Sat 16-2; Sun 16-24. (Map area E4)

Café Padre - Mollukenstraat 2

Located east in the *Indische* neighborhood, you'll find this bar/café. Reggae is the music of choice here as well as jazz and soul; Friday nights DJs spin and it can get packed with locals. The back room, called the Zenergy Lounge, is extremely smoker friendly, joints and cigarettes can be leisurely puffed. They have authentic homemade Surinamese food (dish of the day for €7.50) as well as delicious sandwiches starting at €2.50. Café Padre is located around the corner from Stay Okay (see Hostels) and Studio K (see Film, Live Music). This spot is a great stop if you're heading from Camping Zeeburg to the Center, as it's located en route. Drop by and say hello to Maurits, the super cool owner, settle in and experience some real Amsterdam vibes. Be assured you will be the only tourist, except perhaps another Get Loster. (Map area J6)

Lime - Zeedijk 104, 🏗 639-3020

Whether you're looking for a chill place to hang with a few friends or just want to have an intimate one-on-one conversation, this is a nice place to lounge for a while – especially earlier in the evening before it gets too crowded. The well-designed interior and arty decor make the space feel bigger than it is, and fresh, like the name. Open: Sun-Thurs 17-1; Fri-Sat 17-3. (Map area E4)

De Buurvrouw - St Pieterspoortsteeg 29, 🏗 625-9654

www.debuurvrouw.nl

As well as booking local bands (usually acoustic so the neighbors don't complain), this bar also features DJs, organizes pool tournaments and hosts open stage nights for stand-up comedy, music and poetry. The place is decorated in an arty mish-mash of styles and one wall is regularly used to display new works of art. It's a good late-night spot that gets super busy on the weekends. Open: Mon-Thurs 21-3;Fri-Sun 21-4. (Map area D5)

De Duivel (The Devil) - Reguliersdwarsstraat 87

The Duivel was Amsterdam's first hip-hop bar. Over the years they've kept to their roots, though don't

be surprised if their DJs throw in a little funk here or some dub there. The space is small and dark and on the weekends it can get uncomfortably crowded, but the vibe is always cool. No problem smoking a jay here, of course. Yes, yes y'all. Open:Sun-Thurs 20-3;Fri-Sat 'til 4. (Map area D6)

Diep - Nieuwezijds Voorburgwal 256, 🏗 420-2020

Diep, just around the corner from Dam Square, is a cool little bar where anything can happen: crazy nights or lazy nights, jam sessions, barbeques, DJs of every level and style and local hipster spotting. Out front, weather permitting, there's a bustling terrace. It's popular with Amsterdammers, thus a good place to observe or mingle with the native wildlife. (Map area C5)

Barney's Uptown - Haarlemmerstraat 105, 🕿 427-9469

www.barneys.biz

This joint friendly bar/restaurant has taken the breakfast from the famous Barney's Breakfast Bar, the latter still a popular coffeeshop across the street. They serve pancakes and full breakfasts 'till late. At night the fully-stocked bar is a relaxing place to have a drink and a spliff. 90s New school hip-hop was the music *du jour* last time I visited, but everything from reggae to Hendrix is possible. DJs regularly spin here and they have various parties and nights happening (check their website). (Map area D2,3)

Vakzuid - Olympisch Stadion 35, 🏗 570-8400

www.vakzuid.nl

The 1928 Olympics were held in Amsterdam and the stadium built for the occasion was recently renovated, with this restaurant/bar now housed in the south side. The food's too expensive for me – actually, so are the drinks – but I love the lounge downstairs. With its low, comfortable couches and fake fireplaces, it looks like a 1970s suburban den and the view of the track and field is awesome. There are DJs a few nights a week, but for truly relaxed lounging I recommend weekday afternoons when the place is almost empty. In the summer there's a cushy terrace out front – ideal for recovering from the long bike ride out here. Open: Mon-Thurs 10-1; Fri 10-3; Sat 12-3; Sun 12-1.

Sappho - vijzelstraat 103, 🏗 423-1509

www.sappho.nl

Sappho is a lively women's bar located in a little storefront on a rather desolate stretch of the Vijzel-straat. Early in the evenings it can be a bit desolate inside as well, but usually the DJs have the joint jumping by 11 o'clock – especially at their popular Friday night events. Open: Sun, Tues-Thurs 18-1; Fri-Sat 18-3. (Map Area D7)

Cafe Saarein 2 - Elandsstraat 119, 2 623-4901

www.saarein.nl

This famous old-school dyke bar was one of the first women-only spaces in town. It's still a gay cafe but also caters to a mixed clientele. The neighborhood and the building are both pretty and interesting, and it's a pleasant place to stop in for a meal or a beer and a game of pool or pinball. Open: Sun-Thurs 17-1; Fri-Sat 17-2. (Map area B5)

Gollem - Raamsteeg 4, 🏗 330-2890

www.cafegollem.nl

With over 200 mostly Belgian beers in stock, even the most serious beer lovers will be able to find one they've never tasted. Lists of what's available, including some beers that are exclusive to Gollem, are posted on blackboards around the pub, there are always 10 beers on tap, and each brand of beer is served in a special glass. The bar itself is comfortable but a bit ramshackle and also quite small, so a good time to stop by before it gets packed is just after opening. Or you can check out their newer bar in De Pijp neighborhood (Daniel Stalpertstraat 74). Gollem is very popular with locals and tourists alike, and you might spot the odd beer-brewing Trappist monk in the house, silently checking out the competition. Open: Sun 14-1; Mon-Thurs 16-1; Fri-Sat 14-3. (Map area C5)

De Cantine - Rietlandpark 373, 2 419-4433

www.decantine.nl

The Canteen was once a squat, one of many that used to operate throughout this neighborhood. Now it's a stylish cafe that serves snacks and full meals, though I like stopping in for beer and whiskey on Sunday afternoons when there's live music. Bands start at 16:00 and play anything from jazz to Americana to rock. On Friday nights DJs spin cool and funky tunes until the wee hours. The decor here is clean and simple – the space is also used for art exhibitions – but not cold. They have free wireless internet and, in warm weather, a really nice terrace out front. It's right across the street from the Lloyd Hotel (see Places to Sleep chapter) and it's a pleasant place to break up the trip if you're riding out to explore the modern architecture on the islands just east of here. Open: Sun-Thurs 11-1;Fri-Sat 11-3. (Map Area I4)

www.azart.org

This old ship and its performing crew have been in *Get Lost!* since the very first edition. Since then the artists on board have spent years sailing the world, but they always come back to Amsterdam where they dock in the same old spot on KNSM Eiland. When they're here, the bar opens once or twice a week around 22:00 and the fun begins. There's usually live music, plays, poetry, dancing and anything else the residents dream up during the week. It's a little grungy – the toilet's only for women and guys are expected to pee off the edge of a plank into the water (it feels great!) – but the atmosphere is fun and very welcoming. It's a bit of a trek out here, so you might want to combine it with dinner at End of the World (see Restaurants, Food chapter). Ride your bike or take bus 42 from Centraal Station (direction KNSM Eiland) or night bus 359 (ask the driver to let you off at Azartplein). (Map area J3)

PINT Bock Beer Festival - Late October, Beurs van Berlage, Damrak 277

www.pint.nl/pint/bbf.htm

Every October, beer lovers gather for this three-day festival of bock beer (a traditional lager brewed at the end of harvest season when hops and barley are at their peak). The festival is almost 30 years old and is the biggest celebration of beer in the Netherlands. Once you've paid your €5, there are over 50 bocks to try. Have fun, but be careful or you might find yourself driving the porcelain bus. (Map Area D4)

De Bierkoning (The Beer King) - Paleisstraat 125, 🏗 625-2336

www.bierkoning.nl

It's not a bar, but if you're into beer you'll love this shop located just a stone's throw from Dam Square. Wall to wall, ceiling to floor, beer awaits you in bottles of every shape and size. They have over 950 beers available! It's all neatly arranged by country, with an entire wall devoted to Belgian brews. You can grab a cold one to go, or if you're flying home from Amsterdam, some of the more exotic beers make great presents. Check out the special offers – free beer mugs with certain purchases, and 10 free beer coasters with every purchase (hey, free is free). The only beer I didn't see here was Duff. Open: Mon 13-19; Tues-Fri 11-19 (Thurs 'til 21); Sat 11-18; Sun 13-17. (Map area D5)

The great thing about seeing a movie in Amsterdam is that the Dutch never dub films: They're always shown in their original language with Dutch subtitles.

Prices at the mainstream theaters range from €8 to €12 with evenings, weekends, and holidays the most expensive. Some longer movies may cost even more, so always ask the price. Students with an ISIC card get a discount. And the City, Munt, and Tuschinski sometimes offer cheaper morning screenings.

In keeping with the global trend, big chains are driving most of the independent theaters in Amsterdam out of business, but the few still managing to hang on are included in the list below.

For movie listings pick up the Film Agenda, a free weekly listing of what's playing. It's published every Thursday and is available in bars and theaters. Each of the big commercial cinemas also posts a schedule of all current first-run screenings near their main entrance. The AUB (see Music chapter) has the schedules of most of the independents, and *Amsterdam Weekly* (see Practical Shit) also lists mainstream and alternative film events. On-line, you can find out what's playing at: http://amsterdam.filmladder.nl.

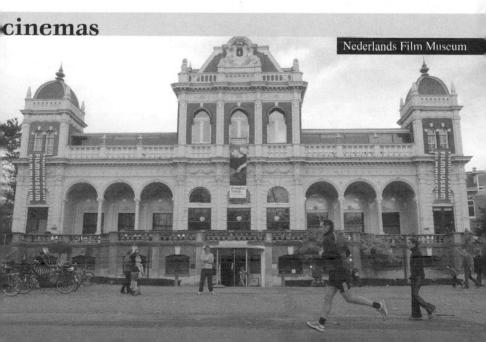

Tuschinski - Reguliersbreestraat 26, 2 626-2633

www.tuschinski.nl

This incredible Art Deco theater opened in 1921 and has been restored to its original splendor. It might just be the most beautiful movie theater anywhere. The prices are a bit higher than some of the other cinemas in town, but it's worth it to watch a film from the comfort of the plush seats in the main hall (Theater #1). Occasionally classic silent films are screened with live organ music: quite an impressive spectacle. Go early so you'll have time to take in all the details of the ornate lobby and café – not to mention the elaborate restrooms! (Map area D6)

Nederlands Film Museum - Vondelpark 3, 25 589-1400

www.filmmuseum.nl

This museum/cinema/café is situated in a big old mansion in Vondelpark (see Hanging Out chapter). They screen a couple of different films every day in their two pretty little theaters. The admission price is €7.80, which includes admission to their temporary exhibitions. You can pick up a monthly listings magazine in the lobby. It's in Dutch, but check where the film was made: They show many from the US (VS) and Britain (GB). Also, many of the foreign films have *engels ondertiteld* listed under the title, which means English subtitles. They feature everything from old black-and-white classics to rock & roll films to women-in-prison flicks. I had a beautifully creepy experience here seeing the original edit of *The Shining* on the big screen. Every Friday night in the summer – weather permitting – a big screen is set up and movies are screened outside. You can enjoy a drink at the café (see Vertigo, Cafés chapter) – a pleasant pre-film experience. (Map area A8)

Filmhuis Cavia - Van Hallstraat 52 1, 2 681-1419

www.filmhuiscavia.nl

This little 40-seat cinema lies just west of the Centrum up over a boxing club. Their program is creative and unique, including a monthly "Straight to Video" night featuring horror, sci-fi, blaxploitation and sexploitation. They sell cheap beer in their café and admission is a very reasonable €4. Most films start at 20:30. Closed in summer. (Map area A2)

Kriterion - Roeterstraat 170, 🏗 623-1708

www.kriterion.nl

There's always an interesting mix of first-run and classic films being shown at this student-operated art-house cinema. Especially popular is the "Sneak Preview" – a surprise screening of a new film every Tuesday at 22:00 (€4.50). Every so often they host parties with DJs and VJs playing into the night. The café in the lobby is busy but relaxed, and you can bring your glass of beer right into the theater. Admission: Weekdays €7; Weekends €7.50. (Map area F7)

Studio K - Timorplein 62, 🏗 692-0422

www.studio-k.nu

International mainstream and art-house films are screened here at this east side theater/café/live music venue. It's got a fresh, local, multi-cultural vibe and there's always something happening here. Located around the corner from Stay Okay (see Places to Sleep). (Map area: J7)

Cinema de Balie - Kleine Gartmanplantsoen 10, 🏗 553-5100

www.debalie.nl

The Balie is a true multimedia center: film house, gallery, theater, and WiFi connected cafe. The two cinemas here show very cool films and many are in English. Although the screen isn't very large in the smaller hall, the seats are much more comfortable. A lot of special events take place here, too: organizations as diverse as the Dutch Transgender Filmfestival and the Africa in the Picture Festival present rare and hard-to-find films. Talks and debates often follow the screenings. Outside is an interesting an installation: Every night from October to April films are projected onto a screen high up on the side of

the building (www.debalie.nl/straal). Take a look as you pass by. De Balie is located just off the Leidseplein. Their schedule is in Dutch and English. (Map area C7)

Melkweg Cinema - Lijnbaansgracht 234 A, 🏗 531-8181

www.melkweg.nl

Upstairs at the Melkweg (see Live Venues, Music chapter), there's a small cinema that shows intriguing retrospectives – films by Cronenberg, classic porn, martial arts and music features, for instance. Films cost €6 and usually start at 20:00. Sometimes they have midnight screenings too. (Map area C7)

The Movies - Haarlemmerdijk 161, 2 638-6016

www.themovies.nl

A mix of new mainstream and art films play in the four small halls that comprise this theater. They also have a popular late-night program just after midnight on Friday and Saturday nights. This is the oldest cinema that's still in use in Amsterdam and its little Art Deco lobby is quite lovely. Admission: 68. (Map area C2)

Cinecenter - Lijnbaansgracht 236, 🏗 623-6615

www.cinecenter.nl

On Sunday mornings at 11:00 the two small theaters here screen new features for only €5. The rest of the week they charge €7 for matinees and €8 evenings, weekends and holidays. The program consists mostly of foreign films, so make sure to confirm that the subtitles are in English. The Cinecenter is located right across the Lijnbaansgracht from the Melkweg (see above). (Map area C7)

anat right above).

le Uitkijk - Prinsengracht 452, 🏗 623-7460

www.uitkijk.nl

When it opened in 1929, de Uitkijk was only the fourth art-house cinema in Europe. With help from some excellent volunteers they still show arty first-run stuff that most of the big theaters ignore. And with the recent addition of digital screening capabilities they now offer even more alternative content. The Jewish Film Footival (www.joodsfilmfestival.nt) takes place here in November. It's located right off the Loidcootroot. (Map area C7)

Rialto - Ceintuurbaan 338, 🏗 676-8700

www.rialtofilm.nl

The Rialto is another independent partly run by volunteers. It's located just south of the Albert Cuyp market (see Shopping chapter). They show some interesting – but mostly foreign – films in their two theaters, so remember to check the language of the subtitles before you enter. Admission is €7.50 Mon-Thurs and €8.50 on the weekend. On Friday afternoons at 17:00 persons under 25 years of age can attend the Rialto's special Moviezone feature (www.moviezone.nl) for only €4.50. In August they sometimes show free films outdoors in the Heinekenplein.

Het Ketelhuis - Haarlemmerweg 8 🏗 684-0112

www.ketelhuis.nl

This is the first and only cinema dedicated exclusively to Dutch film. If it's Dutch they'll screen it—popular, obscure, short, animated – even films made for TV. It's quite unique. The theater is located on the grounds of the Westergasfabriek (see Music chapter). If this sounds interesting to you, it's worth giving them a call as some of the programs have English subtitles. (Map area A1)

Smart Cinema - Arie Biemondstraat 101-111, 2 427-5951

www.smartprojectspace.net

Located in part of a former hospital that now houses the Smart Project Space, the Smart Cinema shows experimental films and videos as well as "alternative" Hollywood films (Coen Brothers, Davic Lynch) in two comfortable small halls. There are free video screenings here every Wednesday and Sunday afternoon. (Map area A7)

Biotoom 301 - Overtoom 301, 778-1145

http://squat.net/overtoom301

This 100-seat cinema is just one of the many cool projects going on at the OT301 squat (see Party Venues, Music chapter). Films are shown a couple of days a week and the programming runs from classics to political documentaries to experimental films. To find the theater, walk to the back of the building and up the stairs. There's a great bar up there too, open at the same time as the theater. Admission is just $\mathfrak{C}3$, or $\mathfrak{C}4$ for a double feature. (Map area A7)

Tropeninstituut Theater - Linneausstraat 2, 🏗 568-8500

www.kit.nl/tropenmuseum

This theater attached to the Tropenmuseum shows rarely-screened international films that often complement special exhibits at the museum and are presented in series – a month of comedies from Iran for example. The subtitles are usually in English, but call or check their website to make sure. Admis sion: €6. (Map area H7)

De Munt - Vijzelstraat 16

De Munt – named after Amsterdam's historic mint right across the street – is a megaplex with 13 halls showing the standard Hollywood fare. But on Tuesdays all films are €6 instead of the regular €9. And films shown before noon are only €4.50. It's modern, clean and comfortable. (Map area D6)

The City - Leidseplein, 623-4570

This cinema is totally mainstream, but the giant screen in Theater #1 is great for big special effects movies. Go to the Jamin candy store around the corner at Leidsestraat 98 to get your munchies before the film. (Map area C7)

Imax - Arena Boulevard 600

www.patheimax.n

Though not as big as most of its North American counterparts, Holland's first Imax is pretty damn nice They charge a whopping €12 (€7.50 before noon) for the newest blockbusters, and sometimes they present Imax 3-D productions. If you're serious about special effects then it's worth the trek out here for the state-of-the-art experience. It's right next to the H******n Music Hall (see Music chapter) and the giant Arena stadium. From Centraal Station take the Metro 54 to Bijlmer station: it's right there.

miscellaneous film stuff

Amnesty International Film Festival - 2773-3624

www.amnesty.nl/filmfestiva

The Amnesty International Film Festival is an annual five-day event focusing on human-rights issues Films and videos are screened at the Balie, Filmmuseum and City theaters (see above). Check their website to see when the next one is scheduled.

Amsterdam Fantastic Film Festival - April, 679-4875

www.afff.nl

AFFF started out over 20 years ago as an all-night horror- and gore-fest but has broadened into a weeklong event encompassing a wide range of films falling under the fantasy heading; sci-fi, thrillers, anime, cult films, and of course horror – they still present a "Night of Terror" every year. They also have director-retrospectives, symposia and lots of premieres: they brought *Kung Fu Hustle* to Holland. That's cool in my book. Films are screened at the Melkweg and other cinemas.

Pluk de Nacht - Late Summer

www.plukdenacht.nl

Pluk de Nacht is a free, open-air mini-festival that takes place at Amsterdam Plage (see Beaches, Hanging Out chapter) every August. Each night over an 11-day period, international feature films and shorts are projected onto a giant screen on the beach. Almost all of them are in English or have English subtitles. Drinks and food are available and they have other fun stuff going on during the festival like old-school Pong tournaments. Recently this festival has also held indoor screenings at other theaters like the Kriterion. From Contraal Station you can take bus 48 and get off at Barentzplein, or you can walk it in about 25 minutes.

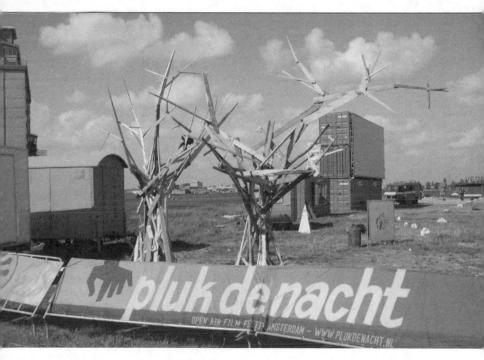

nternational Documentary Film Festival (IDFA) - Late November, 2 627-3329

www.idfa.nl

If you're in town at Cannabis Cup time, look out for info on this famous festival. It's the biggest of its kind, with over 300 documentary films screened at several theaters around Amsterdam. Special events include film-maker retrospectives and programs like "Docs Around the Clock" – a whole night of films with breakfast served in the morning. You can find the program at the AUB (see Music chapter) and De Balie (see above).

Shadow Documentary Film Festival - Late November

www.shadowfestival.nl

This festival runs parallel to IDFA but focuses more on experimental documentaries, often by unknowr directors. Films are shown in the intimate setting of the Melkweg Cinema, as well as the Uitkijk and Filmmuseum (see above), and the public is able to meet and talk with the film-makers after each screening.

Black Soil International Hiphop Film Festival - Late November

www.blacksoil.com

All things hip-hop are covered in this long-weekend festival of film, music, workshops and parties. The Balie (see above) hosts this event, and admission is €7 per screening. It's an international affair with con tributions from artists all over the world, though many are in English. This year's festival was in Rotterdam so check their website for location information. Expect DJs, MCs. graffiti, and break dancers galore.

Roze Filmdagen (Pink Film Days) - Every other December (even years)

www.rozefilmdagen.n

In the past, themes at this gay-and-lesbian film fest have run from horror to religion to the "inevitable fate" of homosexual characters in movies. And of course there's always some porn. Though some o the program is culled from other, bigger queer festivals, it remains a somewhat underground even and a good opportunity to catch rarely screened works. Films and videos are shown at the Cavia, Balie and the Filmmuseum (see above).

Netherlands Film Museum Library - Vondelstraat 69-71, 🏗 589-1435

www.filmmuseum.n

This library is a project of the Netherlands Film Museum (see above) and lies right at the edge of Von delpark. It's a bright, airy space that's perfect for browsing if you're a film lover. A large percentage o their 17,000 books are in English, and there are over 1,700 magazines too. You can't check books out but there is a photocopier in the back. When you're finished, you might want to head up the street to Manege Café (see Cafés). Open: Tues-Fri 10-17; Sat 11-17. (Map area A8)

De Filmcorner - Marnixstraat 263, 2 624 1974

This little shop is packed with used videos and films at good prices. They're mostly porno, but there's also weird shit like super-8 Bruce Lee films and Jerry Lewis movies dubbed into German. Open: Mon Fri 9-12 and 13-17:30; Sat 9-16. (Map area B4)

The Silver Screen - Haarlemmerdijk 94, 🏗 638-1341

www.silverscreen.n

New and used books and magazines all about film. Lots of good stuff to browse through here, including posters, cards, DVDs, videos and laser discs. They're also known for their large collection of horro and cult films. Other places to look for this kind of stuff are Cine Qua Non (Staalstraat 14; 625-5588 and, for posters, De Lach (1e Bloemdwarsstraat 14). The Silver Screen is open: Mon-Fri 13-18; Sat 11 18. (Map area C2)

Drijf-In - Het Buitenland - Oude Haagseweg 51

www.buitenland.org

OK, it doesn't happen regularly, but several times during the last couple of summers the organizers of Het Buitenland (see Music chapter) created a floating cinema. The screen is on the water and so is most of the audience, who arrive by boat (boats can be rented at the nearby Amsterdamse Bos; see Hanging Out chapter). You can watch from land, too. You need a radio to pick up the sound, and a flashlight is handy for flagging down the floating cocktail bar and snack boats. There are usually other performances and DJs too. It's a bit tricky getting out here: from Centraal Station take Metro 50 to station Zuid/WTC and change to Metro 51 (direction Gein). Get off at Henk Sneevlietweg, transfer to bus 164 (direction Schiphol), get off at Oude Haagseweg and walk 5 minutes. Or fuck all that and just ride your bike.

www.cultvideo.nl

As a tourist, you probably won't end up here, but this was the first cool video and DVD rental outlet in Amsterdam. They have an impressive collection of over 5,000 videos including foreign films, sexploitation, cult and trash, anime and a lot more. In the basement they sell second-hand videos and DVDs too. Open: Daily 13-22. (Map area E6)

Sex and lots of it: it's a big part of tourism in Amsterdam. The Red Light District is always crowded, colorful, and deliciously sleazy. It's located just south-east of Centraal Station in the city's oldest district. You'll find streets and alleyways lined with sex shops, live sex theaters and rows and rows of red lights illuminating the windows of Amsterdam's famous prostitutes. This area is pretty safe, but women on their own sometimes get hassled and may want to tour this part of town during the day. Everyone should watch out for pickpockets. Amsterdam's City Council is trying to "clean up" this centuries-old area by kicking out prostitutes and opening fashion boutiques. Businesses in the area have launched a campaign, "Hands Off de Wallen," against this insane action. Type this phrase into any search engine for the latest developments or check www.ignatzmice.com (see below.)

There's also a smaller Red Light area around Spuistraat and the Singel canal near Centraal Station. And another, frequented mainly by Dutch men, runs along Ruysdaelkade by Albert Cuypstraat. But while the Red Light Districts are concentrated in these areas, several of the places I recommenc below are in other parts of the city.

In case you were wondering, the services of a prostitute in the Red Light District start at €50 for a blow job and/or a fuck. At that price you get about 15 to 20 minutes. The condom is included free of charge. For detailed information about the area check out *www.ignatzmice.com* where you'll find printable walking-tour maps, detailed descriptions of each alley and its specialties, and reviews of shows, sex clubs, and the girls themselves.

sex shops

You'll find sex shops everywhere in the Red Light District and you should definitely take a peek inside one. These places all carry roughly the same selection of sex toys, magazines and movies, ranging from really funny to seriously sexy to disgusting. Remember that videos and DVDs play on different systems in different parts of the world. If you buy one, make sure to ask if it will play on your machine back home. The European system (except for France) is called PAL. North America uses NTSC. Also, most of the cheap stuff is of poor quality: you get what you pay for. For better quality goods I'd recommend the following shop:

Female and Partners - Spuistraat 100, 🏗 620-9152

www.femaleandpartners.nl

This is the coolest and classiest sex shop in Amsterdam. It's women-run and offers an alternative to the very male-dominated sex industry. Inside you'll find a wide range of vibrators, dildos and other sex articles. They're always expanding their selection of books and movies, and they also have some incredibly sexy clothes that you won't find elsewhere. The PVC and latex wear is particularly impressive. Everything in the shop is also available via their very efficient mail order service. Stop in for info on fetish parties. Open: Sun-Mon 13-18; Tues-Sat 11-18 (Thurs 'til 21). (Map area C5)

Absolute Danny - Oudezijds Achterburgwal 78, ☎ 421-0915

www.absolutedanny.com

This fetish shop is also women-run and you can tell the difference soon as you walk in. It's much more stylish than the nearby sex stores here in the Red Light District. Single women and couples will feel comfortable shopping here. They stock sensual clothing for men and women, bizarre DVDs and lots of S/M accessories. The owner, Danny, designs a lot of the clothes herself. Open: Daily 11-21. (Map area E5)

Condomerie Het Gulden Vlies - Warmoesstraat 141, 7 627-4174

www.condomerie.com

This was the very first condomerie in the world – and what a selection! There's also an amusing display of condom boxes and wrappers (see Museums chapter). The laid-back atmosphere here makes the necessary task of buying and using condoms a lot of fun. Open: Mon-Sat 11-18, (Map area D4)

Nolly's Sexboetiek - Sarphatipark 99, 🏗 673-4757

In the back of this shop a friend of mine found a bunch of dusty, straight and gay Super-8 and 8mm films from the '60s and '70s for around €4 each – interesting for collectors. Nolly also has a big selection of magazines, some not available in the Red Light District. Open: Mon-Fri 10-18, 3at 10-17.

Blue and White - Ceintuurbaan 248, 2 610-1741

Not far from Nolly's is another sex shop in the neighborhood of the Albert Cuyp Market (see Markets, Shopping chapter). Blue and White has been open for 30 years and has all the required stuff plus a bargain bin full of dildos, other toys, and discount videos. Open: Mon-Fri 9:30-18 (Thurs 'til 21); Sat 12-17.

Miranda Sex Videotheek - Ceintuurbaan 354, 🏗 470-8130

This video store boasts over 10,000 videos. Its two floors are loaded with more porn than you can shake a stick at. You'll find just about every kink and perversion you can imagine, and probably some that you can't. Open: Daily 10-23.

The Bronx - Kerkstraat 53, ☎ 623-1548

www.bronx.nl

This sex shop for gay men has an impressive collection of books, magazines and DVDs – including a section dedicated solely to queer skateboarding films. There are also leather goods, sex toys and the biggest butt plug I've ever seen! In the back there are some private cabins. If you get really worked up you can run across the street to *Thermos Night* (Kerkstraat 58; 623-4936; www.thermos.nl; opens at 23:00), where €18 (€13 if you're under 24) gets you saunas, films, bars, and lots of sweaty guys. Bronx is open: Daily 12-24. (Map area C6)

13

peep shows and live sex

There are several peep-show places scattered around the Red Light District. I went into one and this is what I peeped: In a room the size of a telephone booth I put a two-euro coin in a slot and a little window went up. Lo and behold there was a young couple fucking on a revolving platform about a meter from my face. It wasn't very passionate, but they were definitely, like, doing it. Two euros gets you about 90 seconds. Then I went into a little sit-down booth and for yet another two euros I got a couple of minutes of a video peep show. There is a built-in control panel with channel-changer and a choice of over 150 videos. Everything is there, including bestiality, scat, and roman showers. The verdict? Well, I found it interesting in a weird sort of way. There were mostly men peeping, obviously, but there were also some couples looking around. If you're curious, you should go take a look: nobody knows you here anyway.

Sex Palace - Oudezijds Achterburgwal 84 (Map area E5) Sexyland - St. Annendwarsstraat 4 (Map area E4)

In the name of research I also saw a few sex shows. At some you can bargain with the doorman and the average admission price ends up being about €20. Inside an appropriately trashy little theater, women strip to loud disco music. Sometimes they get someone from the audience to participate by removing lingerie or inserting a vibrator. Then a couple will have sex. It's very mechanical and not very exciting, but it will satisfy your curiosity. At other shows, like Casa Rosso (Oudezijds Achterburgwal 106; 627-8954; www.casarosso.com), you pay a set price of €30 (or €45 including 4 drinks) to sit in a clean, comfortable theater and watch better-looking strippers and couples. Again, it's not really sexy, but the show was more entertaining. I especially liked one couple who did a choreographed routine to Mozart's Requiem – very dramatic!

miscellaneous sex stuff

Fetish Parties

Amsterdam is famous for its fetish parties, where people can dance and socialize in an open manner as well as enjoy the dungeons, darkrooms and play areas provided. There's always a strict dress code – leather, latex, etc. For a listing in English of all the parties around town, go online to Fetish Lights (www.fetishlights.nl) or pick up flyers at Female and Partners (see above).

Prostitution Information Centre (PIC) - Enge Kerksteeg 3, 🛣 420-7328

www.pic amsterdam.com

The PIC offers advice and information about prostitution in the Netherlands to tourists, prostitutes, their clients and anyone else who may be interested. It's located in the Wallenwinkel (www.dewallenwinkel.nn) in the heart of the Red Light District and is open to the public. Inside you'll find pamphlets, flyers, and books about all aspects of prostitution. They also organize tours of the area, and sometimes they host lectures. The shop sells T-shirts, cards and other souvenirs. Open: Tues-Sat 12-19. (Map area E4)

Same Place - Nassaukade 120, 2 475-1981

http://www.sameplace.nl

There are lots of sex clubs in Amsterdam, but this one is unique because it bills itself as a "woman-friendly erotic dance café" and the cover charge ian't too expensive. Everyone is welcome: singles, couples, dykes, fags, fetishists, exhibitionists, transsexuals, and anyone else, but make sure you dress up. They have piercing and body-painting nights, kinky parties in their cellar (which has a dark-room and S/M corner), and sometimes women-only parties. Monday nights are men only. Sunday nights are for couples. Open: Sun-Mon 20-3; Tues-Sat 22-4. (Map area B4)

Women of the World - 25 584-9651

www.womenoftheworld.nl

This fully legal escort service is owned and run by women, and it has an excellent reputation. The belief of the agency is that the personality of the escort is as important to a successful sensual encounter as her body, and it shows in their hiring policies. All the women who work for WOW are well educated, intelligent and imaginative. And hot, of course – check out the profiles on their site. If you go in for this sort of thing and have the money (it's very expensive), these are the sex workers you should be supporting: women who have taken control of their chosen profession and, as a result, are making their lives and those of their colleagues healthier and safer. Couples are also welcome to call.

a note about prostitution

Because prostitution in the Netherlands has not been forced underground, it is one of he safest places in the world for sex-trade workers and their clients to do business. The status of prostitution in Holland was recently changed from "decriminalized" (subject to pragmatically suspended laws, as with soft drugs) to "legalized" (subject to the same aws as any business).

n spite of this progressive legal climate, however, sex-trade workers remain socially tigmatized and are often still exploited. They're required to pay income tax yet coninue to report having difficultly opening bank accounts or arranging insurance policies if hey're honest about the nature of their work. As a result, many of them continue to lead double life, and this is one of the reasons they have such a strong aversion to being photographed. (Don't do it: you're asking for trouble.)

Prostitutes in the Netherlands are not required by law to undergo STD testing. This sitution is strongly supported by the prostitutes' union (The Red Thread) and members of the women's movement who work to ensure the human rights of sex-trade workers.

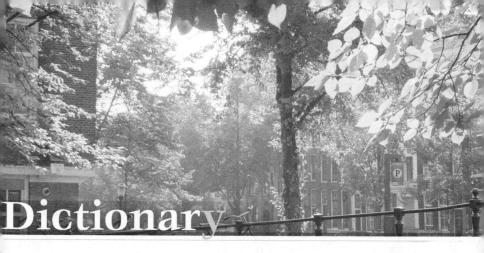

Note: "u" is pronounced like a low growl, like the noise you make when you try to scratch an itch at the back of your throat, like the ch in Chanukah. I'll use "gh" in my attempt at the phonetic spellings. Good luck (you'll need it).

hello / goodbye

see va

thank you

vou're welcome 'please

uck off do you speak

english? now much does

that cost? ree

stoned as a shrimp

jot a light? olling paper

o smoke grass o blowjob

o cunnilingus tore

delicious

ood, to eat, meal = eten (ayten) ice / noodles

vithout meat

= dag (dagh)

= tot ziens (tote zeens)

= dank je wel / bedankt (dahnk ye vel / bidahnkt)

= alsieblieft (allsh yuhbleeft)

= rot op

= spreekt uw engels? (spreykt oo angles)

= hoe veel kost dat? (hoo feyl cost dat)

= gratis (ghrah tis)

= stoned als een garnaal

= vuurtje? (foortchye)

= vloeitje (flu ee chye)

= blow

= pijpen (pie pen)

= beffen

= winkel (veenkel)

lekker

= nasi / bami (in Indonesian restaurants)

= zonder vlees (zonder flays) bon apetit

dessert cosy

really?

what a drag

iuice cheers

watch out squat

fag dykes

Cinderella

bicvcle canal

square left right

asshole!

I practice safe sex

= eet smakelijk (ate sma ke lik)

= toetje (too chye)

= gezellig (ghezeligh)

= echt waar? (eght var)

= wat jammer (vaht yahmmer)

= sap

= proost

= pas op

= kraak (krahk)

= nicht (nickte)

= potten

= Assepoester (ass-uh-poo-ster)

= fiets (feets)

= gracht (ghrahght)

= plein (plane)

= links (leenks)

= rechts

= klootzak!

(literally "scrotum" or "ball bag"; kloat zak)

= Ik vrij veilig (lk fry file igh)

dictionary

= za (zaterdag)

=2.2 pounds

= zo (zondag)

1 ounce = 28 grams

1 kilo

1	= een (eyn)	Temperatures:		Ti	Time:	
2	= twee (tvey)	F	С	12 noon	12:00	
3	= drie (dree) = vier (feer)	104	= 40	1 pm	13:00	
5	= vijf (fife)	95 86	= 35 = 30	2 pm	14:00	
6	= zes (zes)	77	= 25	3 pm 4 pm	15:00 16:00	
8	= zeven (zeven) = acht (ahcht)	68	= 20	5 pm	17:00	
9	= negen (nayghen)	59 50	= 15 =10	6 pm	18:00	
10 = tien (teen)		41	= 5	7 pm 8 pm	19:00	
D	ays:	32 23	= 0 = 5	9 pm	21:00	
m	on = ma (maandag)	14	= 5	10 pm	22:00	
	es = di (dinsdag)	5	= 15	11 pm 12 midnight	23:00	
	red = wo(woensdag) nurs = do (donderdag)	- 4 -13	= 20 = 25	1 am	01:00	
fr		-13	- 25	2 am	02:00	

cold = koud (cowd)
hot = heet (hate)
rain = regen (ray ghen)

what time is it? = hoe laat is het (who laht is het)

3 am 03:00

etc..

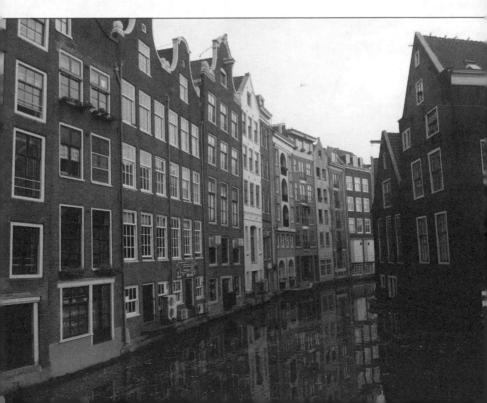

Largest selection of science fiction & fantasy in Europe

Big selection of books on sex, new age, drugs, controversial knowledge

Gay & lesbian books and magazines

Latest manga & comics

Great bargains

Magazines on every possible subject

Second hand books

Large selection on American Studies

10% discount for students, teachers, 65 +

The American Book Center Independent booksellers since 1972

Spui 12 Amsterdam Lange Poten 23 Den Haag

www.abc.nl

emergency & health

Emergency: (police, ambulance, fire) 112

Police: (non emergency) 0900-8844

First Aid: (OLVG Hospital, 1st Oosterparkstraat 179) 599-9111

Crisis Help Line: (24 hours; if you get a message, they're talking with someone else who's in

crisis) 675-7575

Anti Discrimination Office: (complaints about fascism and racism; mon fri 9-17) 638-5551

Doctor Referral Service: (24 hours) 592-3434

Travellers' Vaccination Clinic: (GG & GD, Nieuwe Achtergracht 100; mon-fri 7:30-10) 555-5370

Dentist Referral Service: (24 hours) 570-9595

ACTA Dental Clinic: (cheap treatment by students; mon-fri 9-17) 518-8888

Pharmacies Info Line: (includes after hours locations; message is in Dutch) 694-8709

AIDS Info Line: (anonymous consultation about aids and safe sex; €.10/min) 0900 204-2040

STD Clinic: (free and anonymous treatment; GG&GD, Groenburgwal 44; mon-fri 9-12:30

13:30-17:30) 555-5822

Birth Control Clinic: (Rutgershuis, Sarphatistraat 618; mon-fri 9-16) 616-6222

Abortion & Birth Control Info Line: (mon-fri 9-18:00; €.30/min) 0900-1450

Legal Aid: (mon-fri 14-17) 520-5100

general info lines

Dutch Directory Assistance: (€1.15/call) 0900-8008

International Directory Assistance: (€.90/min) 0900-8418

Collect Calls: 0800-0410

Amsterdam Tourist Office (VVV): (€.40/min, which adds up quickly as they often leave you on

hold for ages; Mon-Fri 9-17) 0900 400-4040

Public Transport Info: (info on trains, buses & trams throughout Holland; www.gvb.nl; €.70/min)

0900-9292

International Train Info & Reservations: (€.35/min) 0900-9296

Taxi: 677-7777

Taxi Complaints Line: (note that you must provide the licence plate number and exact time of

the journey; €.13/min) 0900 202-1881 **Schiphol Airport:** (€.30/min) 0900-0141

Lost and Found Offices: Amsterdam Police (Stephenstraat 18, near Amstel Station; Mon-Fri 12-

15:30) 559-3005; Public Transit Authority (Mon-Fri 9-16:30) 0900-8011

Lost Credit Cards: (all open 24 hours) Amex 504-8666, choose "3"; Mastercard/Eurocard 030

283-5555, choose "1"; Visa 660-0611; Diners 654-5511

Gay and Lesbian Switchboard: (info and advice; Mon-Fri 12-22; Sat/Sun 16-20; www.switch-

board.nl) 623-6565

Youth Advice Centre: (Tues-Fri 13-17; Thurs 13-20) 344-6300

embassies and consulates

(070 = Den Haag)

Amerika 575-5309 / 070 310-9209

Australia 070 310-8200

Austria 471-2438 / 070 324-5470

Belgium 070 312-3456

Britain 676-4343 / 070 364-5800

Canada 070 311-1600

Denmark 070 302-5959

Egypt 070 354-2000

Finland 070 346-9754

France 530-6969 / 070 312-5800

Germany 673-6245 / 070 342-0600

Greece 070 363-8700

Hungary 070 350-0404

Indonesia 070 310-8100

India 070 346-9771

Ireland 070 363-0993

Israel 070 376-0500

Italy 550-2050 / 070 346-9249

Japan 070 346-9544

Luxembourg 070 360-7516

Morocco 070 346-9617

New Zealand/Aotearoa 070 346-9324

Norway 624-2331 / 070 311-7611

Poland 070 360-2806

Portugal 070 363-0217

Russia 070 364-6473

South Africa 070 392-4501

Spain 620-3811 / 070 364-3814

Surinam 070 365-0844

Sweden 070 412-0200

Switzerland 664-4231 / 070 364-2831

Thailand 465-1532 / 070 345-2088

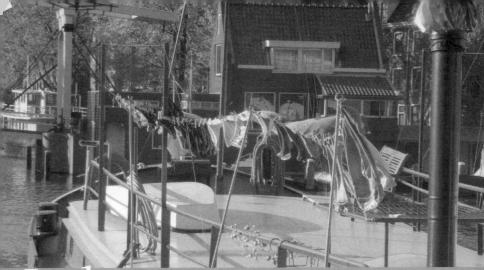

Index

ABC Treehouse	74	Eastern Docklands	12
Amsterdam Dance Event	115	ecstasy	33, 84
Amsterdam Literary festival	74	electro	115
Amsterdam School	104	e-mail	64, 84, 89, 9 °
Amsterdamse Bos	14, 88 , 115, 132	Echer, M.C	107
Anne Frank House	12,16, 22, 106	fair trade cannabis	64
Bad Brains	110	fetish parties	135, 13 6
Baker, Chet	14	Funkadelic	110
Begijnhof	89	gaming	84, 9
Bevrijdingsdag	97	garage rock	112
Bimhuis	13, 111 , 112	Gay Pride Parade	98
Bjork	89	Goth	115
boat tours	16, 22	Haze	65, 6
Botanical Gardens	12, 67, 89, 104 , 106	Heineken Music Hall	11
Bubbleator	69	Hemple Temple bar	10
Cannabis College	69, 71	Hendrix, Jimi	99
Cave, Nick	111	hip hop	113, 114, 124, 13
Cohen, Leonard	89	Hollander, Xavier	13
Concertgebouw	91	houseboats	13, 10,
condoms	135	Ice-o-lator	65, 70
Dam Square	90	indie	63
5 Days Off		international news	75, 90, 11
drum 'n' bass	111, 115	jazz	14, 111, 113, 11

BEST SMARTSHOP IN TOWN

magic truffles > herbal xtc > energizers aphrodisiacs > psycho-active plants & herbs vitamins > oxygen > lifestyle > gallery > music internet > dvd's > books > coffee & tea corner

CONSCIOUS DREAMS HOHOPELLI
Warmoesstraat 12 | Amsterdam
T: 020.4217000 | 6: infokoko@gmail.com
www.myspace.com/kokopelli_amsterdam
NPEN 7 NAYS 8 NIEEH 11:00-22:00

WWW.RADIOFREEAMSTERDAM.COM

index

Keukenhof	107	Queen's Day	9
kid friendly restaurants	100	Queens of the Stone Age	11
Kings of Leon	63	Radio Free Amsterdam	11
Kroller-Muller	107	Radiohead	8
last minute deals	7, 27, 108	Ramones	6
Leidseplein	89	Red Light District	80, 101, 111, 124, 13
magic mushrooms	84	reggae	109, 113, 12
manga	77	Rembrandt	44, 10
Martian Mean Green	63	Rijksmuseum	8, 10
Mexican food	46	Ruigoord	64, 11
micro-brew	123	Schipol Airport	8 , 27, 28, 8
Milky Way (Melkweg)	50, 110 , 129	Seven Bridges	11
Mos Def	111	Shark	10
Museum Card	105	Skinny Bridge	5
Museum Nacht	105	smallest house	10
Museum Weekend	105	Snoop Dogg	6
Museumplein	38, 90	Sonic Youth	11
NDSM Werf	61, 74, 93, 114	space cakes	6
Nelson, Willie	110	squatting	35, 7
New Year's Eve	98	Street Rave	9
Nieuwmarkt	72, 90	sushi	46, 4
nudists	18, 95, 96, 97	tattoos	80, 81, 8
OCCII	53, 95, 110	taxis	21 , 28, 14
oldest house	89	techno	11
Open Monument Day	105	tourist office	7, 29 , 14
OT301		trance	11
Paradiso	110	tulips	74, 10
parking, bikes	12, 15	Uitmarkt	11
parking cars	20	Van Gogh	65, 105, 106 , 10
photo processing	87	vaporizers	63, 66, 69, 9
Pink Point	34	vegan	50, 53, 8
Pixies	110	Vondelpark	18, 38, 58, 88 , 121, 12
pool	66, 112, 114, 125	Westergasfabriek	112, 113 , 12
pothead punks	63	WiFi	8, 9, 13, 46, 58, 12
punk	63, 85, 120	windmill	16, 12
prostitution	134, 137	Wollemi Pine	10
psychoactive plants	69, 84, 106	WW2 Resistance Museu	m59, 10

Come by our shop and choose from over 800 different cannabis related products including books, hemp products and smoking accessories.

We specialise in developing award winning sieve systems for the purest collection of cannabis trichomes, like our innovative Bubbleator range.

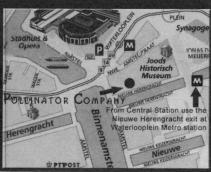

Hemp Works® your one-stop shop for all things Hemp

Featuring our inhouse line of eco-friendly streetwear: **Hemp HoodLamb**® and other Hemp Fashion brands, Cosmetics and Healthy Hemp Seed snacks.

High Quality Seeds from T.H.Seeds®

What else... just great knowledge of all things Hemp and Amsterdam.

HempHoodLamb®

T.H.Seeds® Amsterdam's finest

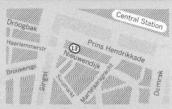

Hemp Works® / T.H.Seeds® Nieuwendijk 13, 1012 LZ, Amsterdam +31 20 4211762

www.hempworks.nl www.hempworks.typepad.comwww.hoodlamb.com -00 www.thseeds.com

DAILY RENTALS 365 DAYS A YEAR

PRICES STARTING AS LOW AS €7 PER DAY

GUIDED BIKE TOURS IN ENGLISH **AVAILABLE YEAR** ROUND

MIKE'S BIKE TOURS AMSTERDAM

134 KERKSTRAAT 1017 GP AMSTERDAM ++ 31 20 622 7970

WWW.MIKESBIKETOURSAMSTERDAM.COM

Notes